'It's not a message I ever intend to convey in words.'

– STANLEY KUBRICK

'Real is good, interesting is better.'

– STANLEY KUBRICK

Stanley Kubrick
A Life in Pictures

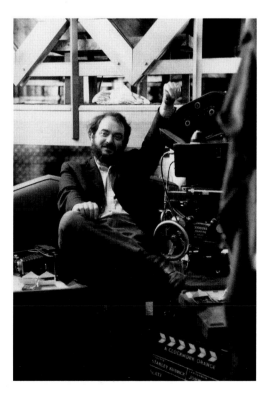

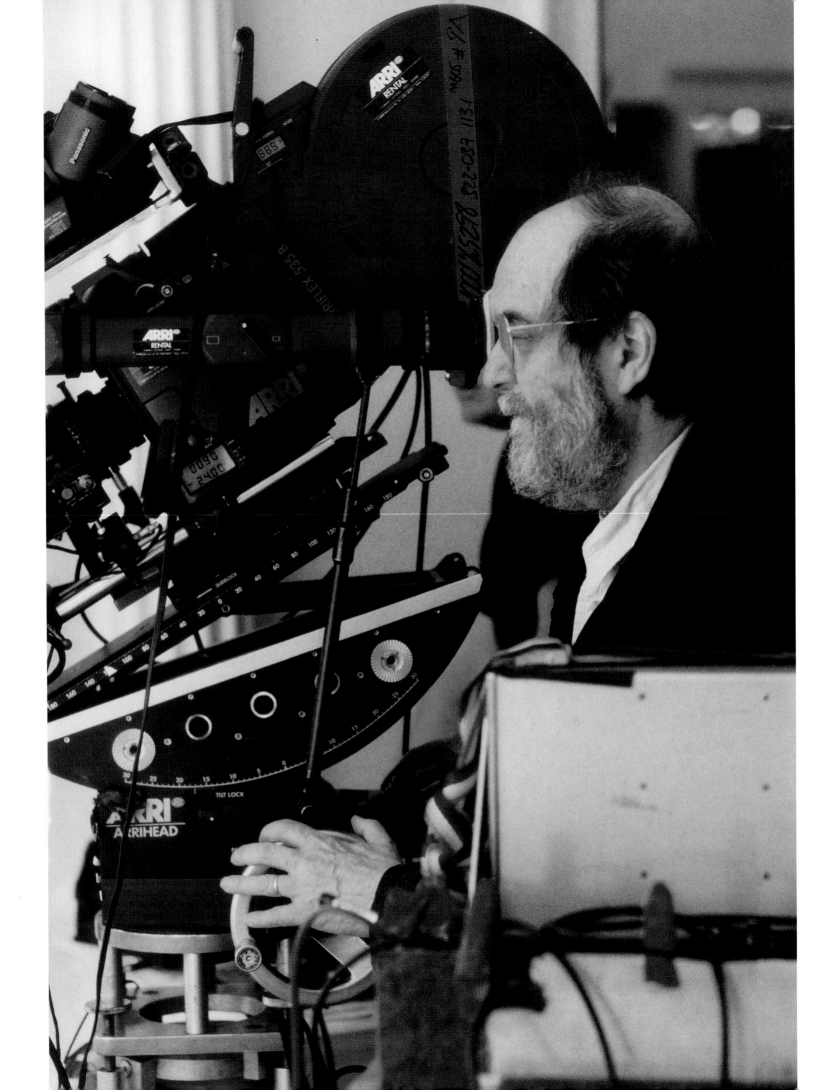

Stanley Kubrick

A Life in Pictures

PHOTOGRAPHS SELECTED
AND WITH A COMMENTARY BY

Christiane Kubrick

FOREWORD BY

Steven Spielberg

A BULFINCH PRESS BOOK

LITTLE, BROWN AND COMPANY

BOSTON • NEW YORK • LONDON

First North American Edition

First published in Great Britain in 2002 by Little, Brown, an imprint of Time Warner Books UK

Where known, the photographic credits are supplied alongside the images.

ISBN 0-8212-2815-3

Library of Congress Control Number: 2002102355

Bulfinch Press is an imprint and trademark of Little, Brown and Company (Inc.)

Typography and design by Anthony Frewin
Printed and bound in Italy

CONTENTS

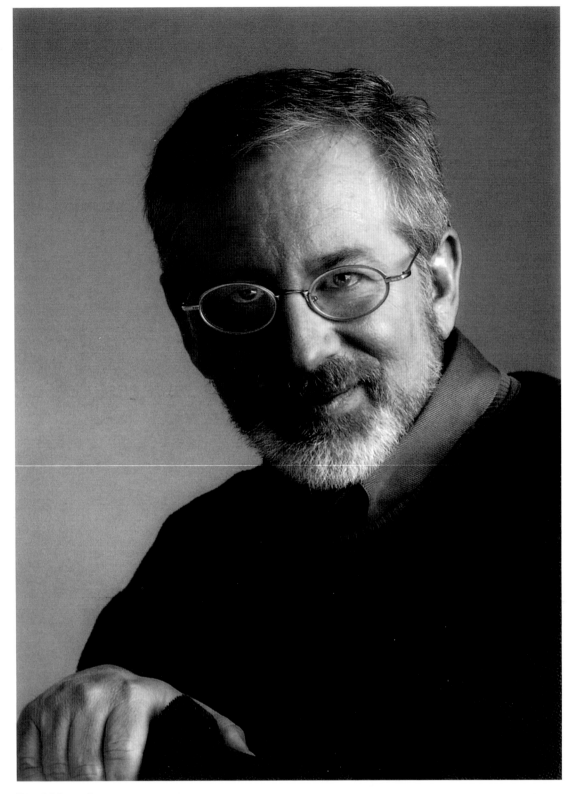

[David James]

FOREWORD BY STEVEN SPIELBERG

STANLEY KUBRICK was a friend of mine for almost eighteen years. He was a colleague and somebody who drove my phone bills to an all-time high.

He invited me years ago to collaborate with him on *A.I.* (*Artificial Intelligence*). I was to direct it and he would produce it. I didn't believe him at first. But I flew straight from Long Island into his kitchen in St Albans where he convinced me with a stack of drawings and a story that moved me no end. Little did I know then that I would have to make the film without him years later.

Stanley Kubrick was the grandmaster of film-making. He created more than movies. He gave us complete environmental experiences that got more, not less, intense the more you watched them. Some of his movies were like stylised theatre – as ritualised as kabuki. Patrick Magee in *A Clockwork Orange*, Tim Carey in *Paths of Glory*, Jack Nicholson in *The Shining* – Stanley pushed those performances to a level that at first seemed overblown, but we followed him into his world until all those characters seemed perfectly normal.

He copied no one, while all of us were scrambling to imitate him. He has had tremendous influence over all my work and over many of my peers. *2001: A Space Odyssey* was the Big Bang that inspired my generation's race to space – and from the deepest part of me I will always thank Stanley for influencing me by making *Dr Strangelove*, and especially that hand-held scene where the soldiers attempt to recapture Burpleson Air Force Base. Those few moments of *cinéma vérité* influenced me greatly in how I approached the photography of *Saving Private Ryan*.

Stanley made movies like an artist because he couldn't help himself. He made films because he had to make films. Even in those long stretches between great works of cinema, he was always in some form of film production. I really think Stanley considered script development as essential as bringing a cast and crew together to actually make the film. He spent so many years on pictures because his thought process – so unique in my experience – needed that much time to percolate. He had thought about *Eyes Wide Shut* since 1970 when he read the novella by Arthur Schnitzler. He could wait it out. He could wait us out. He was pragmatic in waiting for the time to be right, for the culture to be ready, and for things to be right within himself, before bringing something to the screen.

He would think everything through so carefully – he would think it through like the chess hustler that he was when he was working the chess-boards as a young man in Washington Square. He knew how to use Hollywood and the stars to his advantage. He had a tremendous skill for making his films relatively inexpensively and still maintaining the complete control of the true perfectionist.

For such a rational man, *2001: A Space Odyssey* was a step beyond rational. It was all very ordered – maybe his most ordered film until the very end. He let you see that all of this order was leading to something you could not comprehend but was experiential: it was illustrating emotionally what the next evolutionary step was going to be – and you can't do that rationally. *2001* is the emotional illustration of the terrible limits of intelligence, and it's ironic that this most intellectual of American film-makers is the one who succeeded in allowing the irrational to be grasped by audiences of all ages. The Star Child at the end of *2001* is to me the greatest moment of optimism and hope for mankind that has ever been offered by a modern film-maker.

This book will be treasured by *cinéastes* around the globe. Who better to write it than Christiane Kubrick, who was married to Stanley for over forty-two years?

INTRODUCTION BY CHRISTIANE KUBRICK

IT GOES WITHOUT SAYING that this is a book that Stanley would never have produced himself. He would have seen it as a distraction. A distraction, greedy of time and effort, which diverted those precious resources from his life and his work. And I can picture him now, with a barely disguised smile, saying, 'A perfect job for a widow, eh?'

I've lost count of the number of books that have been published on Stanley: shelves and shelves of critical studies and monographs, magazine articles beyond count, and surprisingly or not, depending on your point of view, two full-length biographies. All of these works are worthy in their own way, but all to me are a little like *Hamlet* without the Prince of Denmark. Well, in this book I've attempted to put the Prince back into the play.

This is essentially a family album of photographs, 'lightly and slightly' added to, which I hope will present Stanley as I knew him, as my children and other members of the family knew him, and as those who worked with him knew him. The photographs will also, I pray, correct the mistaken view of Stanley as some sort of isolationist misanthrope out of *Dr Mabuse* by way of Howard Hughes.

Stanley saw his films as important, not what he did in his spare time or what his favourite food was. But this proved to be somewhat out of step with present-day ideas of fame and celebrity. Stanley didn't invite glossy magazines into our home and didn't appear on talk shows, therefore he was deemed a hermit and probably a little mad, too. After all, doesn't everyone want to be noticed, to be famous, to be talked about? No, not in

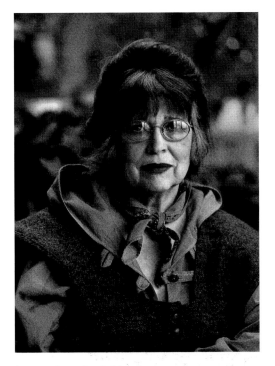

[Manuel Harlan]

12 *that* way. Also, there was an inherent contradiction in the phrase 'hermit film director' which seemed lost on those who used it. One can be a hermit writer or artist or poet, but how could anyone be a hermit film director? This is one of the most gregarious of artistic pursuits.

Stanley was, literally, surrounded by dozens, if not hundreds of people most of the time, as the pictures here will show. And he enjoyed it.

I have not divided Stanley's life into chapters in this book. His life, our lives, cannot be cut into uniform sections. I have started with picture 1 and gone through to the end, representing his life as a continuous thread without zoning, pausing only for a colour section in the middle.

And now, some thanks. Many people have contributed to the making of this book, both wittingly and unwittingly, and I am sure for every name I can remember there must be at least two I have forgotten. To those whose names are not included here I offer a double helping of thanks garnished with an apology.

Steven Spielberg must be thanked for writing the foreword. And, in alphabetical order, I would also like to thank all of the following who have contributed in so many ways: Roger Arar, Louis C. Blau, John Calley, Sir Arthur C. Clarke, Geoffrey Crawley, Tracey Crawley, Tom Cruise, Melanie Viner Cuneo, Michael Dovan, Iris Frederick, Anthony Frewin, Nick Frewin, Jan Harlan, Manuel Harlan, Andrew Hewson, Beth Humphries, Brian Jamieson, Malcolm Kafetz, Nicole Kidman, Warren Lieberfarb, Vincent LoBrutto, Kristie Macosko, David Meeker, Matthew Modine, Gene Phillips SJ, Sydney Pollack, Ned Price, Dan Richter, Alan Samson, Terry Semel, Julian Senior, and Leon Vitali.

Lastly, I would like to end with one of Stanley's favourite quotes:

The tragedy of old age is not that one is old,
 but that one is young.
 OSCAR WILDE: *The Picture of Dorian Gray (1891)*

Stanley was aware of this more than most.

STANLEY KUBRICK: A CHRONOLOGY

1928 Stanley Kubrick born Thursday 26 July to Jacques and Gertrude Kubrick at the Lying-In Hospital in Manhattan.

Kubrick family resides at 2160 Clinton Avenue in the Bronx.

1934 Barbara Kubrick, sister, born 21 May.

Stanley Kubrick begins public school at P.S. 3 in the Bronx, New York.

1937 Kubrick family moves from Clinton Avenue apartment to houses on Grant Avenue in the Bronx, first 1131, then 1135.

1938 Kubrick begins schooling at P.S. 90.

1940 Kubrick leaves P.S. 90 and spends the fall semester with Martin Perveler, his mother's brother, in California.

1941 Spends spring semester with his uncle in California.

Kubrick returns to the Bronx and enters William Howard Taft High School.

1942 Kubrick family moves to 2715 Grand Concourse in the Bronx.

1943 Kubrick is a percussionist in the Taft orchestra and plays drums in the school's swing band – Eydie Gormé is the vocalist.

Kubrick becomes active in the Taft photography club.

1944 Kubrick family now living on Shakespeare Avenue in the Bronx.

Kubrick is photographer for the Taft newspaper and member of the *Taft Review.*

1945 As a high school senior, Kubrick's photograph of a newsvendor with defining reaction to the death of President Franklin Delano

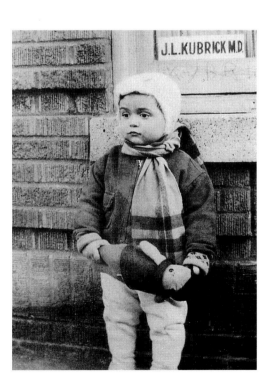

See picture No. 1.

Roosevelt appears in the 26 June issue of *Look* magazine. He is paid $25.00.

Kubrick family now living in a private house at 1873 Harrison Avenue in the Bronx.

1946 2 April: *Look* publishes Kubrick photo series of his English teacher, Aaron Traister, acting out Shakespeare in his Taft classroom.

16 April: *Look* publishes Kubrick photo series 'A Short Short in a Movie Balcony,' featuring high school friend Bernard Cooperman.

Kubrick graduates from Taft High School, enrols in evening classes at City College and becomes a staff photographer for *Look.*

1947 Kubrick gets his pilot's licence on 15 August.

1948 11 May: Kubrick profiled in *Look* as a 'two year *Look* Veteran'.

29 May: Kubrick marries Toba Metz at a civil ceremony in Mount Vernon, New York (subsequently divorced).

The couple moves to 37 West 16th Street in Greenwich Village.

1949 *Look* publishes Kubrick's photo story on middleweight boxer Walter Cartier.

1950 Kubrick directs his first film, a short, *Day of the Fight,* adapted from the Cartier photo story.

1951 26 April: *Day of the Fight* opens at the Paramount Theater in New York City.

Kubrick resigns from *Look* to pursue film-making career.

Directs the short film *Flying Padre* released by RKO-Pathé as part of the Screenliner series.

1953 Kubrick commissioned by the Seafarers' International Union to direct a short 16mm industrial film. *The Seafarers* is his first film in colour.

Kubrick directs his first feature film, *Fear and Desire,* which is independently produced and released.

Katharina Christiane born to Christiane Susanne Harlan (Kubrick's future wife) and Werner Bruhns.

1955 11 January: Kubrick marries ballerina and choreographer Ruth Sobotka in Albany, New York (subsequently divorced).

Directs independent film, *Killer's Kiss.*

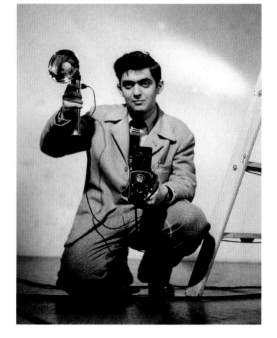

See picture No. 21.

1956 Kubrick meets James B. Harris. They form Harris-Kubrick Pictures.

Kubrick directs *The Killing.*

1957 *Paths of Glory* becomes the second Harris-Kubrick production. Kubrick marries Christiane Susanne Harlan.

1958 6 April: Anya Renata Kubrick born to Christiane and Stanley Kubrick.

1959 Kubrick directs *Spartacus.*

1960 5 August: Vivian Vanessa Kubrick born to Christiane and Stanley Kubrick.

1962 Directs *Lolita*, Kubrick's first film produced entirely in England.

1963 End of Harris-Kubrick Pictures. Kubrick moves on to produce, direct and adapt Peter George's novel *Red Alert*, a drama about a nuclear superpower conflict (*Dr Strangelove*).

1964 *Dr Strangelove, or: How I Learned to Stop Worrying and Love the Bomb*, a black comedy about nuclear annihilation, is released.

Kubrick writes to Arthur C. Clarke about making 'a really good sci-fi movie'.

December: Clarke finishes first draft of a novel written in collaboration with Kubrick to be adapted into a screenplay.

1965 Tuesday, 23 February: in a press release, MGM announces its commitment to Kubrick's next film, *Journey Beyond the Stars* (*2001*).

April: Kubrick announces *2001: A Space Odyssey* will be produced in England.

December: Keir Dullea arrives in London. Clarke completes first draft of the screenplay.

29 December: first day of principal photography on *2001.*

1966 8 January: the *2001* production moves from Shepperton to MGM Studios in Boreham Wood, north of London.

June: Clarke flies to MGM in Hollywood to screen demo reel with some completed scenes to appease the anxious studio executives.

1967 Kubrick and his special effects team execute massive special effects work.

Autumn: Kubrick shoots 'The Dawn of Man' segment.

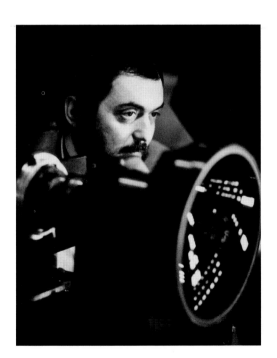

See picture No. 155.

1968 March: Kubrick screens the first composite print of *2001*.

3 April: *2001: A Space Odyssey* opens in New York City, then in Hollywood the next day.

July: Clarke's novel *2001: A Space Odyssey* is published.

1969 Kubrick in pre-production on *Napoleon*. United Artists, once interested in the three-hour epic, turns Kubrick down due to the studio's dismal financial situation.

Kubrick wins Academy Award for Best Visual Special Effects – *2001: A Space Odyssey*.

1970 15 May: Kubrick completes the first draft screenplay adaptation of the Anthony Burgess novel, *A Clockwork Orange*.

Winter: production begins on *A Clockwork Orange*.

1971 Production and post-production of *A Clockwork Orange* completed.

19 December: *A Clockwork Orange* premieres in New York and San Francisco.

1973 Warner Bros tells *Variety* that Kubrick will be shooting a film starring Ryan O'Neal and Marisa Berenson in England, with principal photography to begin in May or June.

1974 Concerned over violent copycat crimes linked to *A Clockwork Orange*, Kubrick pulls the film from distribution in England.

Shooting commences on *Barry Lyndon* production.

1975 18 December: *Barry Lyndon* premieres in New York City.

1977 Kubrick in pre-production on film based on Stephen King's novel *The Shining*.

1978 Kubrick and novelist Diane Johnson adapt *The Shining* for the screen.

Production begins on *The Shining*.

Vivian Kubrick films the documentary, *Making of the Shining*.

1979 23 May: *The Shining* opens in New York.

Making of the Shining is shown on BBC television.

1982 Kubrick reads *The Short-Timers,* a novel by Gustav Hasford, after learning about it in *Kirkus Reviews*.

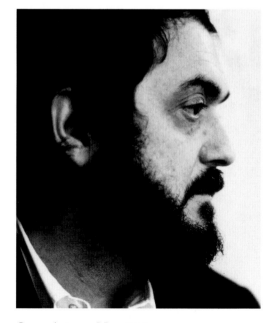

See picture No. 164.

1985 Kubrick formally asks Michael Herr to collaborate on the screenplay adaptation of *The Short-Timers*. Gustav Hasford also works on the script.

 23 April: mother, Gertrude Kubrick, dies in Los Angeles at age 82.

 19 October: father, Jacques Kubrick, dies in Los Angeles at age 83.

 Kubrick's film project now named *Full Metal Jacket* is in final stages of production.

1987 26 June: *Full Metal Jacket* opens in US cinemas.

1989 Kubrick begins pre-production on *A.I.* based on a Brian Aldiss short story.

1991 *A.I.* abandoned when Kubrick concludes the special effect technology necessary is not currently available.

1993 May: Kubrick in pre-production on an adaptation of Louis Begley's WWII Holocaust novel, *Wartime Lies*. Project is renamed *Aryan Papers*.

 Warner Bros announces Kubrick's next film will be *A.I.*

1995 December: Warner Bros press release announces Kubrick's next film, *Eyes Wide Shut,* a story of jealousy and sexual obsession, will start filming in summer 1996, with a screenplay by Kubrick and Frederic Raphael. Production of *A.I.* will follow.

1996 Kubrick receives the Directors' Guild of America D.W. Griffith Award for Lifetime Achievement in film directing.

 Kubrick receives a Special Golden Lion Award at the Venice Film Festival for his contribution to the art of cinema.

1997 *Eyes Wide Shut* based on Schnitzler's *Traumnovelle* announced to open in the autumn, later put back.

1999 Stanley Kubrick dies on 7 March of a sudden heart attack six days after screening the final work print of *Eyes Wide Shut* to Warner Bros.

 Eyes Wide Shut opens on 16 July.

 The Kubrick Collection is released on video and DVD by Warner Bros.

2000 Theatrical re-release of *Dr Strangelove.*

 Theatrical re-release of *A Clockwork Orange* in Britain – first time film is officially shown since it was withdrawn by Kubrick in 1974.

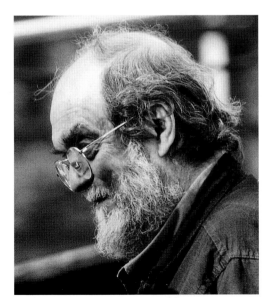

On *Eyes Wide Shut*, 1998.
[Manuel Harlan]

2001 Kubrick documentary *Stanley Kubrick: A Life in Pictures* premieres at the Berlin Film Festival.

Summer: *A.I.* directed by Steven Spielberg opens.

2001: A Space Odyssey re-released.

Stanley Kubrick
A Life in Pictures

PART ONE

1928–1964

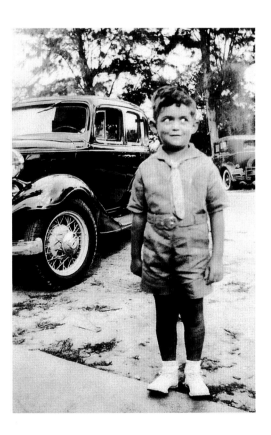

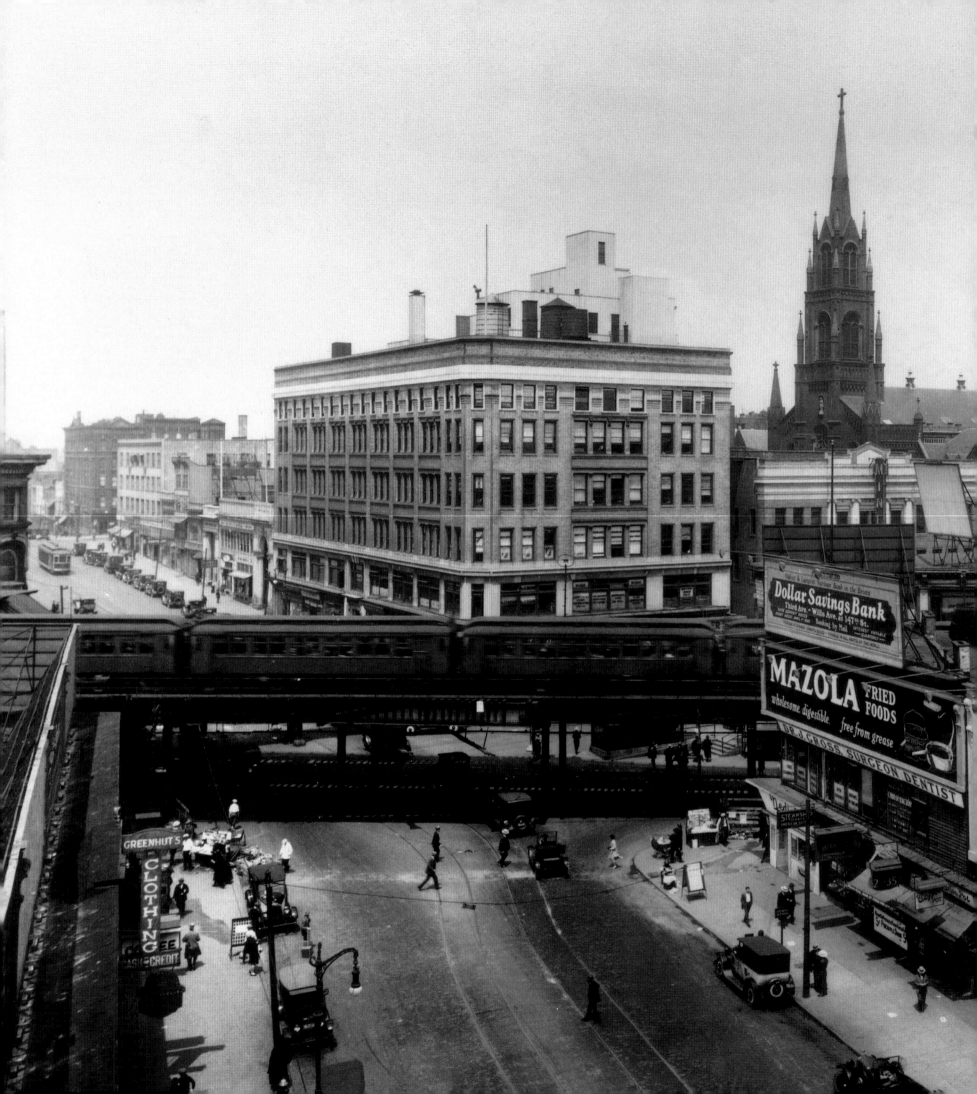

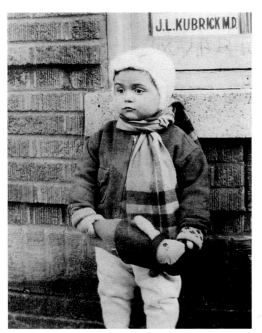

1

Stanley aged two in 1930 clutching a rag doll outside of his father's surgery in the Bronx, not too far away from the family home on Clinton Avenue.

Stanley's father, Jack, was a neighbourhood MD and also a passionate photographer who communicated his enthusiasm to his son at an early age.

Stanley once said that when he was a child there seemed to be a movie house on every street corner in the Bronx. Perhaps there was . . .

1930 was a good year for movies: *All Quiet on the Western Front*, Howard Hughes' *Hell's Angels*, Josef von Sternberg's *The Blue Angel*, Buñuel's *L'Age d'or*, and Garbo talked for the first time in *Anna Christie*.

2

The Bronx. This was the New York borough Stanley grew up in, the city that was home.

The photograph of East 149th Street was taken around the time Stanley was born. A proud and bustling borough with a large first and second generation immigrant population that was determined to get ahead. Stanley's mother, Gert, reflected this. She told him he could do anything.

[New York Public Library]

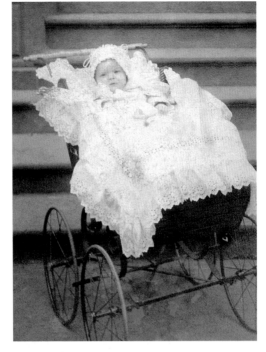

3
Stanley's mother, Gertrude Perveler, known to everyone simply as Gert. She was born in New York City in 1903. Her parents had immigrated from Eastern Europe.

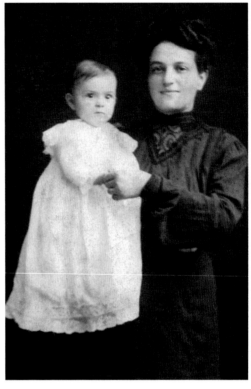

4
Gert aged about four months with her mother, Stanley's grandmother, Celia. The photograph was probably taken at the family home on East 4th Street in Manhattan.

5
Stanley's father, Jack, aged about five. Jack, or to give him his full name, Jacques L. Kubrick, was born in 1902 on Rivington Street in Manhattan. It was always unclear whether the L. stood for Leonard or Leon.

6
A studio portrait of Gert in her early teens, around 1916.

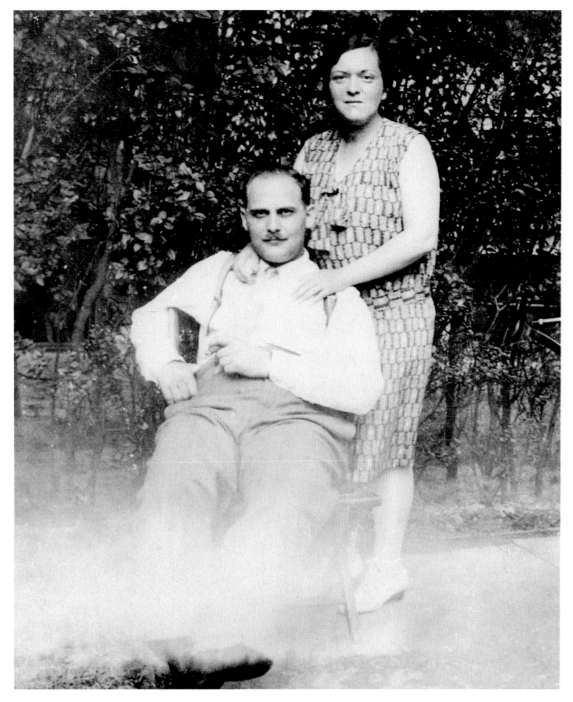

7
Jack and Gert in October 1927, shortly after their marriage. Jack had qualified as an MD and had recently begun practising in the Bronx. Their first home together was at 2160 Clinton Avenue.

Jack was passionate about photography and this passion was communicated to Stanley at an early age.

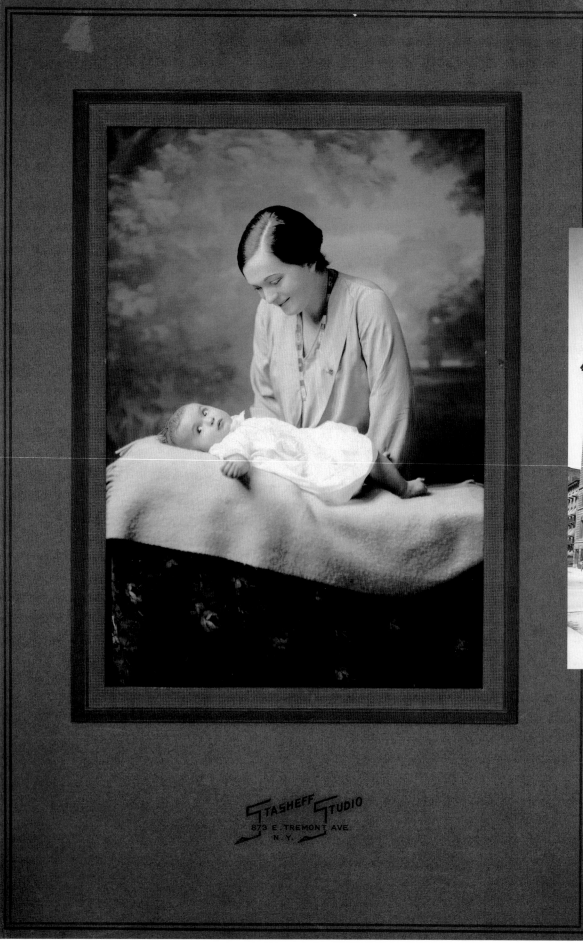

STASHEFF STUDIO
873 E. TREMONT AVE.
N.Y.

8

Stanley at around three months of age in 1928 with his mother, Gert.

This is the earliest photograph I know of Stanley. The picture was taken at the Stasheff Studio, a neighbourhood commercial photographers, on Tremont Avenue in the Bronx, a short walk from Clinton Avenue.

Copies of this in the presentation card folder would have been sent out to family and friends.

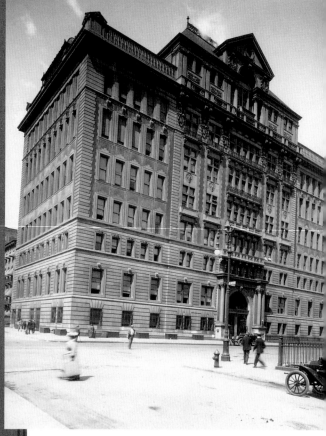

9

Stanley's birthplace: the Lying-In Hospital in Manhattan on Second Avenue, between 17th and 18th Streets.

Although Stanley spent nearly the first twenty years of his life in the Bronx, he was actually born here in Manhattan on 26 July 1928.
[New York Historical Society]

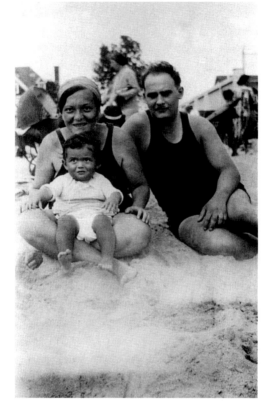

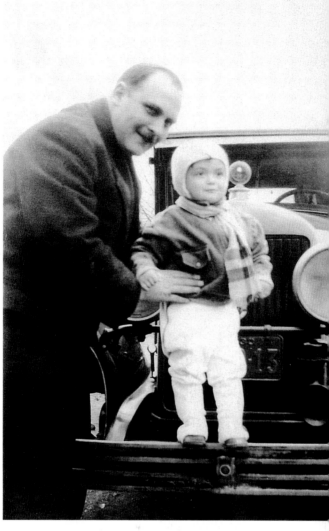

10
Stanley in a grand pram outside of
the family home on Clinton Avenue
in 1929.

Smiling in the background is his
grandmother, Celia.

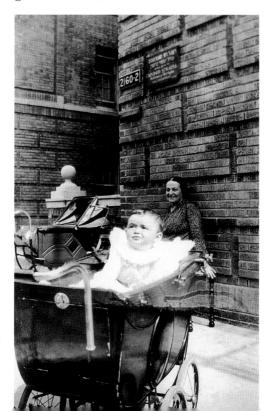

11
I always think of this photograph as
the one in which Stanley is first
recognisable as Stanley. He was
around eighteen months old and his
apprehension, not allayed by Gert
and Jack, may be due to the
crowded, noisy and unfamiliar
surroundings of a beach, probably
Coney Island.

12
Jack proudly displays his son, again
about eighteen months old, and an
automobile that was probably his.

13

Stanley at the age of five or there-
abouts in a posed photograph
almost certainly taken by Jack on a
family day out to a rural location.
As to what is attracting Stanley's
attention, we can only guess.

14

An eight-year-old Stanley with his
sister, Barbara, then about two
years, photographed by Jack in
1936. Barbara was unmistakably
Barbara even then. Her looks
changed very little over the ensuing
years.

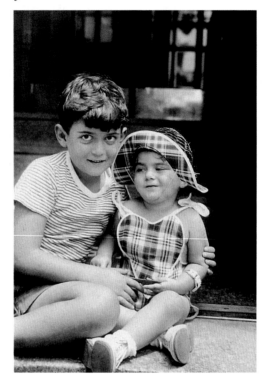

15

Stanley, again aged about eight,
with Gert. He looks engaging.
 Notice the pen in his pocket.
Stanley would have a lifelong love
affair with pens, pencils and
markers, and always acquired them
in multiples as if the supply was
about to dry up.

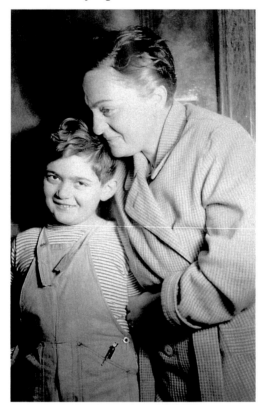

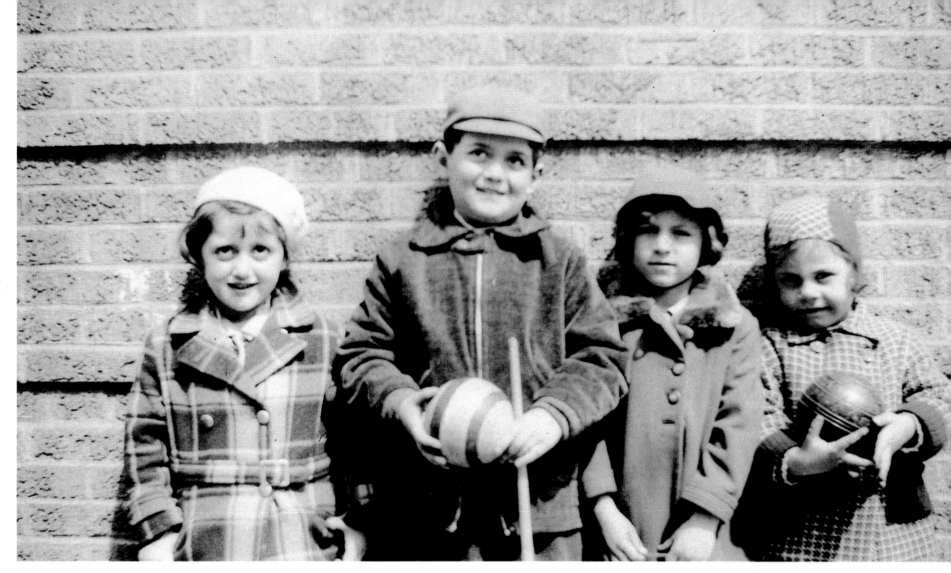

16
Stanley and three playmates from
the 'hood. Photographed by Jack,
The Bronx, circa 1936.

17
A photograph taken around 1936
outside the family home on Clinton
Avenue. Barbara was two.
　　Stanley's luxurious head of hair
is shaped like a Davy Crockett hat.

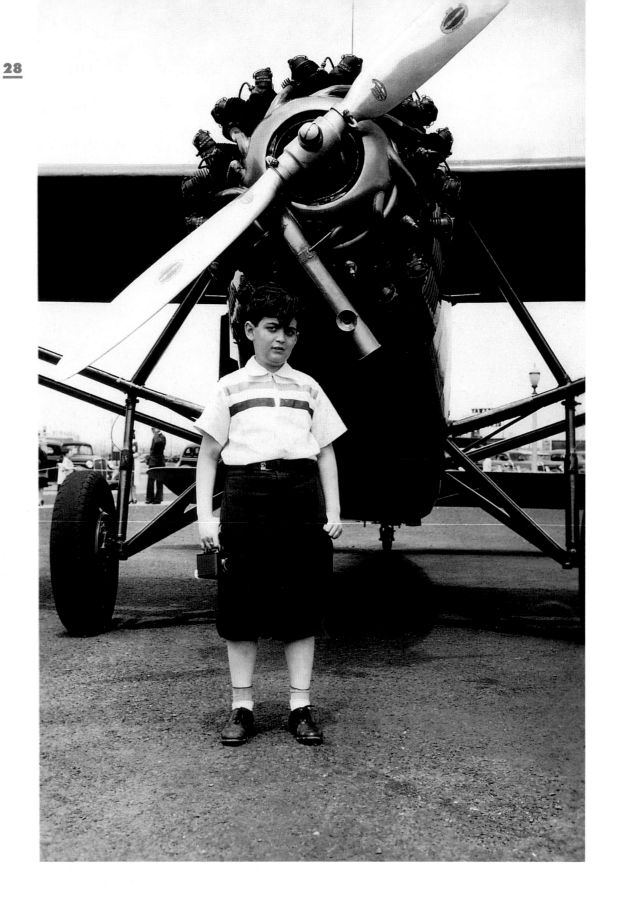

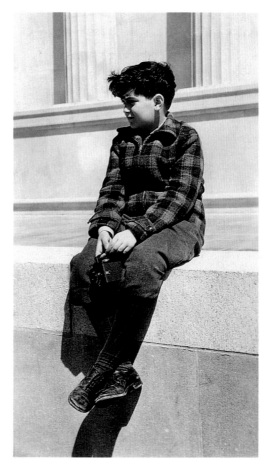

18

An unhappy Stanley captured in a staged pose by Jack around 1938.

Note the camera in Stanley's right hand, and note too the trousers: plus-fours or shorts just too generously cut?

This picture was taken at a local airfield. Interestingly, in the late 1940s Stanley would acquire a pilot's licence.

19

Stanley at the age of ten or thereabouts, circa 1938. The camera he is clutching appears to be the same camera seen in the previous photograph and may have been Jack's movie camera.

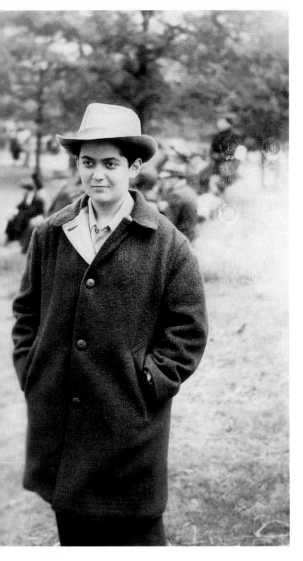

20
A smartly dressed young teenager: Stanley aged about thirteen or fourteen around 1942.

Stanley was famously uninterested in clothes and Gert was still selecting, buying and shipping clothes to him when we met in 1956. He never seemed to have the time or the inclination to do it himself.

21
The photographer: still an amateur but on the cusp of becoming a professional. This picture may have been taken by Jack in his studio at the family home.

Very smart chequered trousers, a fashionable 1940s jacket, and a collar and tie. Again, all chosen by Gert.

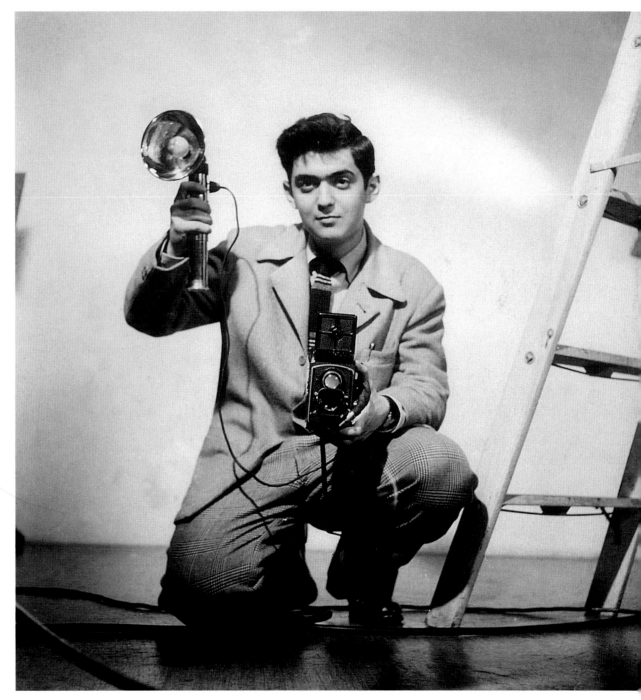

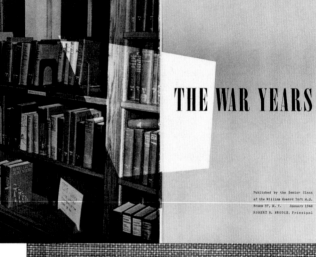

THE WAR YEARS

Published by the Senior Class
of the William Howard Taft H.S.
Bronx 57, N. Y. January 1948
ROBERT R. BRODIE, Principal

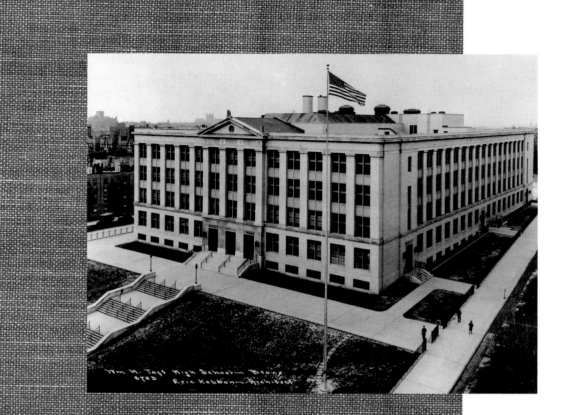

Wm. H. Taft High School in Bronx
6723 Eric Kebbon, Architect

TAFT SENIOR

JAN., 1945

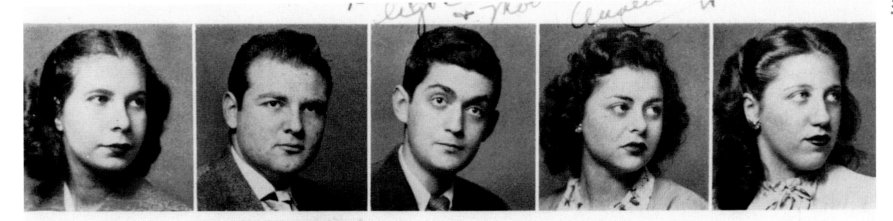

KRUH, PHYLLIS Library Aide, War Bonds and Stamps Salesman. Inside the school she's quiet as a mouse; but outside—I wonder!

KRULIK, HERBERT A. Service Aide to Dr. Mandel, Locker Room Aide. Here is a boy who looks as if he is ready to do something. When will he do it?

KUBRICK, STANLEY Taft Review, School Band. When he was on the TAFT REVIEW, you always found him in a stew.

KUPERBERG, THELMA Girls Emergency Room, Locker Room, Library Aide. Sweet and quiet in every way—No knock for her is all I say.

LANDMAN, HERMINE I. Hall Marshall, Aide to Miss Sultan, Knocks and Boosts Committee (Typist). Fellows come from far and wide just to be at Hermine's side.

22 *(left inset)*
The main title spread of the *Taft Senior Year Book* from January 1945. The volume was designed with some flair by the students themselves, and Stanley took many of the photographs.

23 *(left)*
The cover of the *Taft Senior Year Book*.

24 *(right inset)*
William Howard Taft High School in the Bronx. Stanley attended the school from 1941 to 1946. Among his classmates were Eydie Gormé, the singer, Alexander Singer, the film director, and Steven Marcus, the academic.

Stanley's academic successes were modest but it was a good period for his photographic interests.
[New York Public Library]

25
Stanley as he appeared in the *Year Book* alongside some fellow students. His entry notes that he was associated with the *Taft Review*, a student magazine, and the school band.

On the *Review* he was, principally, a photographer.

He actually played in two school bands, as a drummer with the school swing band and as a percussionist with the school symphony orchestra.

At one time Stanley considered becoming a professional drummer, but after several exhausting weeks on the road with Vaughn Monroe's band for a *Look* magazine feature in the late 1940s, he realised he had made the right choice in becoming a photographer.

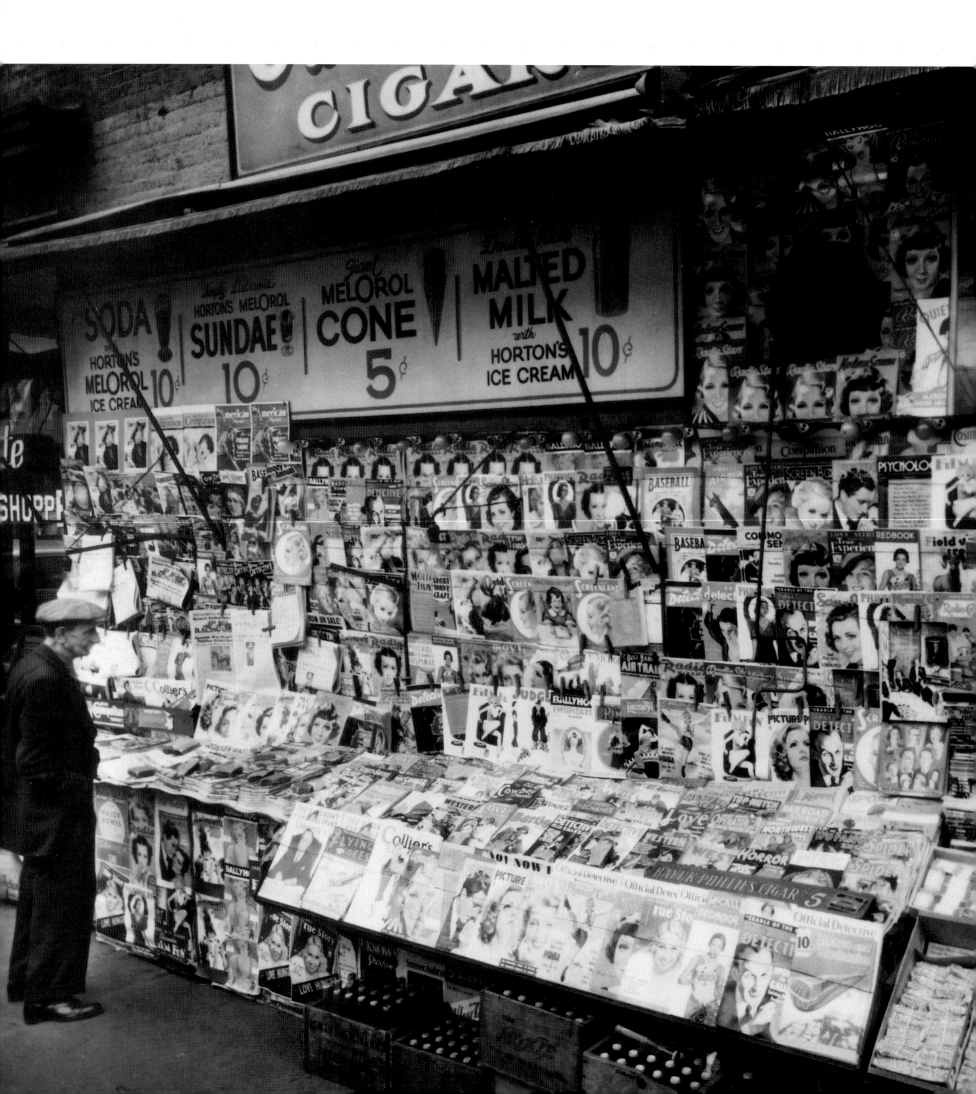

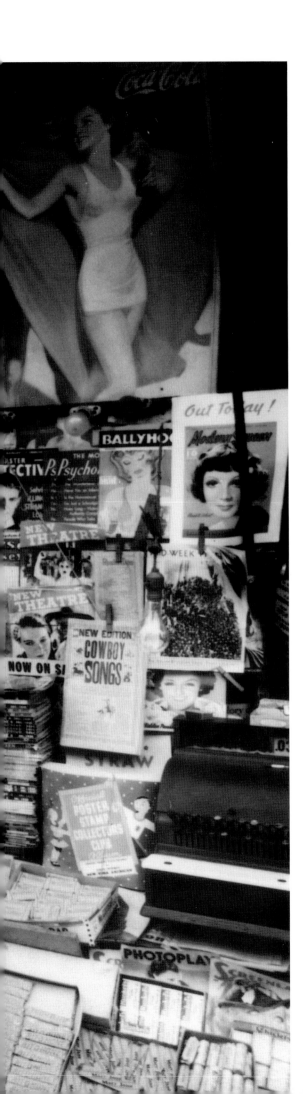

26

A typical New York news-stand in the 1930s showing the wide variety of magazines available.

There were many outlets for a photographer and Stanley would leave Taft High School for a job as a staff photographer with *Look* magazine.

This photograph was taken by Berenice Abbott in 1935. She was a photographer Stanley greatly admired and he met her several times in the early 1950s.
[Museum of the City of New York]

27

A Bronx *nabe*, as *Variety* would say. That is, a neighbourhood cinema, the RKO Franklin on Prospect Avenue in 1941.

You were never far away from a cinema in the Bronx and Stanley visited them all. Movies would fascinate him from an early age, and he used to say whether the picture was good, bad, or indifferent, it didn't matter, you could learn something from it.
[Bronx County Historical Society]

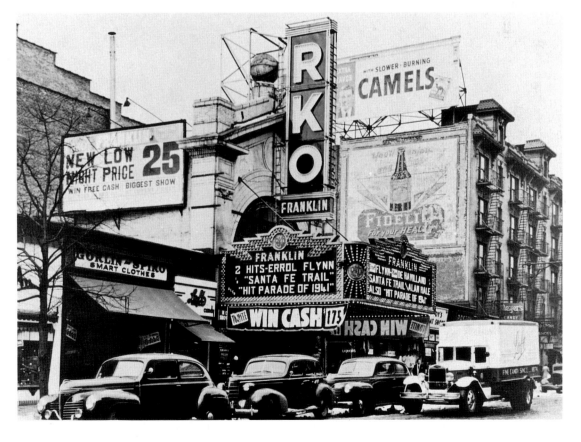

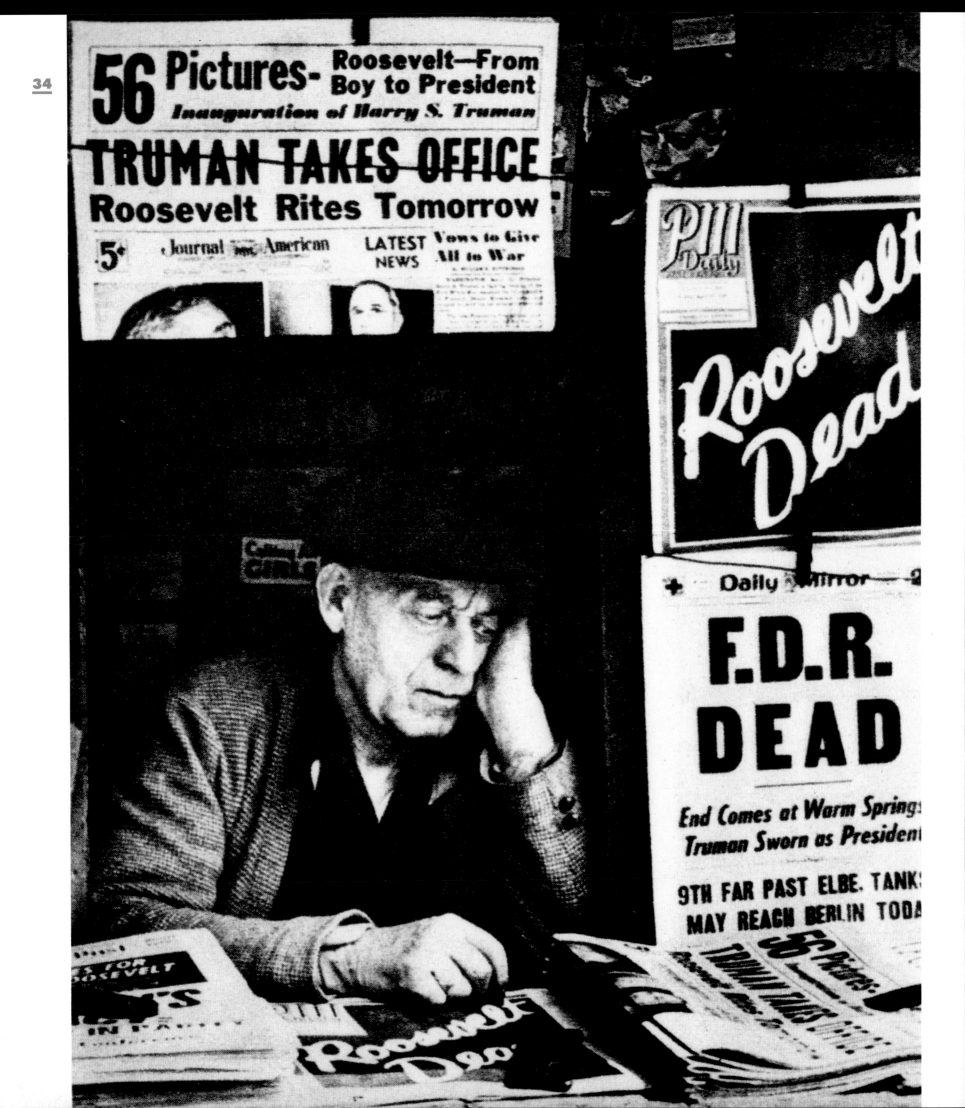

28 (left)

The picture that presaged Stanley becoming a professional photographer. He took it while still a student at Taft and promptly sold it to *Look* magazine for twenty-five dollars. It appeared in the 26 June 1945 issue.

When Stanley left Taft in 1946 he became *Look*'s youngest ever staff photographer, a position he would hold until 1950.

29

An intriguing film publicity still from 1947. The caption on the back reads: 'During the afternoon of hot summer days when Mark Hellinger was in New York making his new picture, *The Naked City*, watermelon was the favorite snack for his cast and crew. Here, Barry Fitzgerald (in straw hat) and Hellinger's crew partake of a favorite Eastside pastime, eating watermelon on the sidewalk.' No mention at all of the film's director, Jules Dassin, who would shortly be blacklisted.

To the left of the film's star, Barry Fitzgerald, stands a photographer with a Rolleiflex camera and a slice of watermelon: young Stanley, who was probably covering the shoot for *Look* magazine.

Interestingly, *The Naked City* was loosely based upon the work of a photographer Stanley greatly admired and befriended: Weegee, otherwise Arthur H. Fellig (1899–1968).

See also Nos 32, 115, 116, 123.

A veteran photographer at 19, Stanley Kubrick makes up for youth with zeal

THE DISTINGUISHED faculty members and officials at Columbia University weren't used to being pushed around. So what did this rank teen-ager mean, telling them what to do?

Like any experienced photographer, Stanley Kubrick knew exactly what he wanted. The impatient mutterings of dignitaries had long since failed to ruffle this quiet, brown-eyed youngster. For two weeks, Stanley stuck to the job on the university campus and got the excellent pictorial story of Columbia that appears with Don Wharton's article, on pages 25–33.

At 19, Stanley is a two-year veteran on the LOOK photographic staff. And even before he was graduated from high school in the Bronx, in 1946, he sold his candidly shot pictures to LOOK.

When Stanley joined the staff, his fellow photographers were quick to observe his intense preoccupation with his work. In a spirit of friendly co-operation, they formed a "Bringing Up Stanley Club," dedicated to reminding Stanley not to forget his keys, glasses, overshoes and other miscellaneous trivia.

The subtle influence of this loosely organized advisory group has also brought an apparent change in the young man's clothing tastes. Once given to wearing teen-age trade-marks—saddle shoes, lounge jackets and sports shirts—Stanley now leans toward glen plaid business suits and white shirts.

But his preoccupation with photography is unchanged. In his spare time, Stanley experiments with cinematography and dreams of the day when he can make documentary films.

The young fellow may go on forgetting his keys. But photographically, Stanley doesn't need any help in bringing himself up.

Cover pictures of Tabak sunback dresses in three variations are by Sprague Talbott.

Look

AMERICA'S FAMILY MAGAZINE

REG. U. S. PAT. OFF.

MAY 11, 1948 • VOL. 12, NO. 10

EDITOR: Gardner Cowles

CHAIRMAN OF BOARD: John Cowles ASSOCIATE EDITOR: Fleur Cowles EXECUTIVE EDITOR: Daniel D. Mich
MANAGING EDITOR: Henry Ehrlich ART DIRECTOR: Merle Armitage ASS'T MANAGING EDITOR: Woodrow Wirsig

DEPARTMENT EDITORS: Joseph B. Breed III, Mrs. Raymond Clapper, Harold B. Clemenko, Patricia Coffin, Tim Cohane, George Eells, Andrew Hepburn, Ben Kocivar, Frank B. Latham, Joanne Melniker, Hubert Pryor, Joseph Quine, Matilda Smith, de Benneville Wickersham • ASSISTANT EDITORS: Hope Beauchamp, Lewis W. Gillenson, Jack Hamilton, William Houseman, Henriette Kish, Leonard Schurman • PHOTOGRAPHERS: Arthur Rothstein, *Technical Director;* Frank Bauman, James Chapelle, Bob Hansen, James Hansen, Doug Jones, Stanley Kubrick, Bob Sandberg, Sprague Talbott, Maurice Terrell, Earl Theisen; Vincent Silvestri, *Dark Room Manager* • ART DEPARTMENT: Verne Noll, *Ass't Art Director;* William Townsend, *Manager;* Elinor Beckwith, Jack Boydston, Al Ewers, Irving Kramer, Paul Pack, William Rosivach • WEST COAST: Jean C. Herrick, *Vice-President in charge:* Stanley Gordon, *Editor;* Teme Brenner, Dan C. Fowler • WASHINGTON: Richard Wilson, William Mylander, Nat Finney, William B. Arthur • PICTURE RESEARCH: Homer Cable, *Director;* Charles Seviour • EDITORIAL RESEARCH: William J. Burke, *Director;* William Downey, *Librarian* • WOMEN'S DEPARTMENT: Alice Richardson, *Fashion and Beauty Editor;* Lily van Ameringen, *Ass't Fashion Editor;* Marcia Wilson Reed, *West Coast Fashions;* Charlotte Adams, *Food and Household Editor;* Charlotte Devtee, *Art Editor;* Theodora Aronstam, *Merchandise Editor;* Hershel Bramson, *Department Art Editor;* Eugene Gilbert, *Editorial Consultant on Youth.*

Address all Editorial Mail to 511 Fifth Ave., N. Y. 17, N. Y. • Address all Subscription Mail to LOOK Building, Des Moines 4, Iowa.

Manuscripts or art submitted to LOOK should be accompanied by addressed envelopes and return postage. The publisher assumes no responsibility for the return of unsolicited manuscripts or art.

30
The contents page of the 11 May 1948 issue of *Look* proudly boasts that at the age of nineteen Stanley was already a veteran photographer.

31
As a staff photographer for *Look*, Stanley was on the road every day shooting stories. Here, America at play in the late 1940s at a roller rink.

What were essentially ephemeral photos now, of course, have historic value in documenting an America that is but a memory.

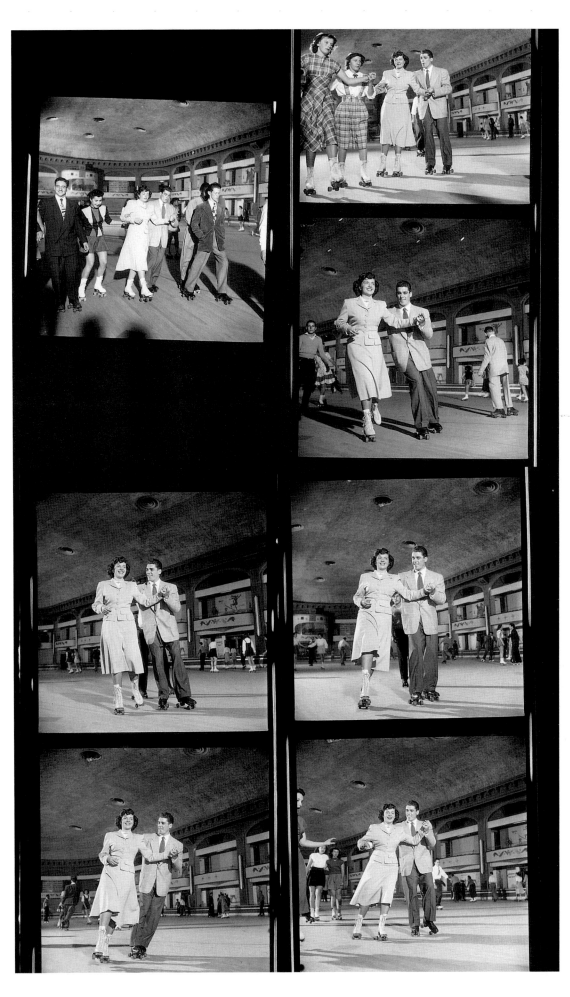

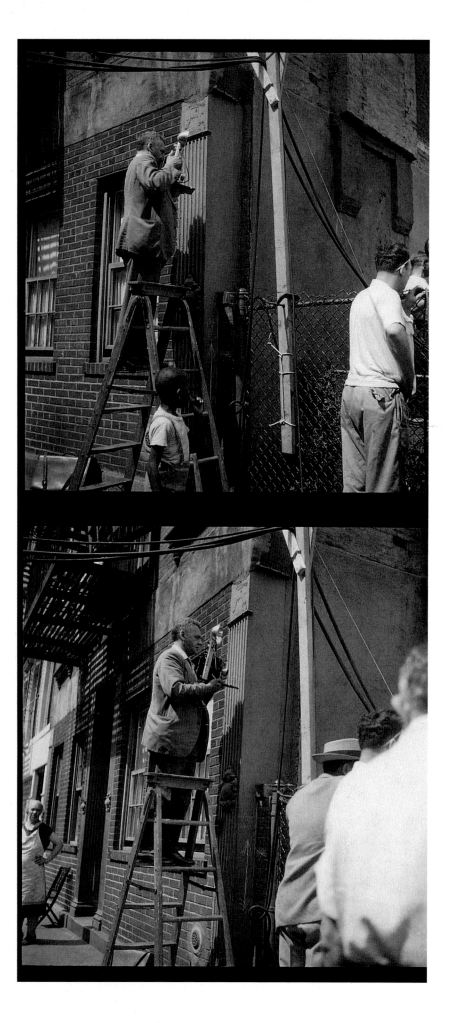

32
Two shots of Weegee taken by Stanley somewhere in New York City in the late 1940s. These may have been on the set of *The Naked City*, the Jules Dassin film.
See also Nos 29, 115, 116, 123.

33
One of the contact sheets of the actor Montgomery Clift, for a feature Stanley did that appeared in the 19 July 1949 issue of *Look*.
Stanley admired Clift, who came to the premiere of *Dr Strangelove* in New York in 1963 where I met him. The fourteen years after the photo session had not been kind to Clift. He had aged greatly, mainly because of his drinking, yet though he was drunk, he was both sweet and charming.

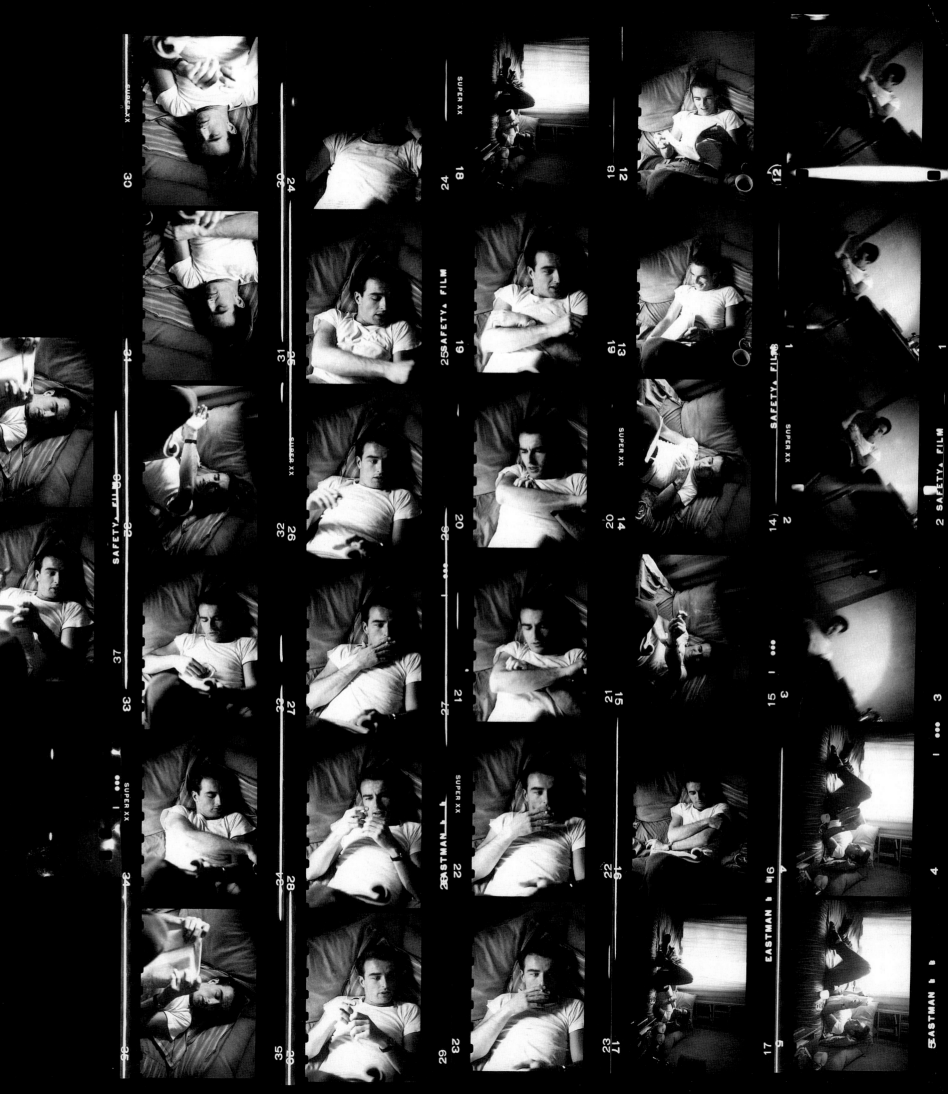

35 *(right)*
Another contact sheet from the
same time. Musicians featured
include Errol Garner again, Big Sid
Catlett, the innovatory drummer
whom Stanley much respected,
Pee Wee Russell again, and the
trumpeter-cornetist Muggsy Spanier.

34
Stanley's keen interest in swing and
jazz resulted in him handling many
of the musical features for *Look*.
Amongst the jazz musicians in the
contact sheet below: Sharkey
Bonano, the New Orleans clarinetist
George Lewis, Errol Garner at the
piano, and Pee Wee Russell.

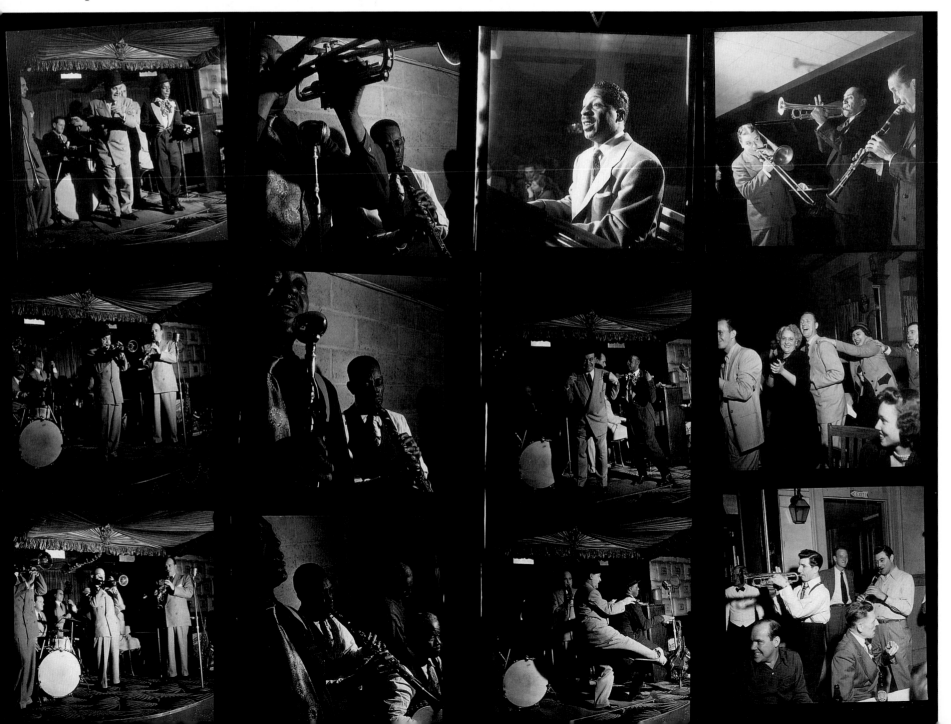

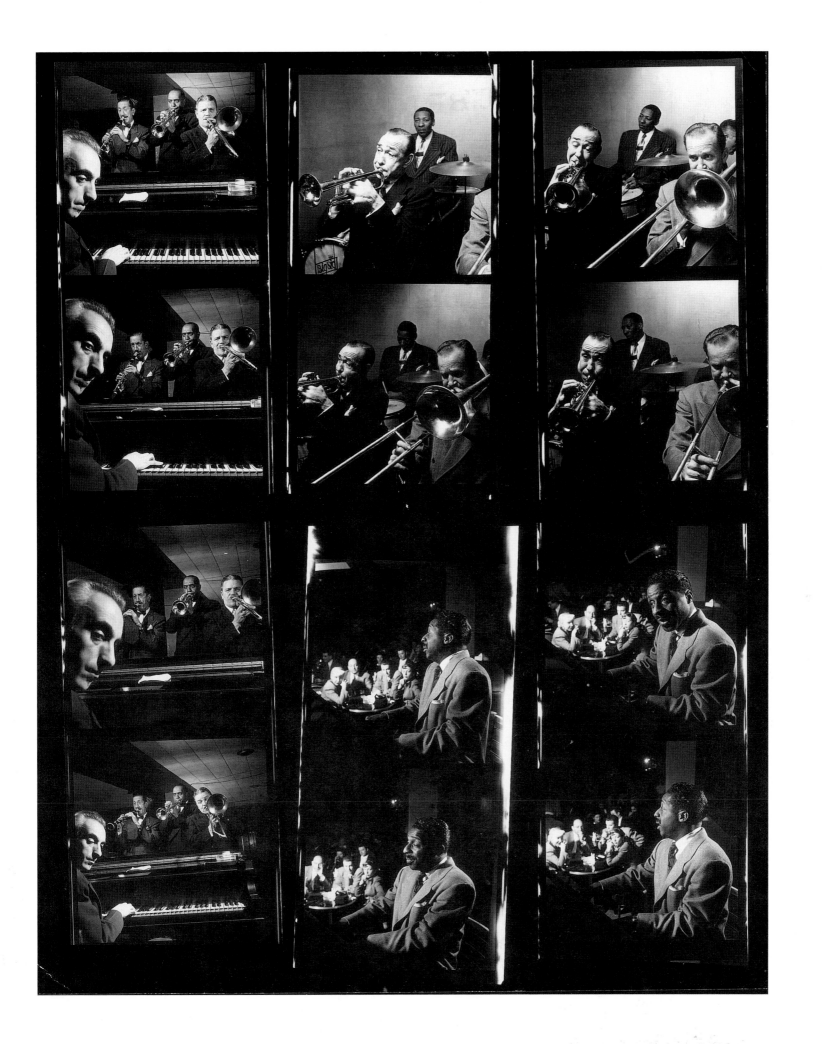

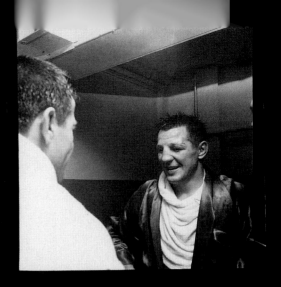
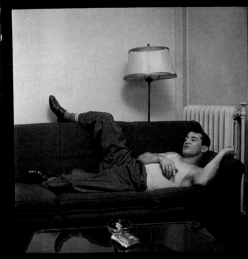
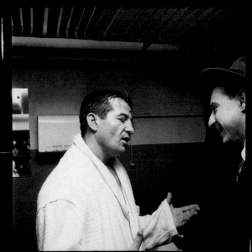
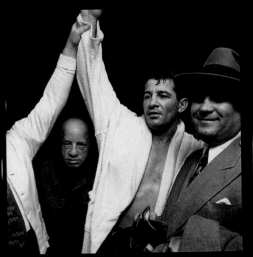
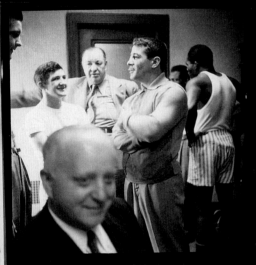
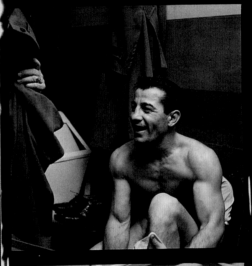
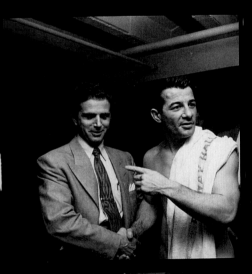
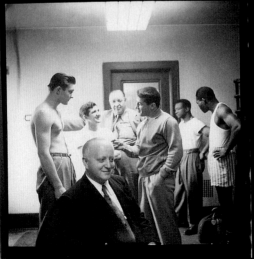
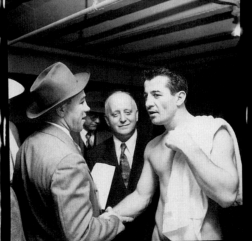
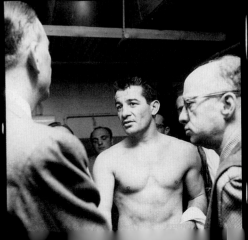

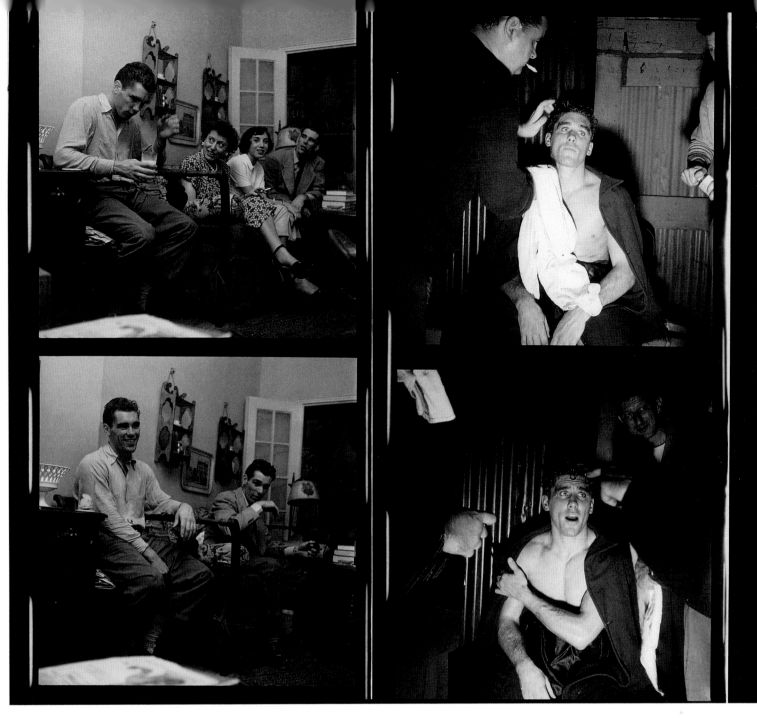

36

A shoot for a *Look* feature on
Rocky Graziano, the middleweight
champion, 1947–8, from when
this contact sheet dates.

Stanley was a boxing enthusiast
throughout his life – as a spectator,
that is.

37

Another *Look* feature on a boxer,
this time Walter Cartier, a young
middleweight who lived in
Greenwich Village. The article
appeared in a January 1949 issue.

After this feature Stanley quit
Look magazine and made a
documentary film about Cartier:
Day of the Fight. This was Stanley's
very first film and he directed,
photographed, and edited it. It
played at the Paramount Theater
in New York in 1950.

There would be no looking back
now – Stanley wanted to make
movies and nothing else.

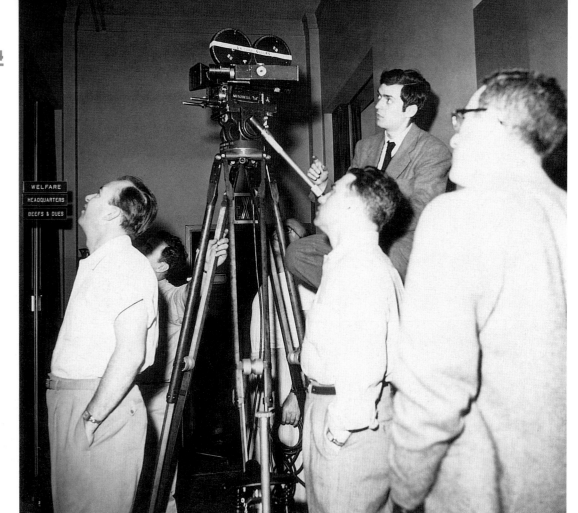

39
Stanley's first theatrical feature was *Fear and Desire*, shot on location in California in 1953. He directed, produced, photographed and edited the film that was largely financed by his uncle, Martin Perveler.

This is a production still taken on location.

38
After *Day of the Fight*, Stanley made *Flying Padre,* a short film about a priest who piloted himself in an aeroplane around his vast parish in New Mexico. Then, in 1953, he was commissioned by the Seafarers' International Union to direct and photograph a promotional film, *The Seafarers.* This was Stanley's first venture into colour; he would not shoot in colour again until *Spartacus* in 1960.

This shot was taken during the production of *The Seafarers* at the union headquarters.

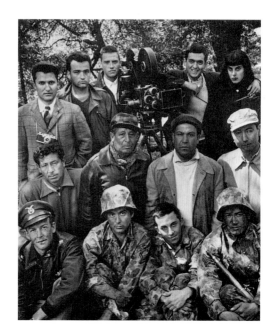

40 *(left)*
The cast and crew of *Fear and Desire* in California. To Stanley's left is Toba Metz, Stanley's first wife, who was credited as dialogue director in the film's credits. Second from right in the front row is the then actor Paul Mazursky, who subsequently became a famous film director himself.

Fear and Desire owed more to the European art house tradition of movie-making than it did to the American film industry. Stanley disowned it and would have happily gathered together every print and neg and consigned them all to an incinerator had it been possible.

41
In an improvised dressing room while on location for *Fear and Desire*. To Stanley's right is the actor Frank Silvera who would also appear in Stanley's next film.

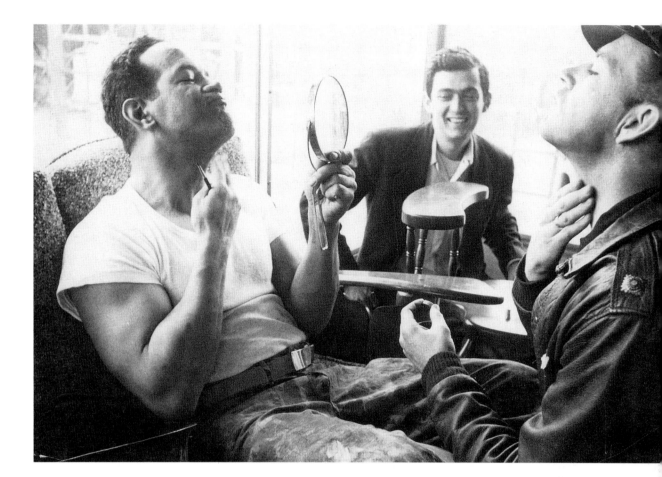

42
Stanley directing Paul Mazursky from behind the camera somewhere in the woods of northern California.

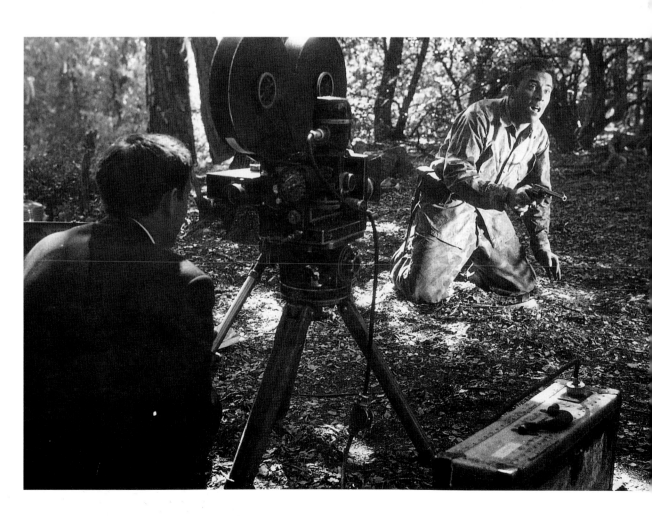

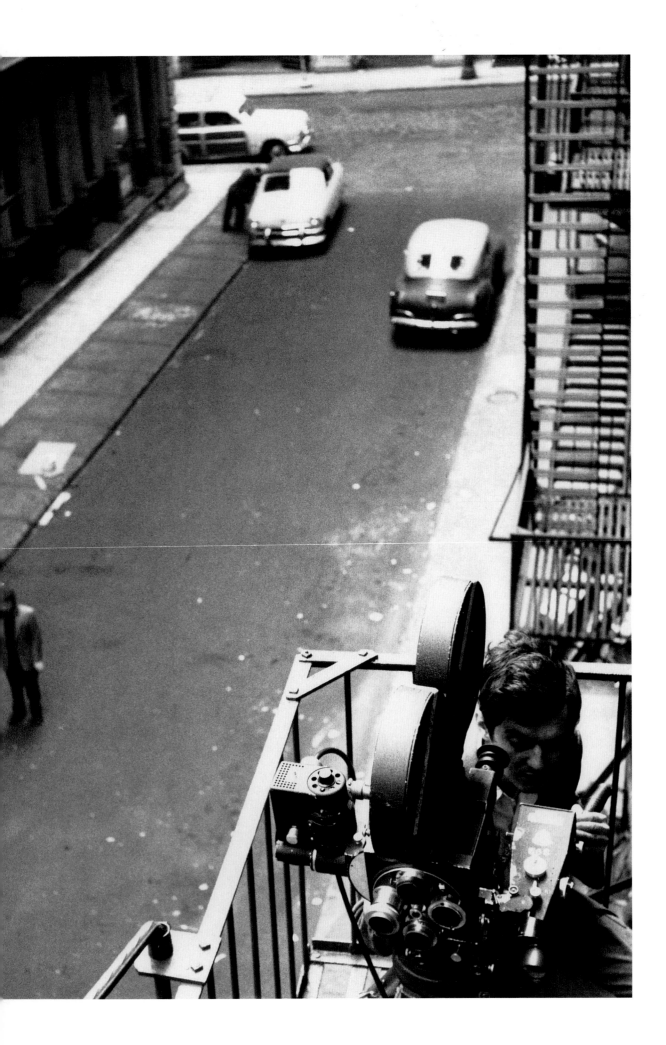

43
Stanley's next film was shot in the town he knew best, New York, in 1955.

Killer's Kiss was a *noir* thriller about a failed boxer, played by Vince Edwards, who falls in love with a club hostess (Irene Kane), who is also the mistress of the club's owner, played by Frank Silvera.

The stills photographer on the film was Alexander Singer, Stanley's school friend; he took many marvellous shots during the production that capture not only Stanley but also the New York of the time.

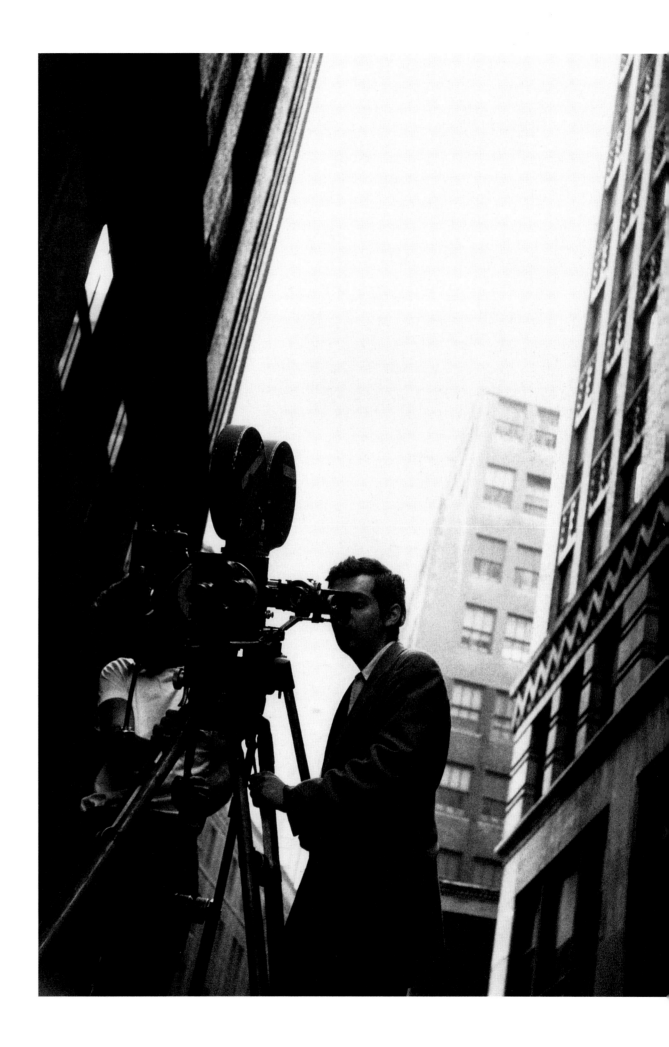

44
Another shot of Stanley on *Killer's Kiss* by Alexander Singer.

Stanley behind his little clockwork
35mm Eyemo motion picture
camera. He used it occasionally on
films where the standard studio
cameras proved too big or unwieldy
for a particular shot, including *A
Clockwork Orange*, when it was
thrown from a window to capture
the POV (point of view) of Alex, the
film's protagonist, in his suicide
leap.

This photograph was taken by
Alexander Singer.

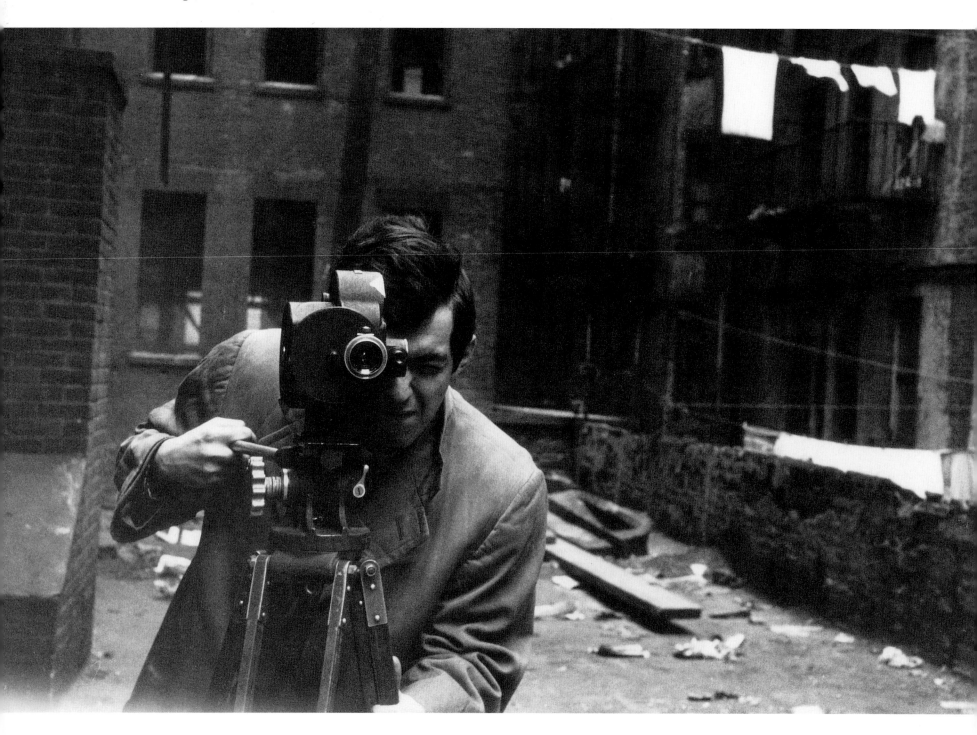

46
Stanley lining up a shot through the viewfinder of Irene Kane and Vince Edwards on *Killer's Kiss*.

The film has received praise from many critics for the dark and haunting lighting Stanley achieved.

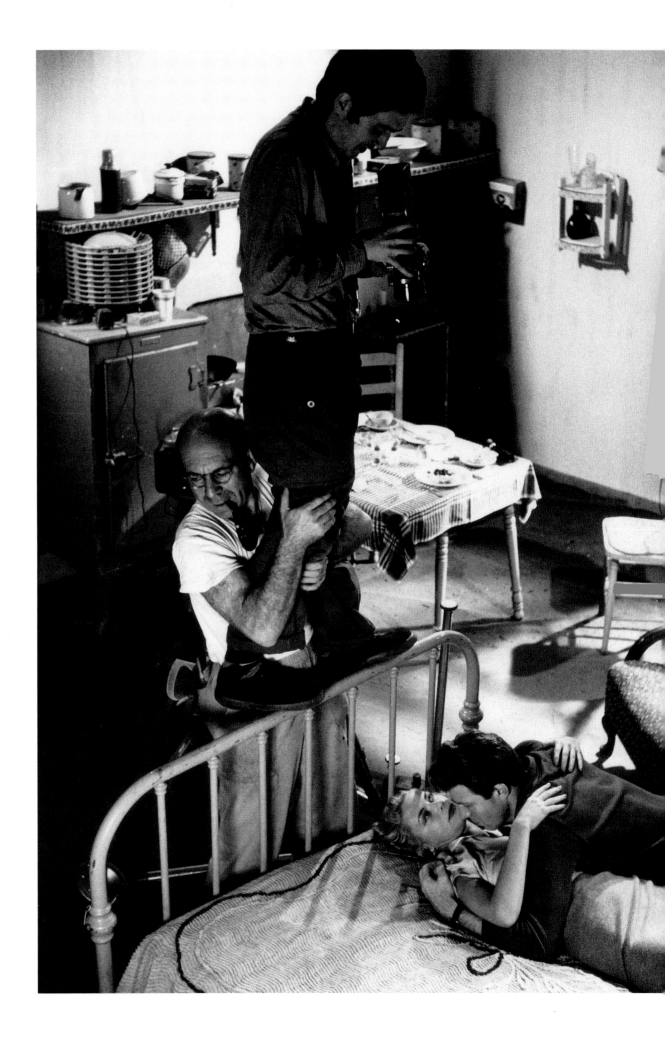

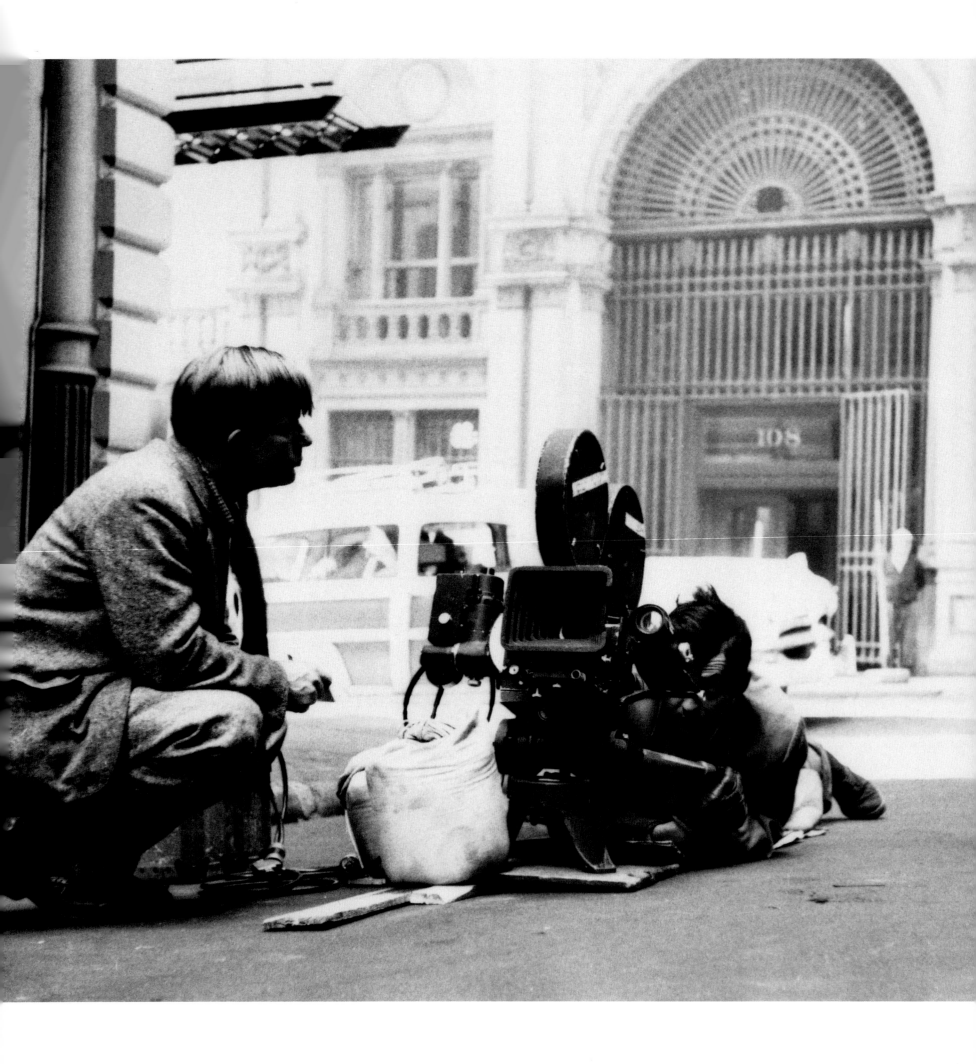

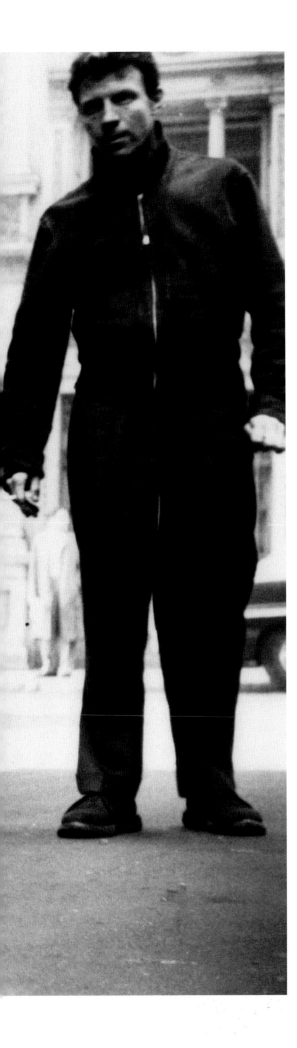

47
At Penn Station in New York shooting the opening scenes of *Killer's Kiss*, Stanley supine behind the camera and Vince Edwards on the right.
[Alexander Singer]

48
Scouting rooftop locations for the final scenes of *Killer's Kiss*.

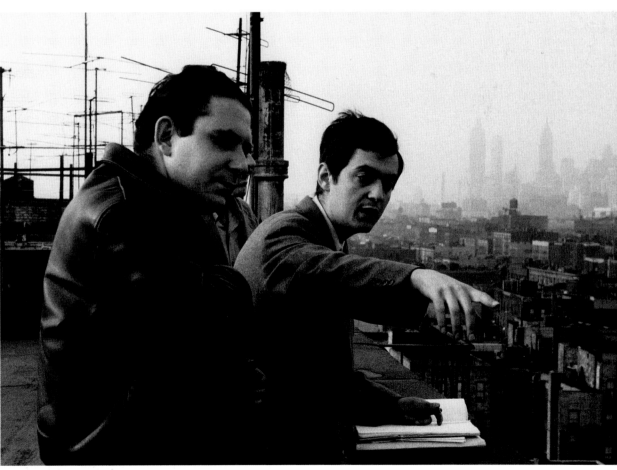

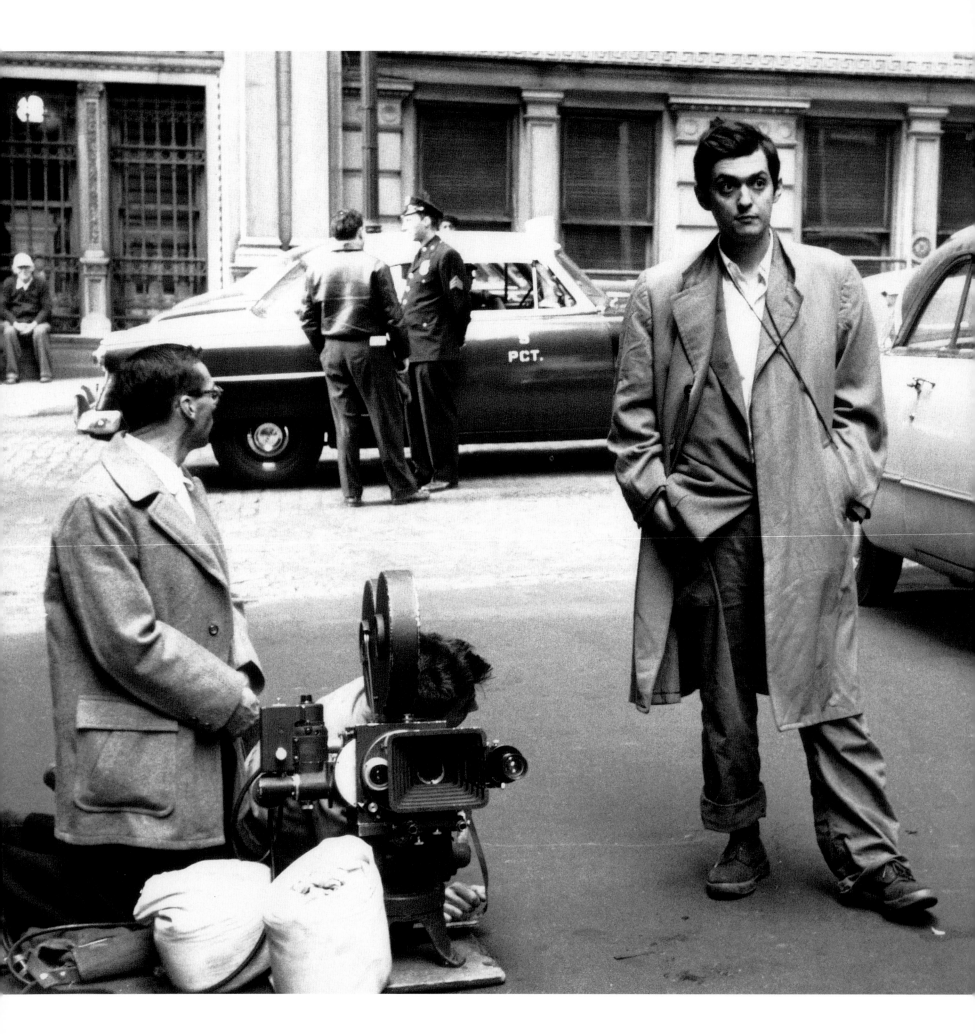

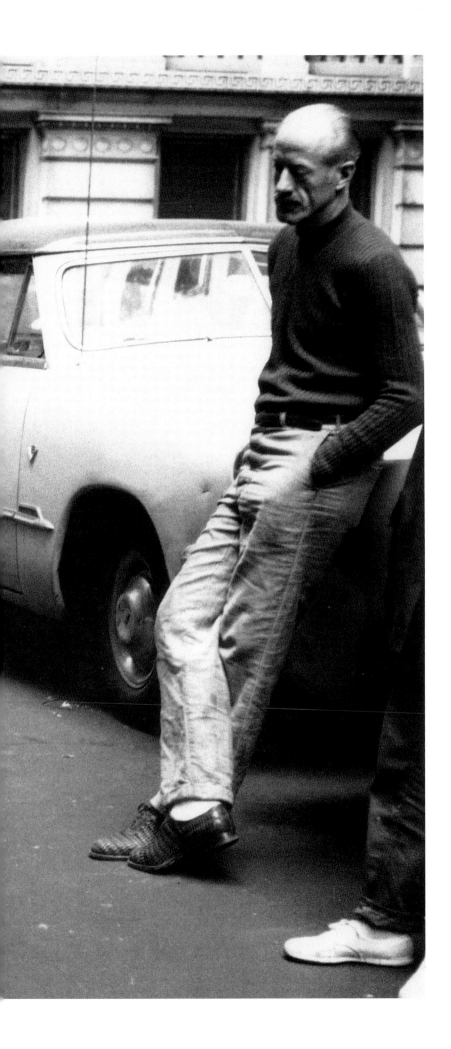

49 *(left)*
One of my favourite photographs of Stanley, almost certainly taken by Alexander Singer, who captures that distant, wistful and hopeful look that Stanley made his own.

Note Stanley's indifference to his clothing: a baggy pair of work trousers, one cuff rolled up high, the other dragging on the floor, a pair of cheap, lace-up loafers, and a fine raincoat that may have seen better days. This indifference remained with him throughout his life.

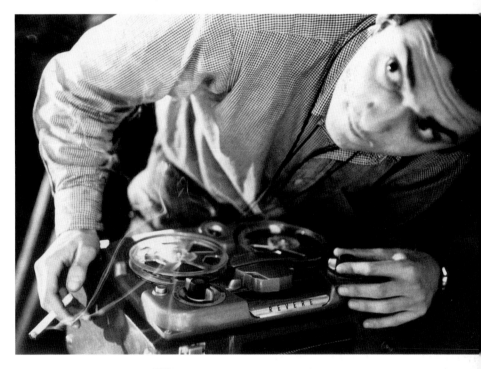

50
Sound recording on *Killer's Kiss*. Gert would have chosen and sent the smart shirt to Stanley.

Stanley was an intermittent smoker up until the early 1980s when he claimed to have quit entirely.

51
Stanley's second wife, Ruth Sobotka. She was a ballet dancer by profession and performed and choreographed the dance sequence in *Killer's Kiss*.
[Alexander Singer]

52
The young director and his trusty viewfinder on the set of *Killer's Kiss*.
 An affectionate portrait by Alexander Singer.

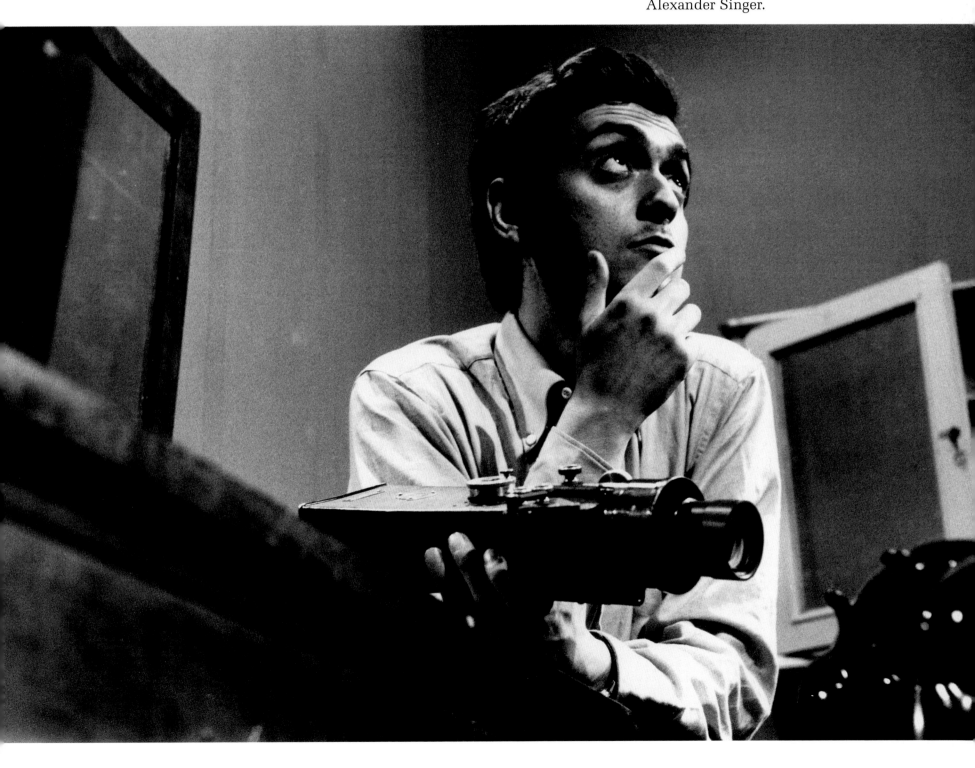

53
Stanley's next film was *The Killing*, made in Los Angeles in 1956. This story of a racetrack heist is now widely acclaimed as a *noir* classic. He took with him Vince Edwards from *Killer's Kiss* and he is pictured here with Vince and Marie Windsor who, Stanley said, was kind and helpful towards him and very professional.

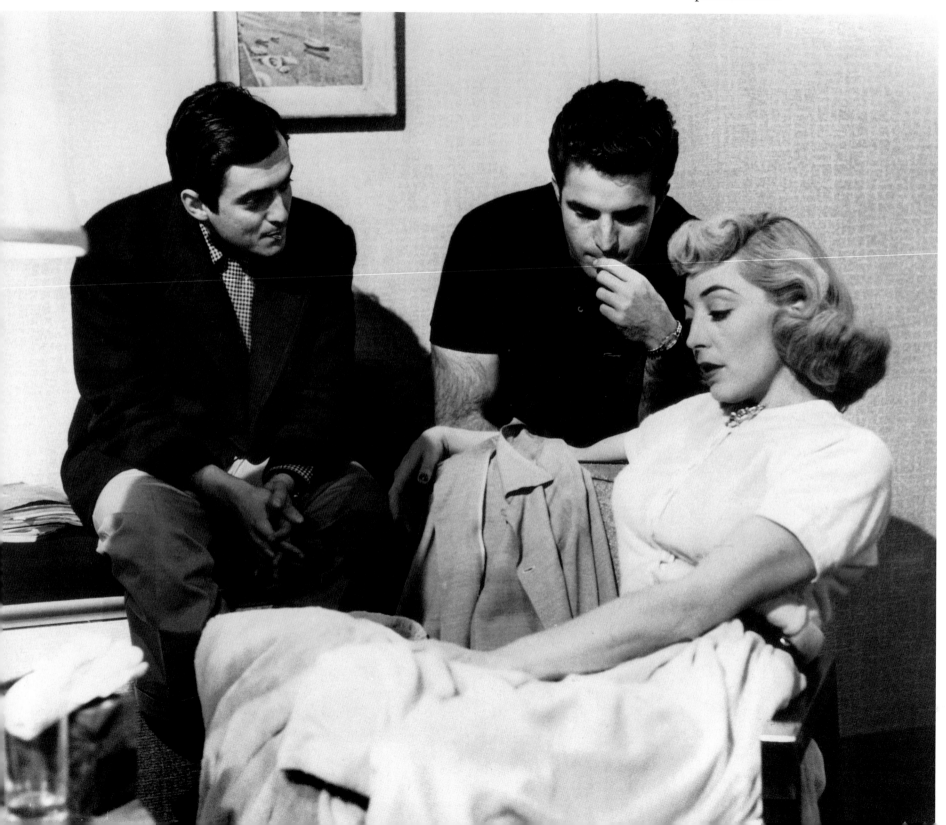

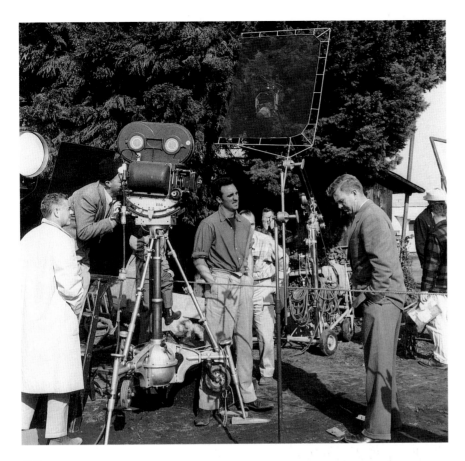

54
On location in Los Angeles for *The Killing*. On the left, in the white mac, is Lucien Ballard, the lighting cameraman who was briefly married to Merle Oberon. Stanley had a major disagreement with him at the beginning of shooting when Ballard tried to convince him that a 50mm lens a certain distance back was the same as a 28mm lens close up. Stanley knew otherwise.

In the centre with his hands in his pockets is that wonderfully unique actor Timothy Cary, whom Stanley would later use again in *Paths of Glory*. On the right is *The Killing*'s lead, Sterling Hayden, who would be seen again in *Dr Strangelove*.

55
Rehearsing somewhere in downtown Los Angeles.

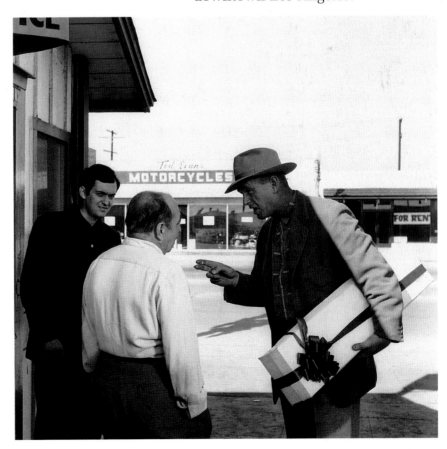

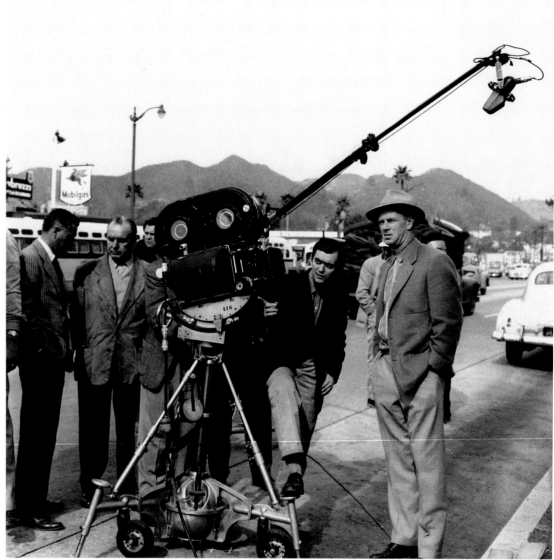

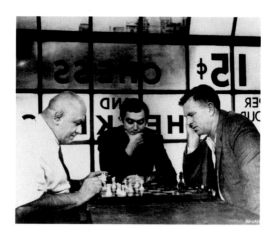

57

Stanley with Kola Kwariani (left) and Sterling Hayden (right) in the chess club set from *The Killing.*

Kwariani, who plays Maurice Oboukhoff in the film, starts a fight at the racetrack that serves as a distraction for the robbery masterminded by Sterling's character.

Stanley was familiar with the New York chess clubs and based the set design on the clubs he played and hustled in.

56

A very youthful looking Stanley eager to get on with the street shooting. Sterling Hayden is on the right, and on the left, the always elegantly dressed Lucien Ballard.

58 *(right)*

Stanley with, centre, James B. Harris, and on the right, Alexander Singer.

Jimmy Harris was Stanley's partner and producer on *The Killing, Paths of Glory, Lolita* and *Dr Strangelove.* He later produced other films and directed *The Bedford Incident* and *Cop.*

Alexander Singer was at Taft High with Stanley and was *The Killing*'s associate producer. He subsequently became a film director himself.

In the background is the RCA sound van. In those days a whole vehicle was needed to transport the sound recording equipment, whereas today a recorder can fit comfortably into a briefcase.

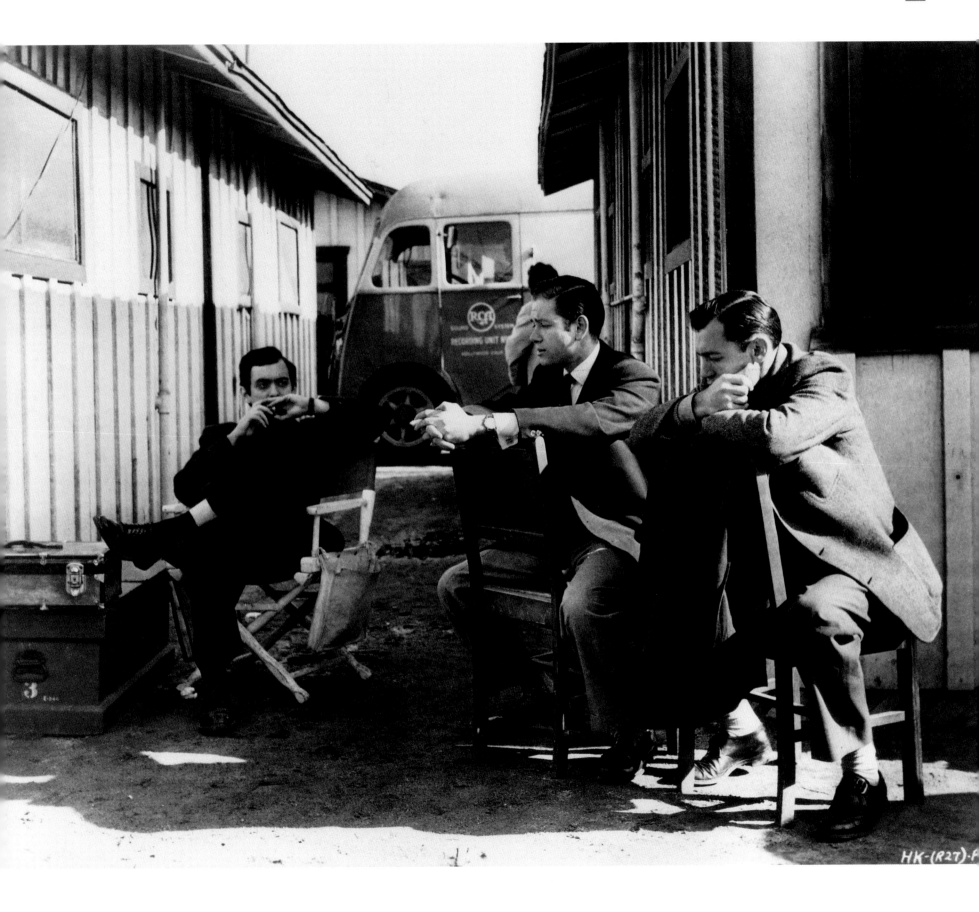

HK-(R27)-F

59
At Los Angeles airport where *The Killing*'s ending takes place: Sterling Hayden, Jimmy Harris and Ruth Sobotka, Stanley's second wife, who was the film's art director.

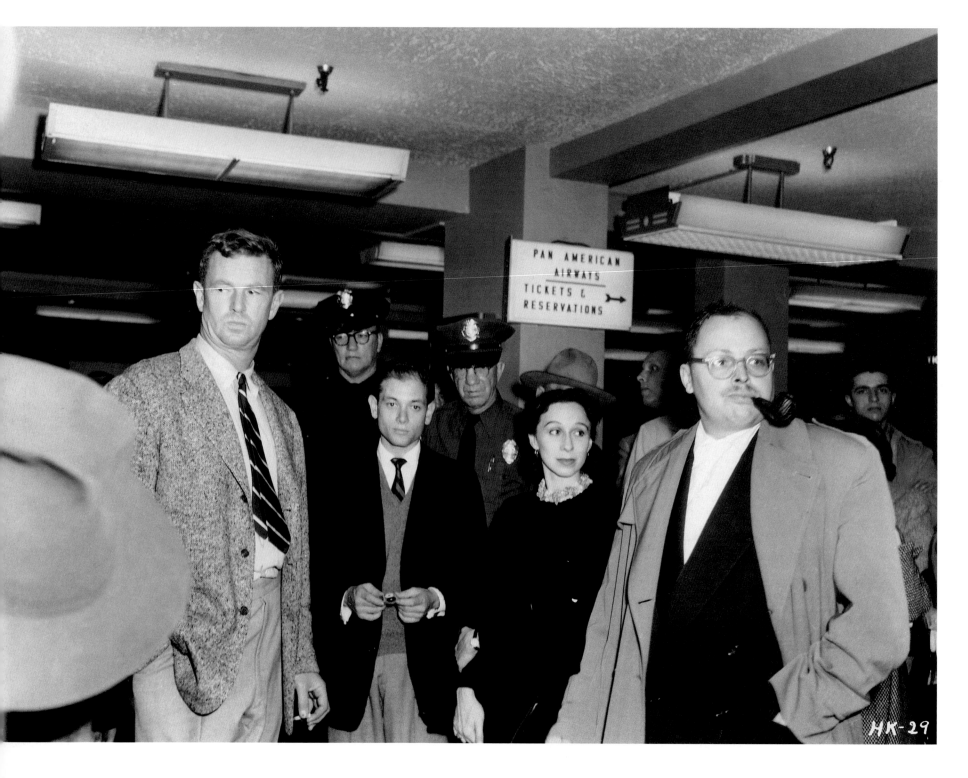

Stanley with George and Sherry
Peaty, otherwise Elisha Cook Jr
and Marie Windsor, the ill-starred
married couple. George worshipped
the ground Sherry walked on and
Sherry hated the air George
breathed. The result was tragedy.

Stanley always spoke fondly of
Elisha Cook Jr and was as pleased
with his performance as he was
with that of Marie Windsor.

HK-(R2)-Pub-1

61
Sterling and Stanley on location.
 Stanley's smart jacket with the
patch pockets would have been
bought by Gert back in New York
and shipped out to California.

62
Lining up a shot of Marie Windsor
with Vince Edwards who played her
lover in the film.

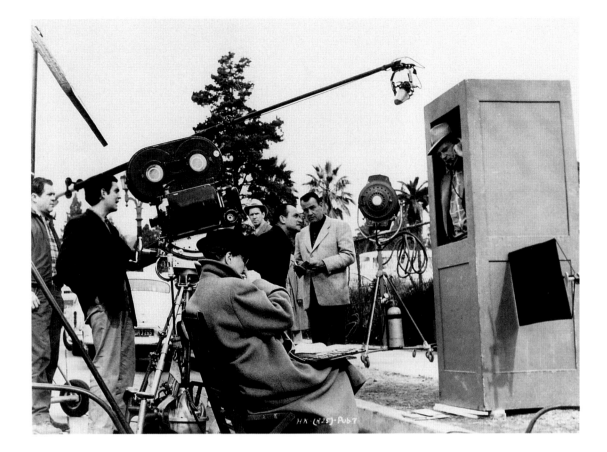

63
A difficult shot? Sterling Hayden rehearses in what appears to be a telephone booth.

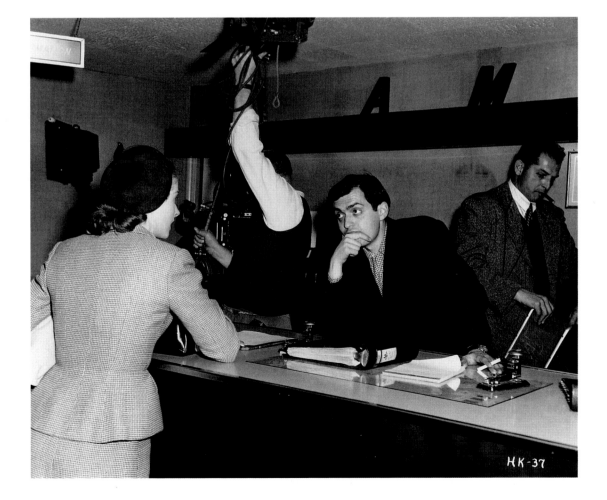

64
Stanley appears skeptical about a suggestion by Colleen Gray who plays Sterling Hayden's girlfriend in *The Killing*. This was taken at the airport where the film's final scenes were shot.

On the right, the sartorially unchallenged Lucien Ballard.

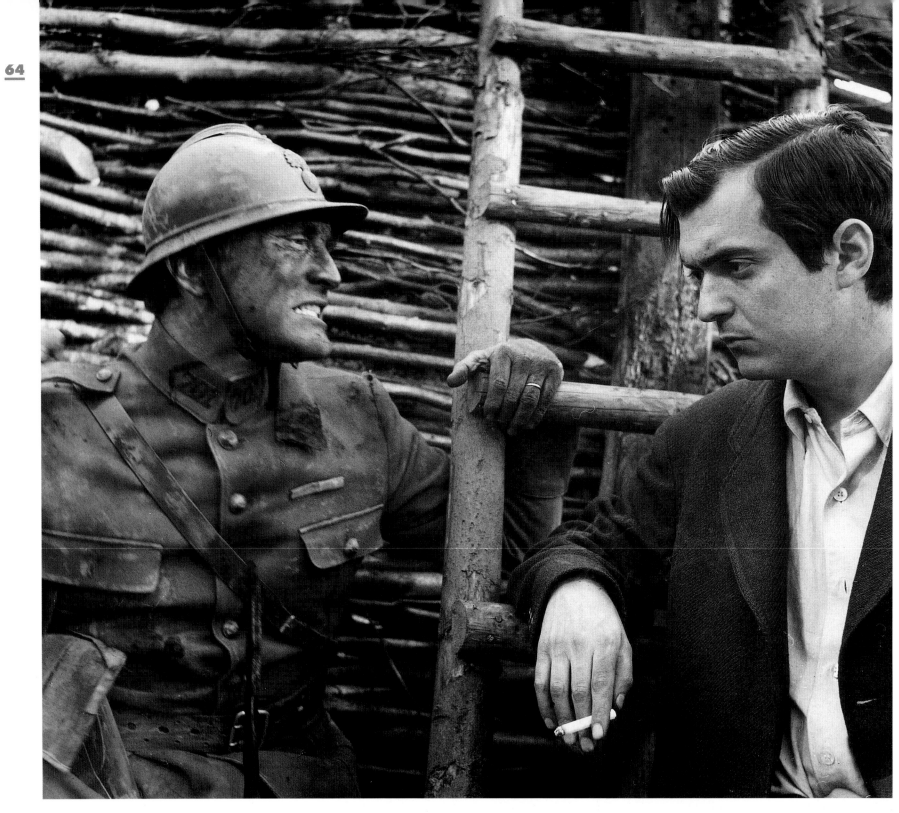

65
Kirk Douglas, seen here practising
his teeth-grinding act, was responsi-
ble for a quantum leap in Stanley's
career by asking him to direct *Paths
of Glory*, based upon a true story of
the French army during World War I.
 Stanley is wearing the same
jacket he wore on *The Killing*.

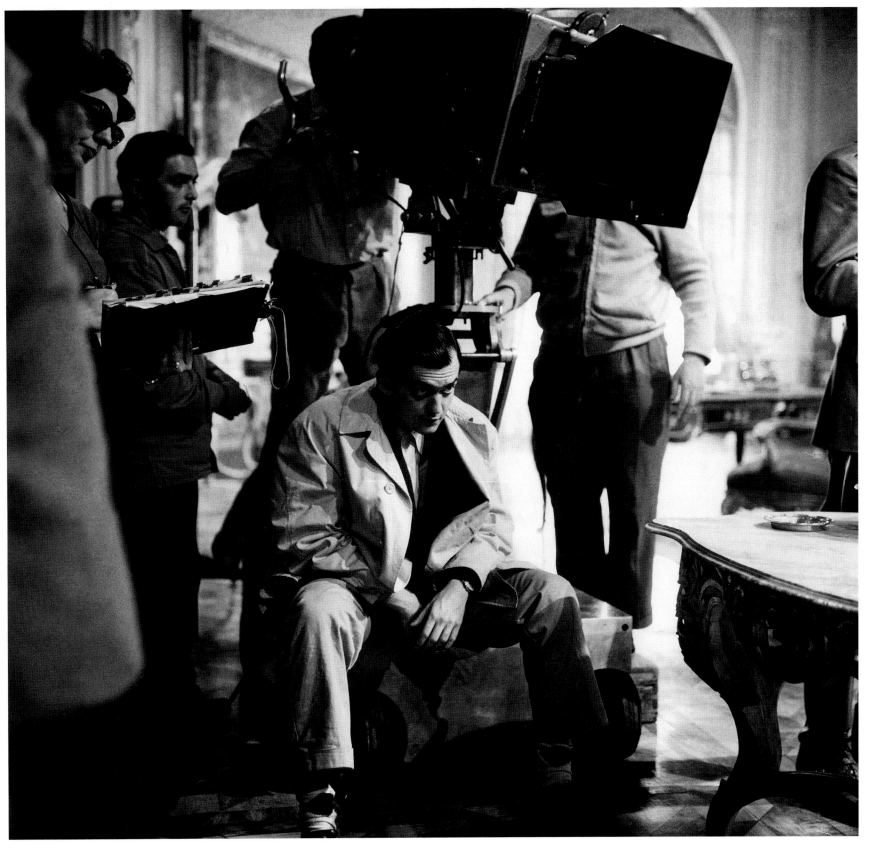

66
Paths of Glory was shot in Germany in 1956–7, and many of the interiors were filmed at Schloss Schleissheim, a chateau just outside of Munich.

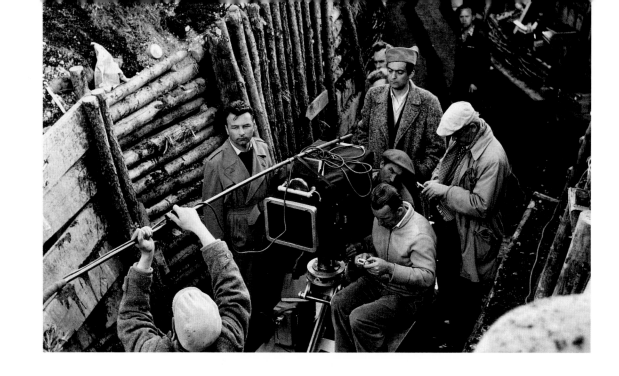

67, 68
The hard-edged realism of the film and, in particular, the tracking shots through the trenches were a revelation at the time for movie audiences, who were used to a 'glossed over' Hollywood approach to the subject.

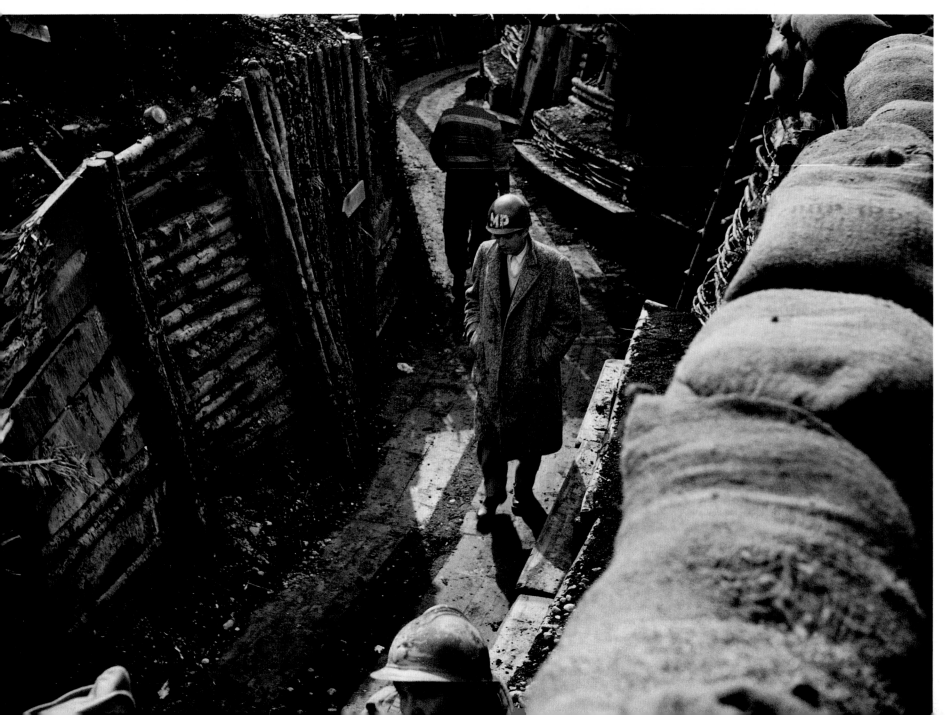

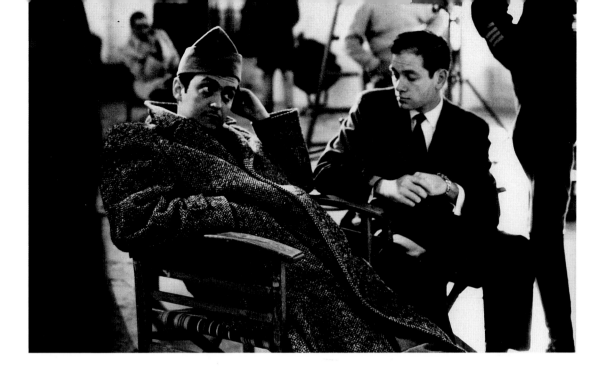

69
Stanley, again in a cap, with Jimmy Harris.

70
With Kirk at Schloss Schleissheim. The figure with his back to the camera is Adolphe Menjou who plays Broulard, the French general.

No studio art department could ever match the baroque plasterwork of Schleissheim's interiors.

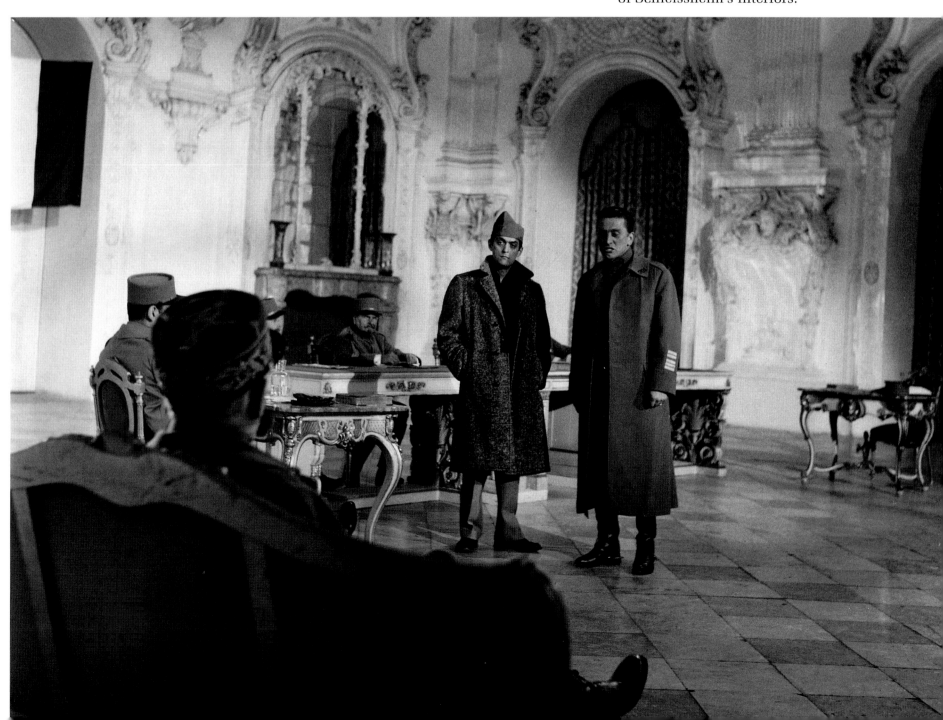

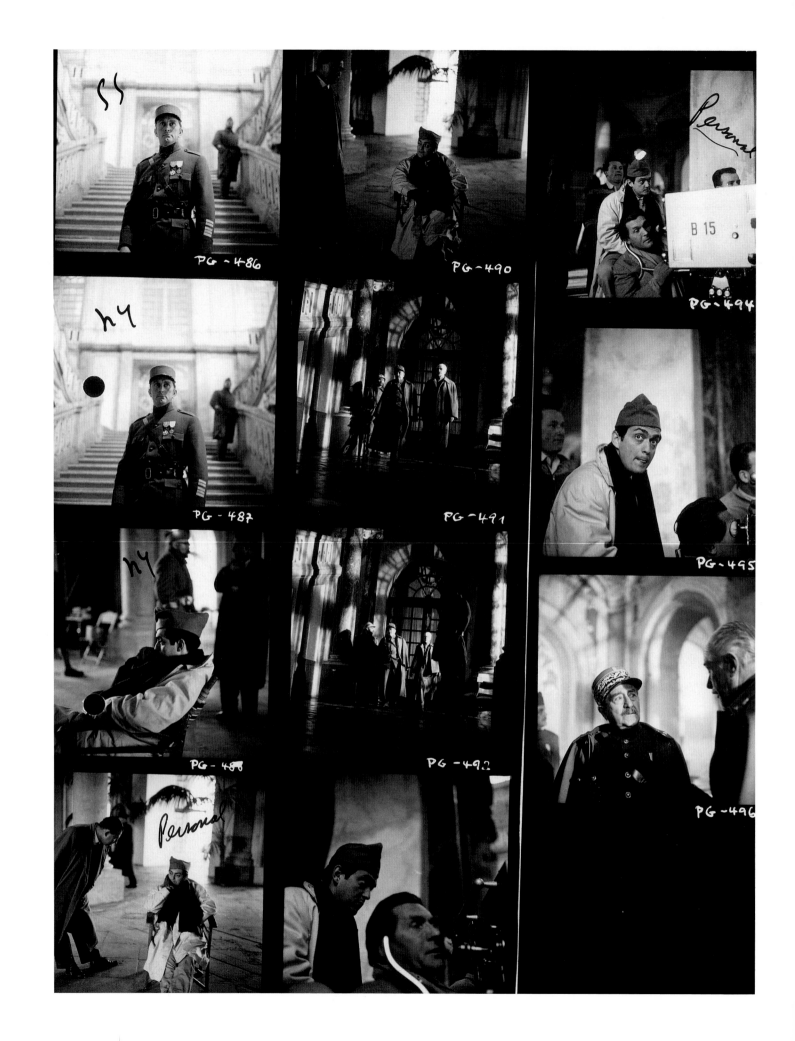

71 *(left)*
A contact sheet of stills taken
during the production of *Paths of
Glory*. Stanley can be seen along
with Kirk, Adolphe Menjou and
George Macready.

72 *(above)*
Stanley first saw me acting on a
German television programme and
after contacting my agent and meet-
ing me he cast me as the young girl
who sings to the troops in the bar at
the end of the film.

I appeared under my professional
name of Susanne Christian.

In this still from the film I am
with Jerry Hausner, who played the
bar owner who introduces me.

73
SUSANNE CHRISTIAN – *Actress*.
My publicity still from the 1950s,
and *very* 1950s it is – an angled
head-and-shoulders shot, eyes
to the ceiling, and out of focus
shadows on the backdrop.

This was used in theatre
programmes and for other publicity
purposes.

74
A magnificent photograph of the camera trolley that tracks down through the arrayed soldiers for the execution scene towards the film's end. Everyone seemed to wear hats in those days, except for Stanley who is sporting some sort of woollen cap that looks as warm and comfortable as it does unfashionable. But, as Stanley would say, blow is more important than show.

75 (right)
A contact sheet of stills from *Paths of Glory*.
Me, alone amongst the battle-weary troops, during a break from shooting. Kirk, meanwhile, in the far right column, has benched facilities in the executive tent.

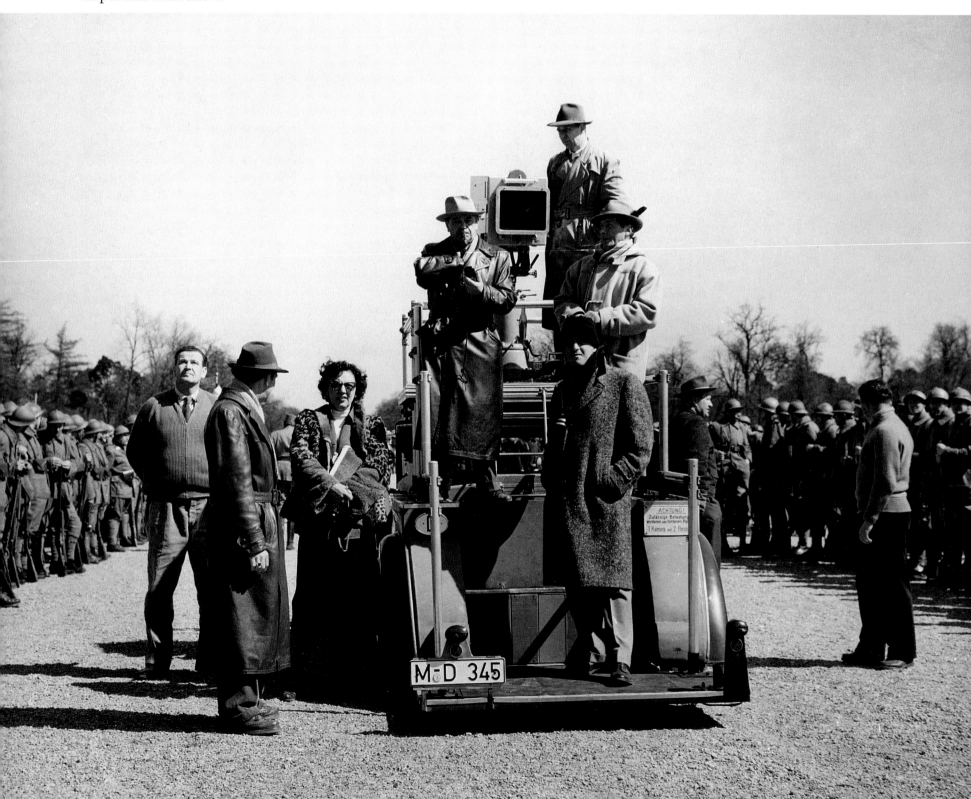

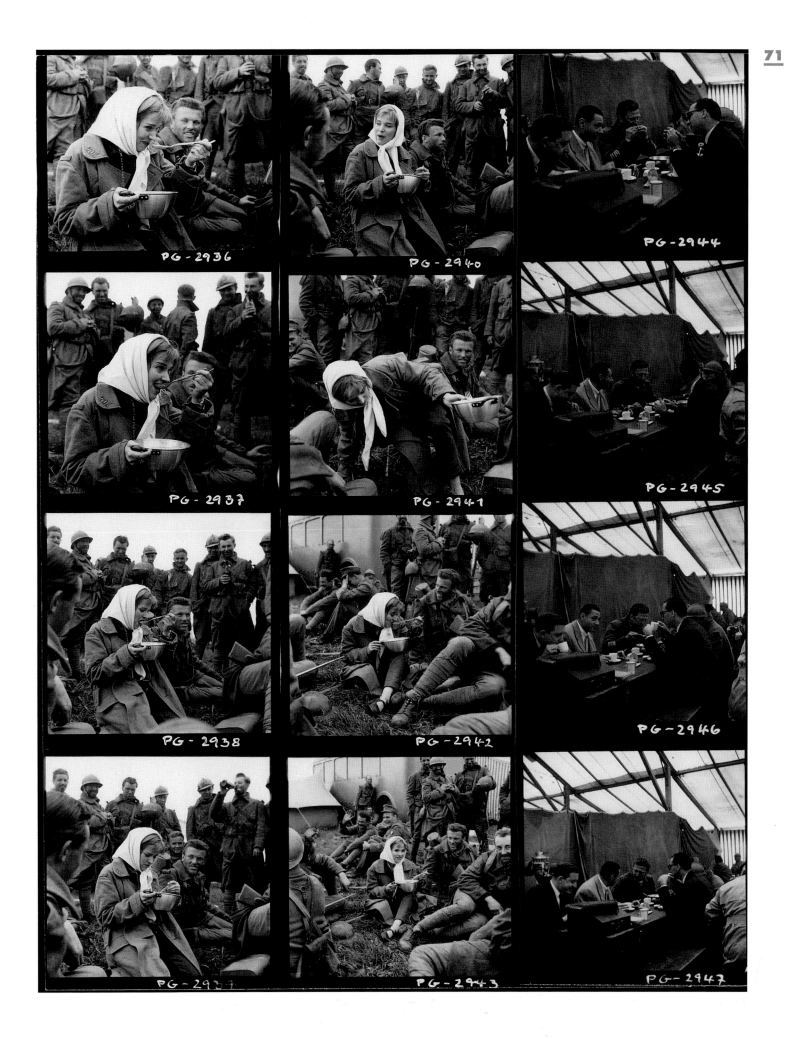

71

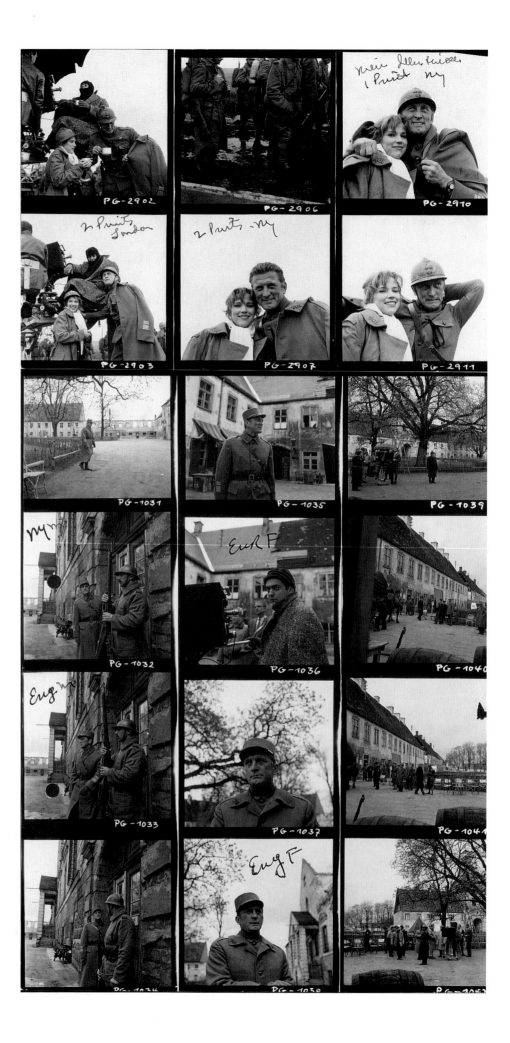

76
Another *Paths of Glory* stills contact sheet featuring, in ascending age and power, me, Stanley, and Kirk Douglas.

77
Stanley, alone (except for the stills photographer!) and revising the script at Schloss Schleissheim.

78
After the completion of *Paths of Glory* I returned with Stanley to California and we were married in 1957. We later had our first daughter, Anya.

Here we are in August 1960 in Beverly Hills. I am holding Vivian, who was then a little over a week old. Anya, then a year old, is in Stanley's arms, while sitting between us is Katharina, then seven, my daughter from my previous marriage.

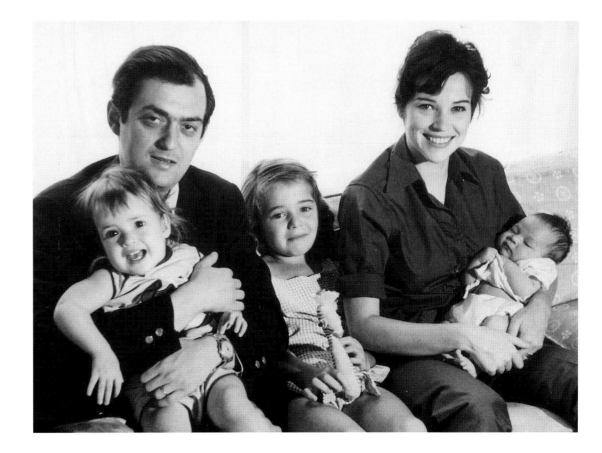

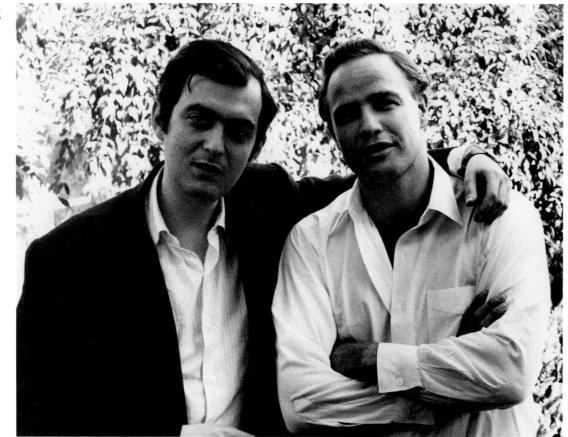

79
Stanley with Marlon Brando who engaged him to work on the script and production of the film that would be released as *One Eyed Jacks*. Stanley soon realised that Marlon wanted to direct the film himself and left. And Marlon did direct it himself.

80 (*below left*)
At our house on Camden Drive in Beverly Hills. This was during the period when Stanley was working with Brando.

On the right is Carlo Fiore, an actor friend of Marlon's who subsequently went on to write a revealing book about him (*Bud: The Brando I Knew*, 1974).

81 (*below*)
Jimmy Harris in his office pondering the next project for Harris-Kubrick Productions.

Stanley's next film was not a moderately budgeted independent film but a full-blown Hollywood blockbuster with lots of Big Names(!). Kirk Douglas wanted him to direct *Spartacus* after firing Tony Mann only a few days into filming.

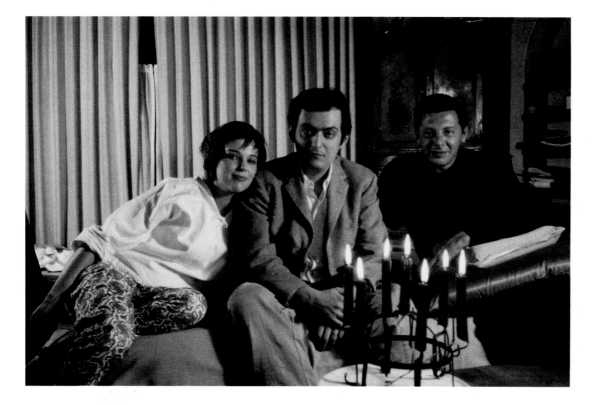

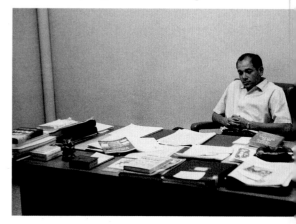

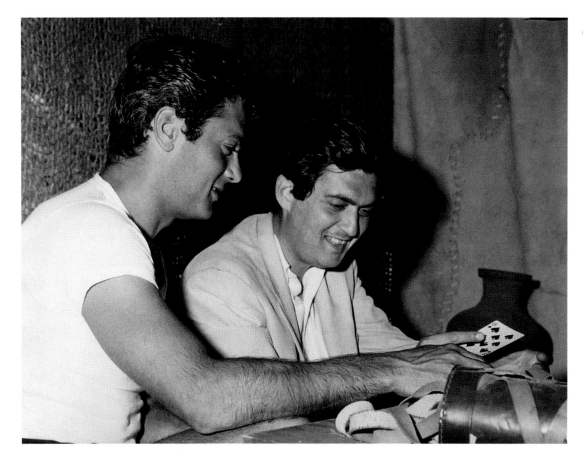

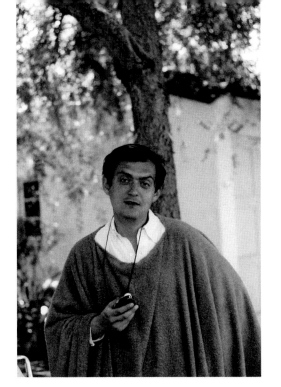

82
On location for *Spartacus* in Spain. Stanley took to this gladiator's poncho and found it warm and cool, depending on the weather, and, most importantly for him, unrestricting. He continued wearing it until there was little left to wear.

83 *(upper right)*
Two New York boys together. With his friend, Tony Curtis, an actor who went out of his way to befriend and support Stanley on *Spartacus* when many of the bigger names regarded him bemusedly as some young kid who had to be humoured.

84 *(right)*
The great British actor Charles Laughton billowing like a Dutch *schuyt* on the way to the set for the beginning of the day's filming.
 On the left is John Gavin, an actor who would later be appointed US Ambassador to Mexico by Ronald Reagan in the 1980s (and don't forget he lost Janet Leigh in *Psycho*; he played her lover at the beginning of the film).

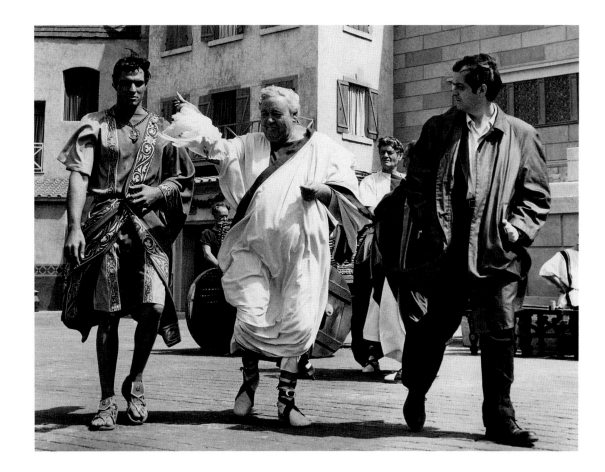

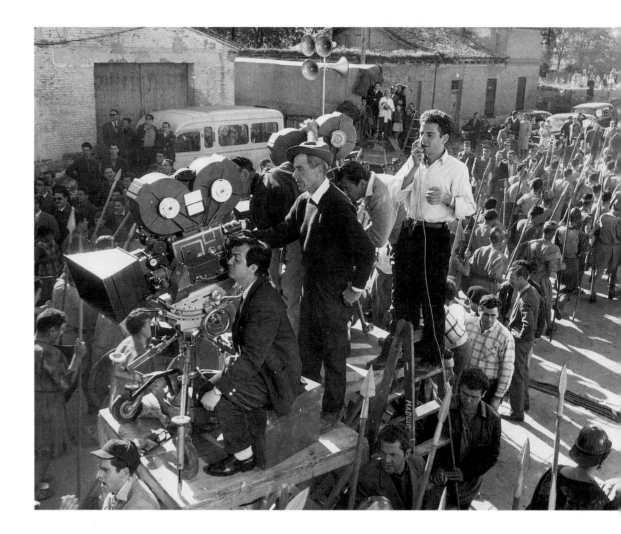

85
Stanley behind the camera checking
a line-up for a crowd shot of
Spartacus slaves. Note the second
camera behind.

86
Stanley with Kirk, who appears to
have a little too much ageing make-
up, and a fine actor, the late John
Ireland.

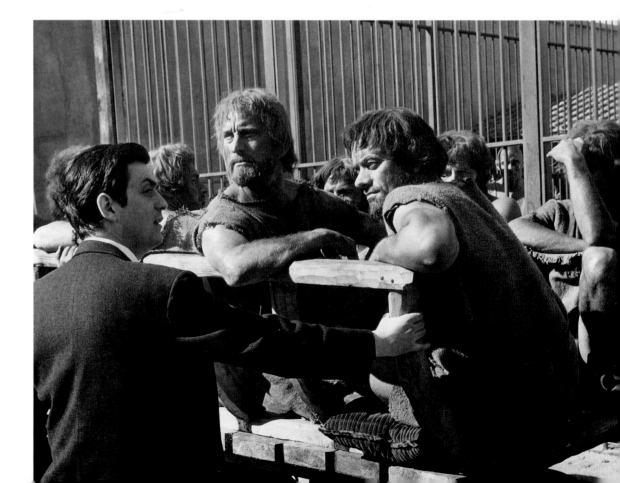

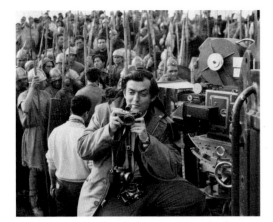

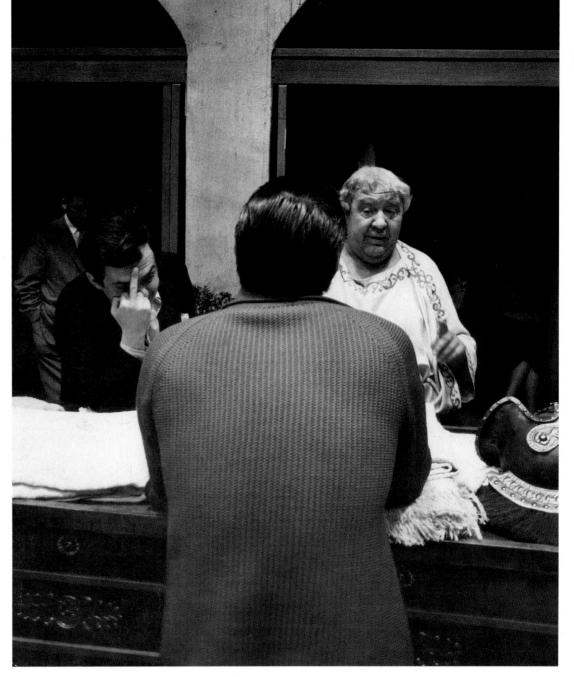

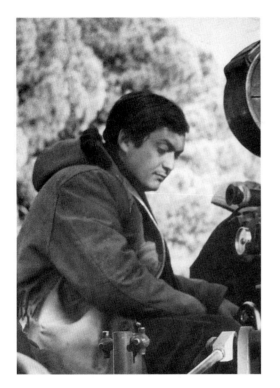

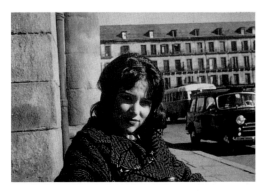

87 *(left upper)*
Stanley takes some shots himself.
He never went anywhere without a
camera.

88 *(left middle)*
Patient and resigned behind the
camera.

89 *(left lower)*
Me in the Piazza Major in Madrid.

90
I do not think Stanley is reacting to
a suggestion of Charles Laughton's,
but one never knows . . .
[William Read Woodfield]

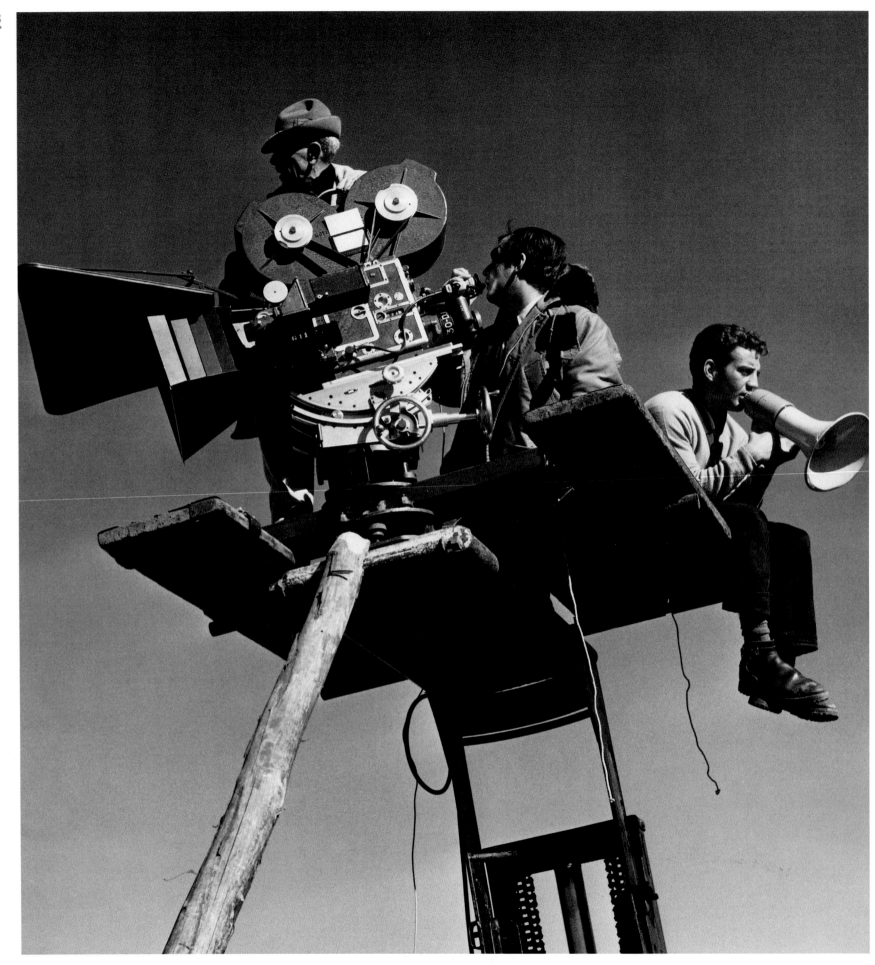

91 *(left)*
High atop the camera crane with Russell Metty, the lighting camera-man, and an assistant director.

There was much friction between Metty and Stanley at the beginning of filming. Metty regarded Stanley as an upstart who had yet to learn the arcane ways of Hollywood.

92 *(below)*
A quizzical looking and warmly wrapped up Stanley with heavily made-up extras high in the Spanish mountains.

93 *(right)*
In the sunlight of California after the unit returned from Spain.

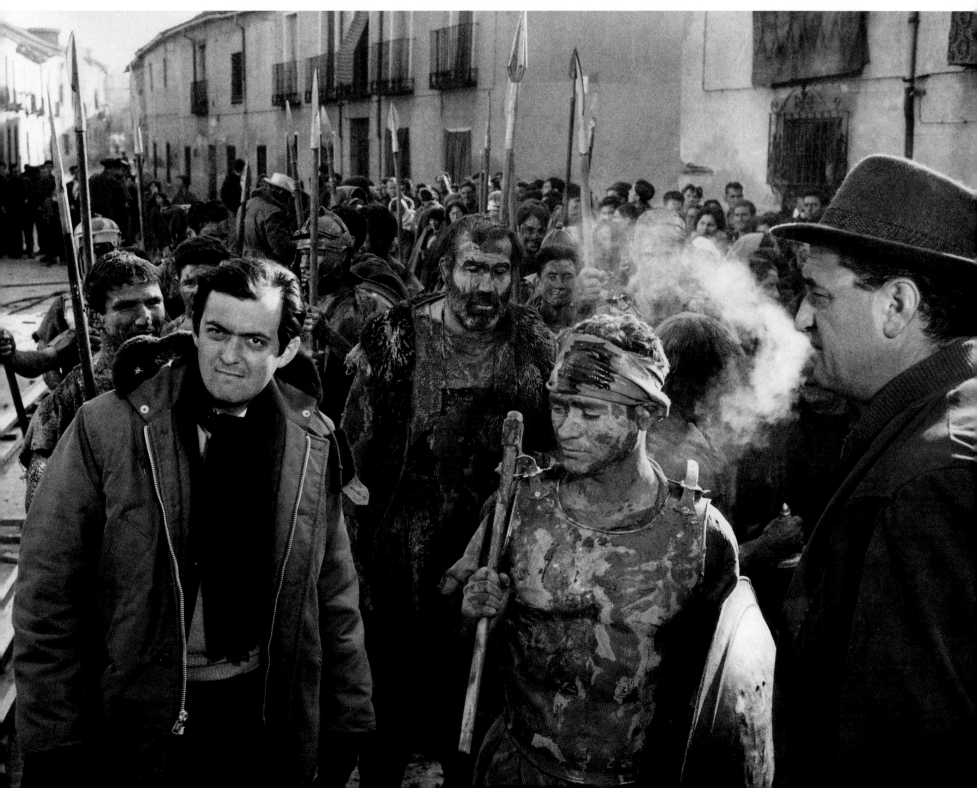

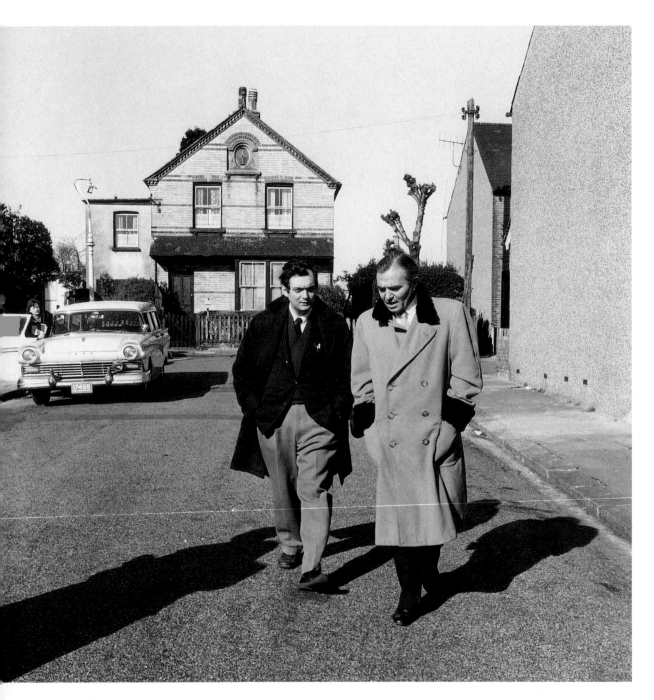

96 *(right)*
Sue Lyon was cast as the eponymous Lolita. Here Stanley goes over the script with her in a shot I staged and photographed in Los Angeles for the Tinseltown newspapers.

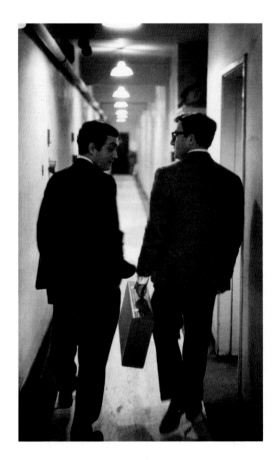

94
After completing *Spartacus*, Stanley and Jim Harris acquired the rights of Vladimir Nabokov's controversial novel, *Lolita*, and decided that it would be easier and cheaper to shoot the film in England. So we moved *en famille* to the UK.

James Mason was cast as Humbert Humbert, the elderly academic who falls for the nymphet, Dolores Haze, aka Lolita.

Here, in 1961, Stanley is with James Mason outside the house where Humbert finds Lolita for what will be their final meeting.

95 *(right)*
With Peter Sellers who would play the important role of Clare Quilty in *Lolita*.

Stanley and Peter were made for each other. Their ideas dove-tailed and they each spurred the other on with ideas and challenges.
[Patrick Ward]

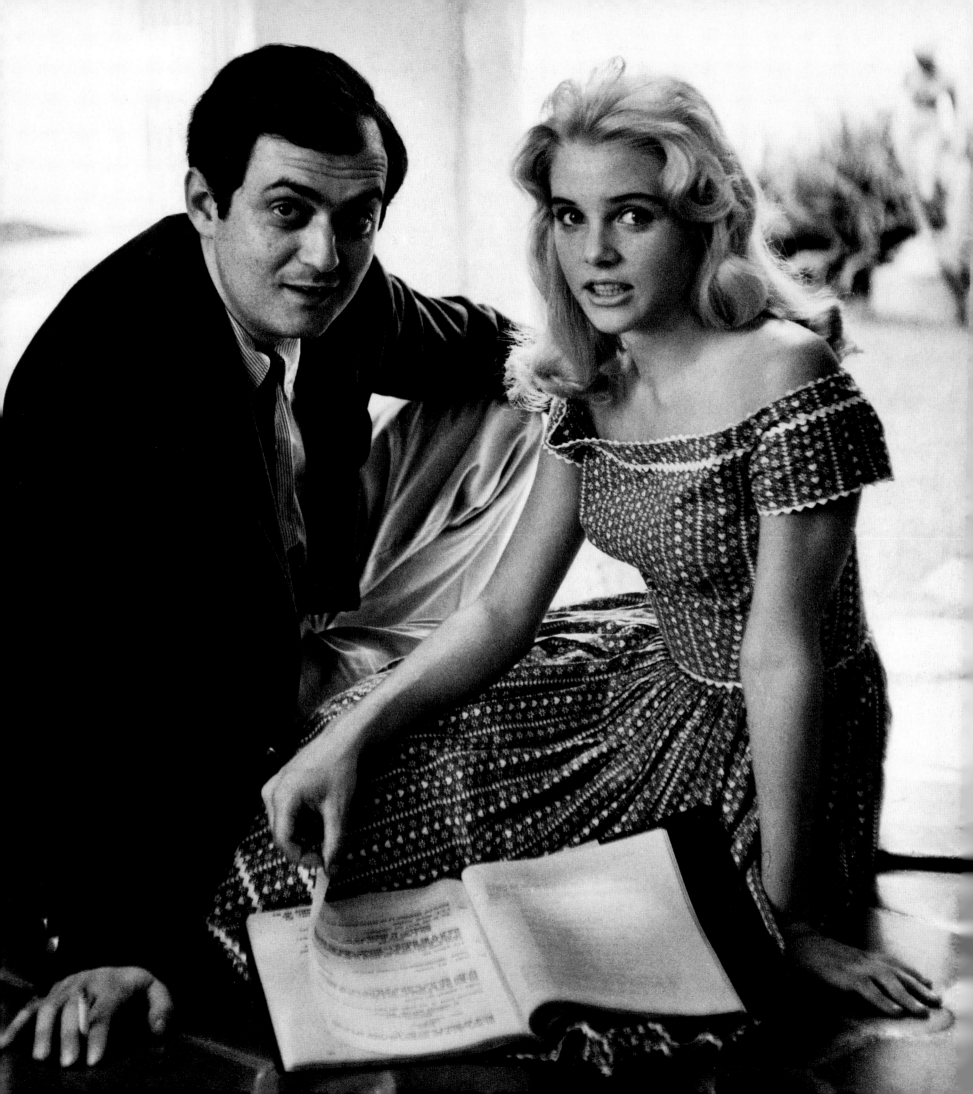

97, 98
Stanley's mother, Gert, with James
Mason at our apartment in Central
Park West, New York. I am not sure
whether it was Stanley or I who
took the photographs.

99
Lolita was made at the old ABPC
Studios in Elstree, north-west
of London, but locations were
frequently used for the production.

This shot was taken at a garage in
Aston Clinton near Aylesbury that
was dressed to appear as an
American service station.

On the left is the lighting camera-
man Oswald 'Ossie' Morris. Note
the camera on a strap around
Stanley's neck.

The exteriors of Humbert's car
driving through New England,
Vermont, Maine and other locations
in the States, were directed by
Stanley and filmed by Bob Gaffney,
the lighting cameraman. We were
all in a second car, but I 'played'
Lolita in the principal car for the
closer shots.

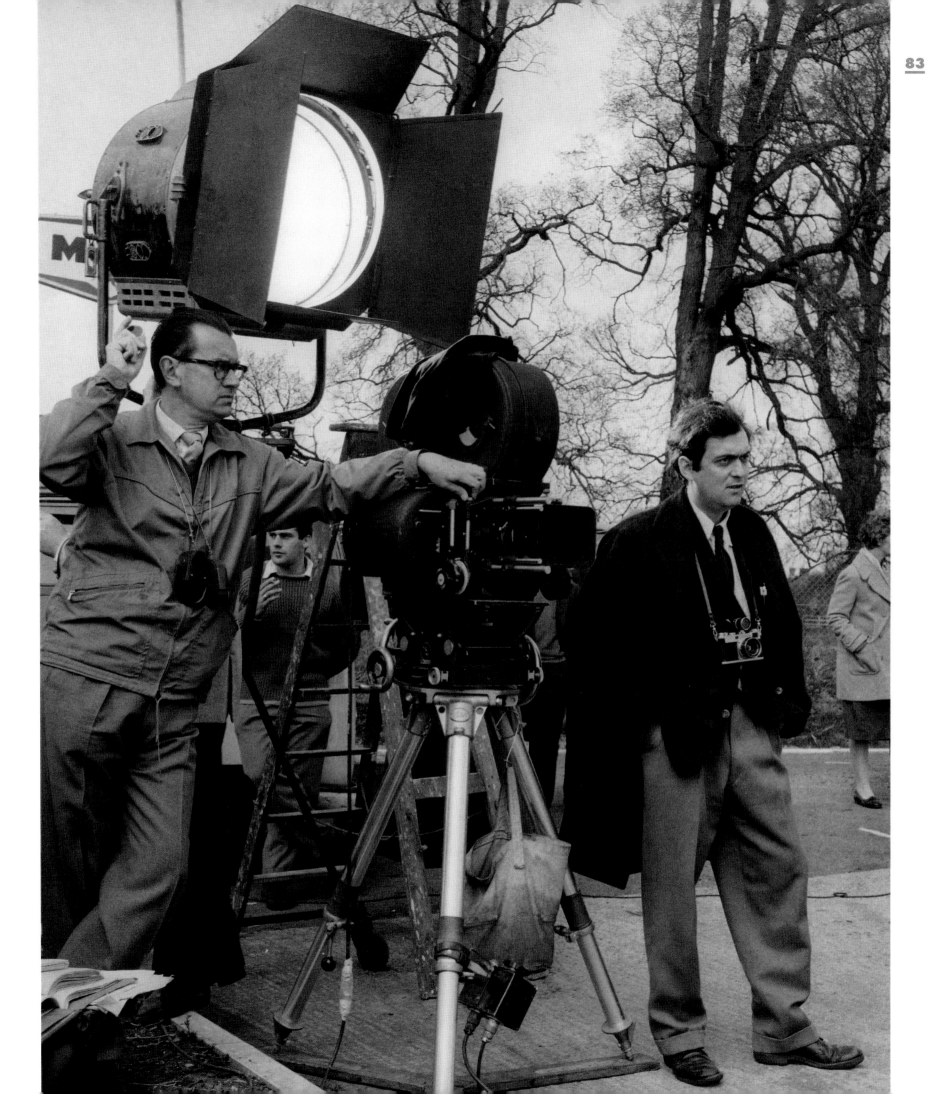

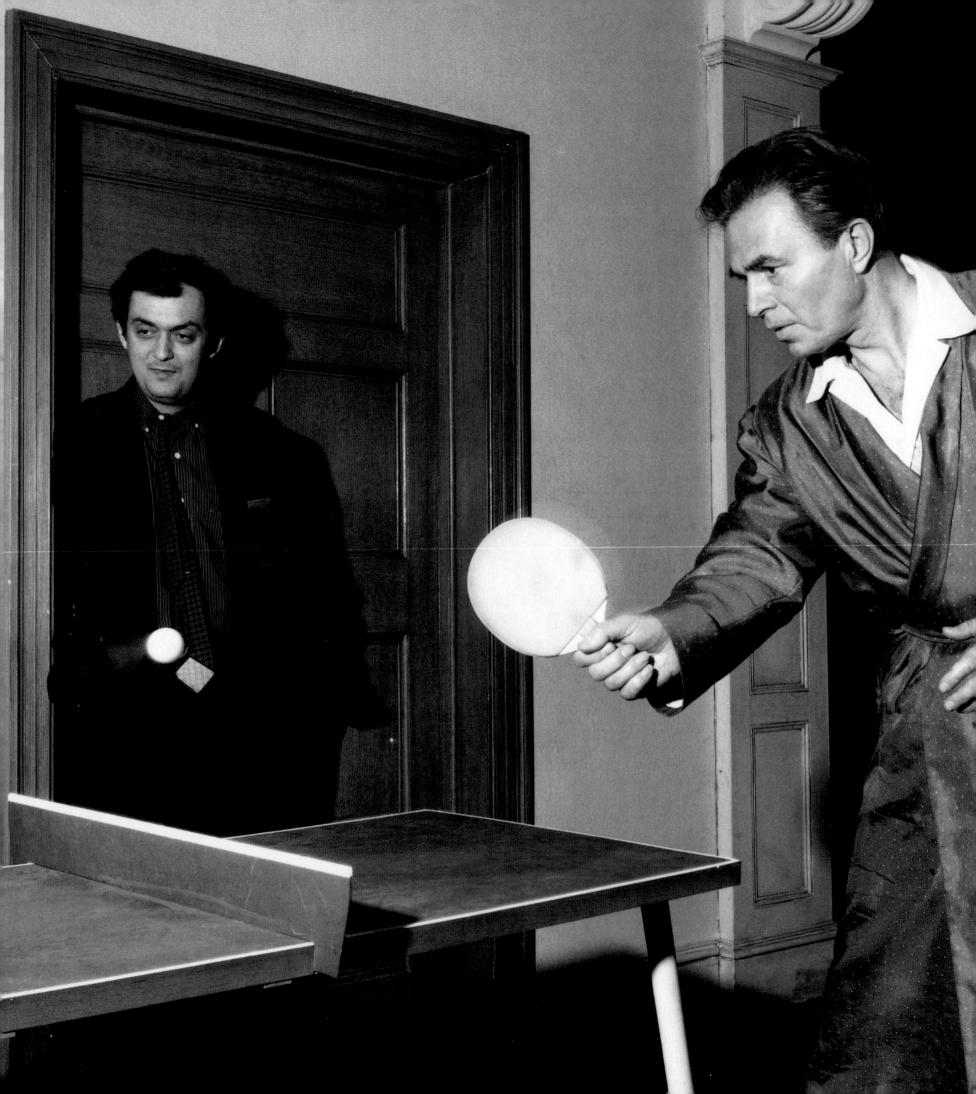

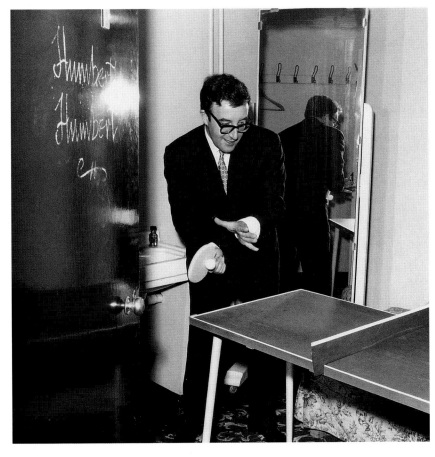

100, 101
Stanley was never a great practical sportsman but he made an exception for table tennis, and here he has communicated his enthusiasm to both James Mason and Peter Sellers.

102
Stanley looks up to an out-of-focus Sue Lyon after making some script changes.

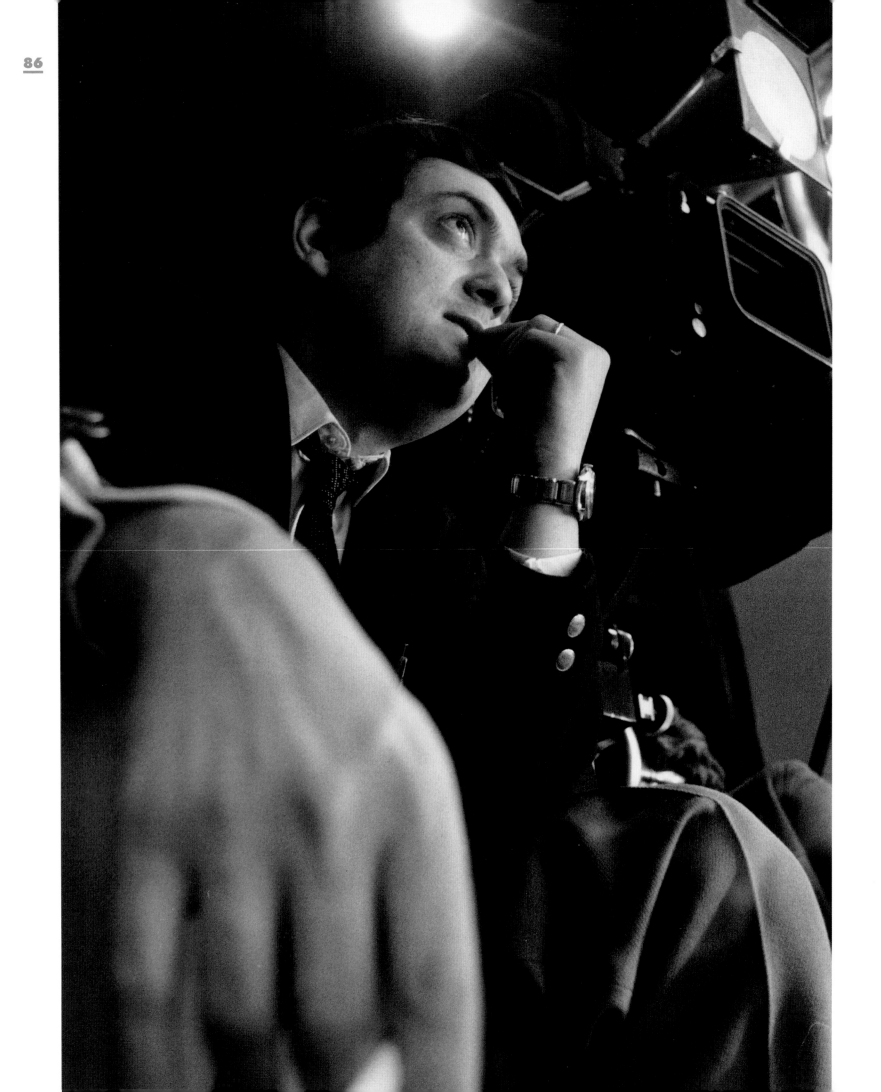

103 *(left)*
An expectant Stanley on the set of
Lolita. Note the smart blazer, collar
and tie.

104 *(right)*
Stanley directing Peter Sellers (off-
screen), with James Mason out of
focus in the background preparing
to shoot Peter's character, Clare
Quilty.
[Patrick Ward]

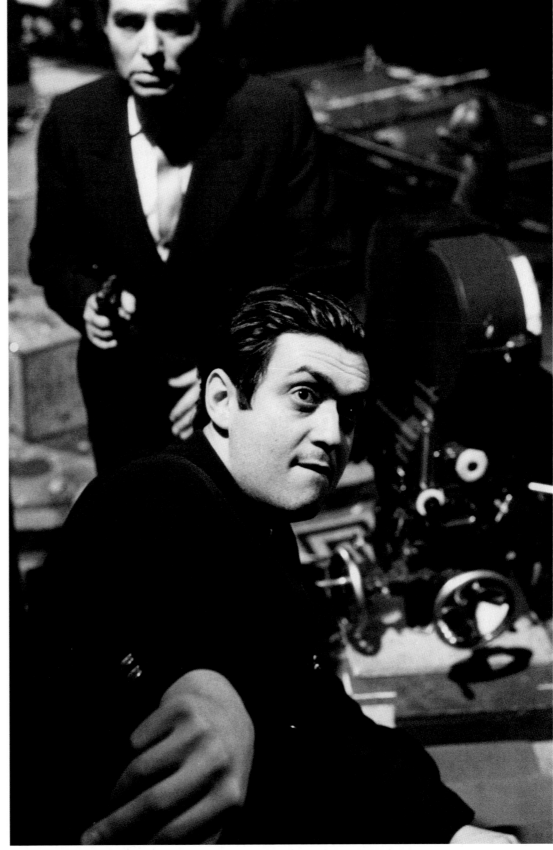

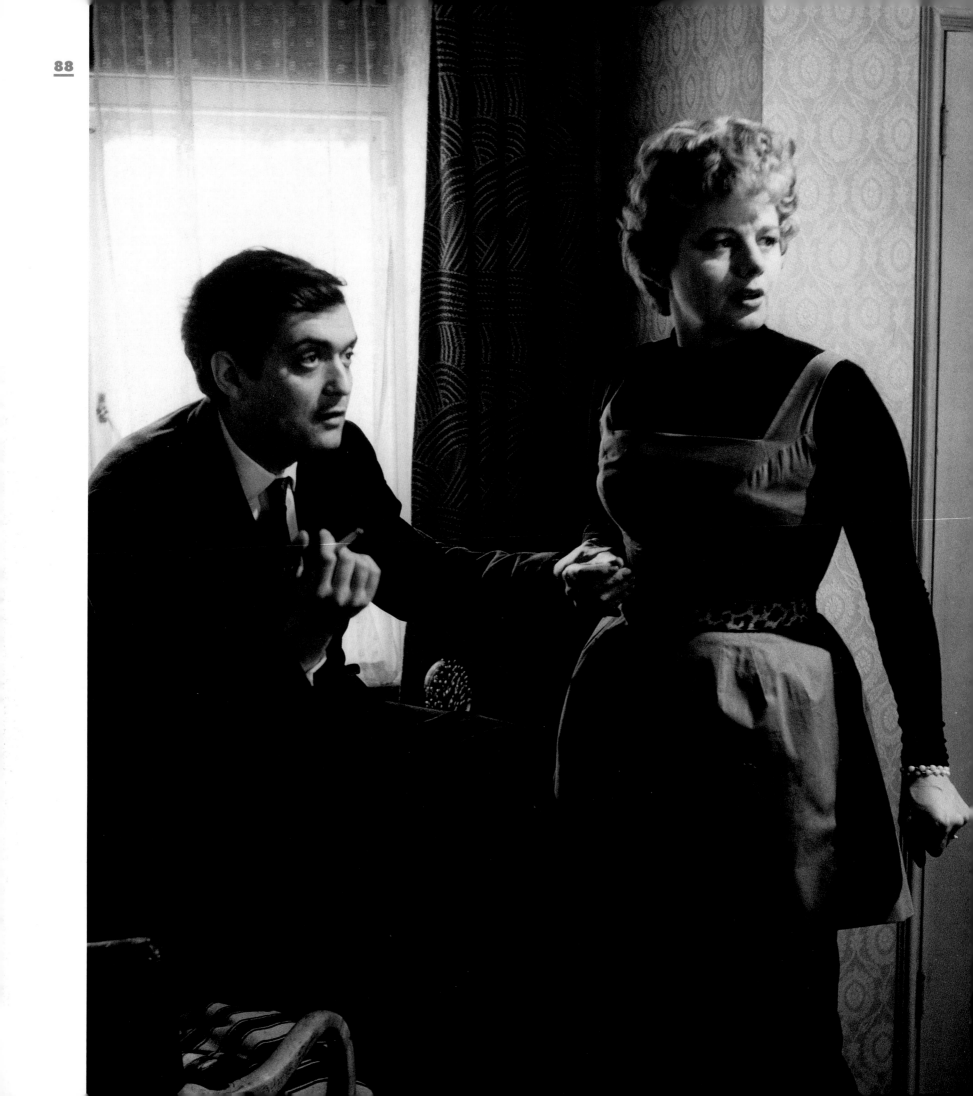

105
With Shelley Winters who played Lolita's mother and who later in the film would be killed in a car accident, thus freeing Humbert to run off with his nymphet.

107
Rehearsing the party scene with Shelley Winters and Peter Sellers.

106
On location in Chalfont St Giles, north-west of London, for the house that would serve as the Haze home.

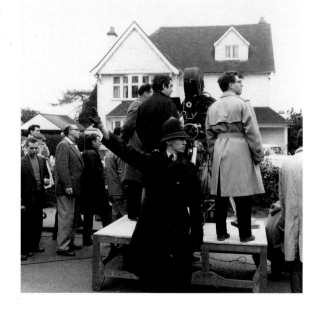

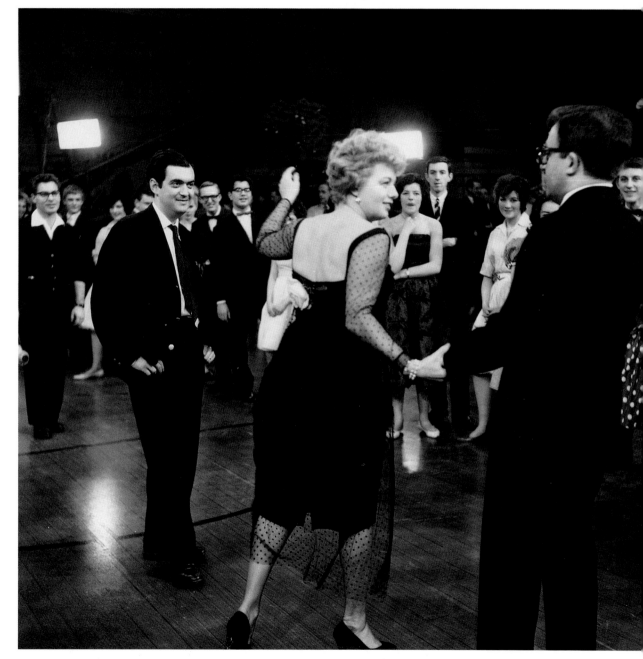

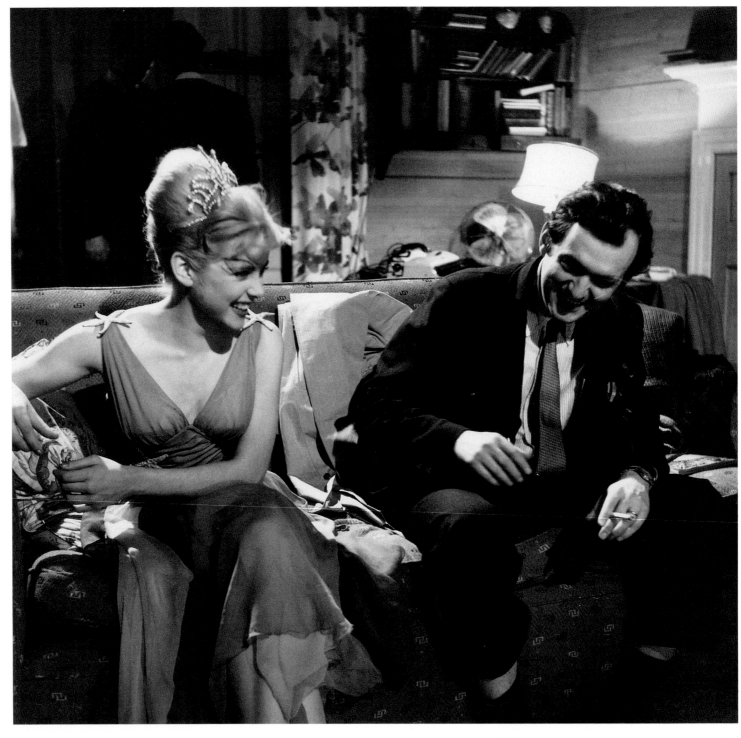

108
Sue Lyon, Stanley, and Stanley's
cigarette on the set at ABPC Studios
in Elstree.

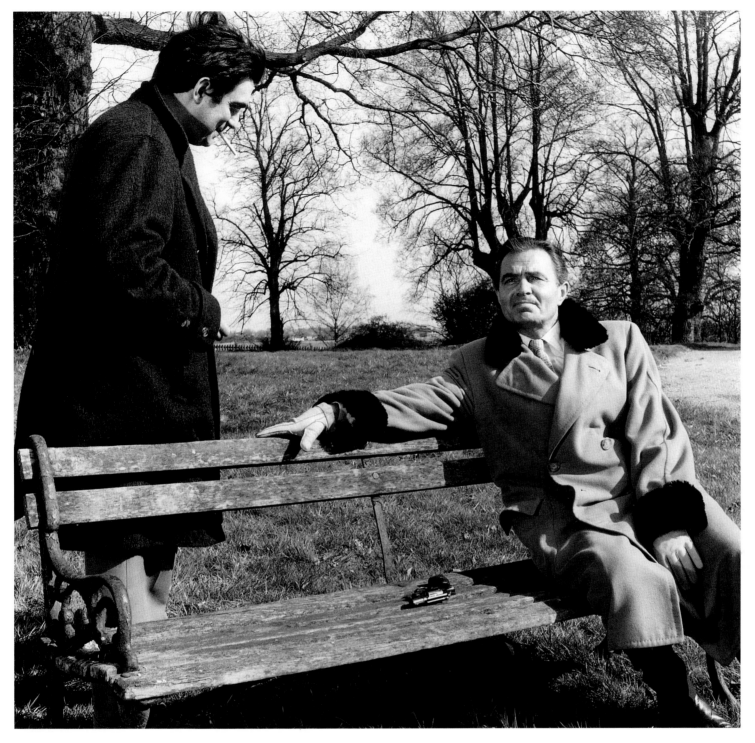

109

In the grounds of Hillfield, the large, castellated house west of Elstree that would be the baronial home of Clare Quilty in *Lolita*. This is the opening of the film when Humbert shoots Quilty.

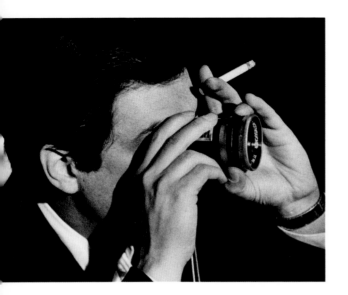

110
Stanley and his little Tewe
viewfinder. He used it on many
films and I still have it.

111
Peeking through the curtains on one
of the *Lolita* sets at the studios in
Elstree.

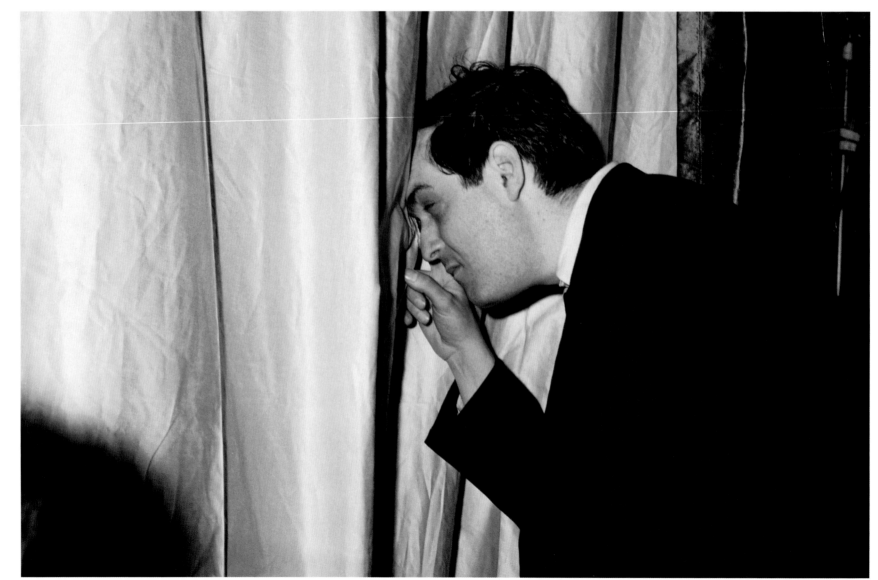

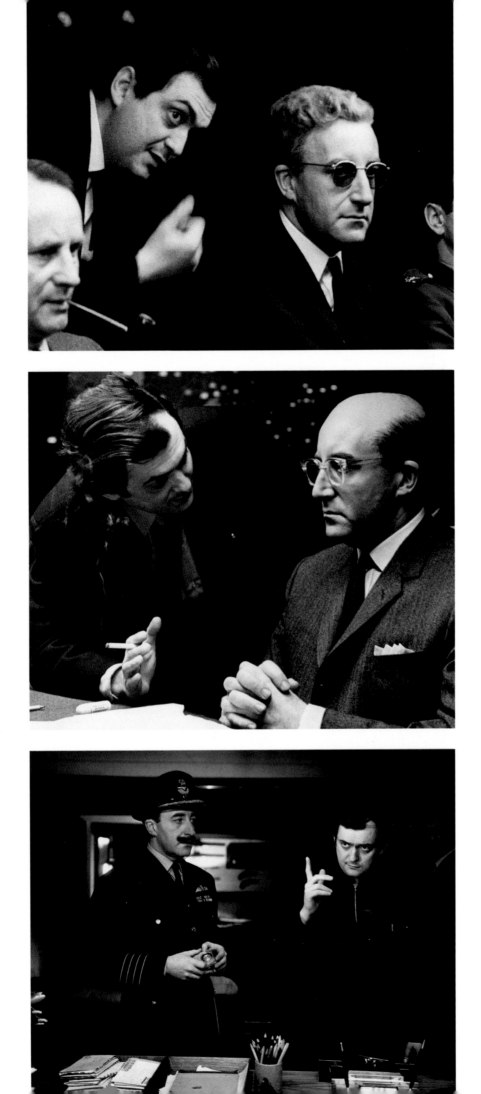

The three faces of Peter Sellers in *Dr Strangelove, or: How I Learned to Stop Worrying and Love the Bomb.* Descending, they are: Dr Strangelove himself (a figure, as Stanley said, that presaged Henry Kissinger); the liberal and well-meaning US President, Merkin Muffley; and from the Royal Air Force, that quintessentially English figure, Group Captain Lionel Mandrake.

Dr Strangelove was made in England at Shepperton Studios, west of London, in 1963.
[113 – Bob Penn]

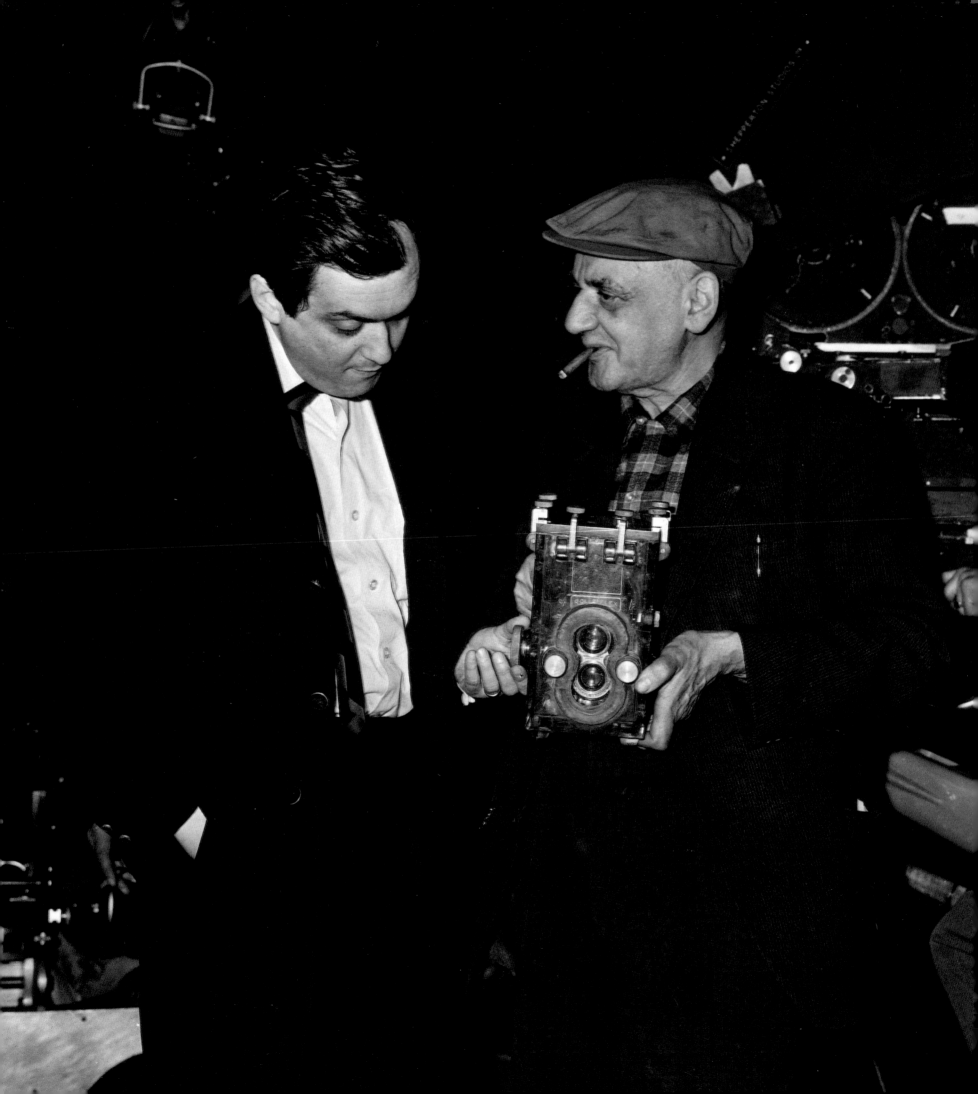

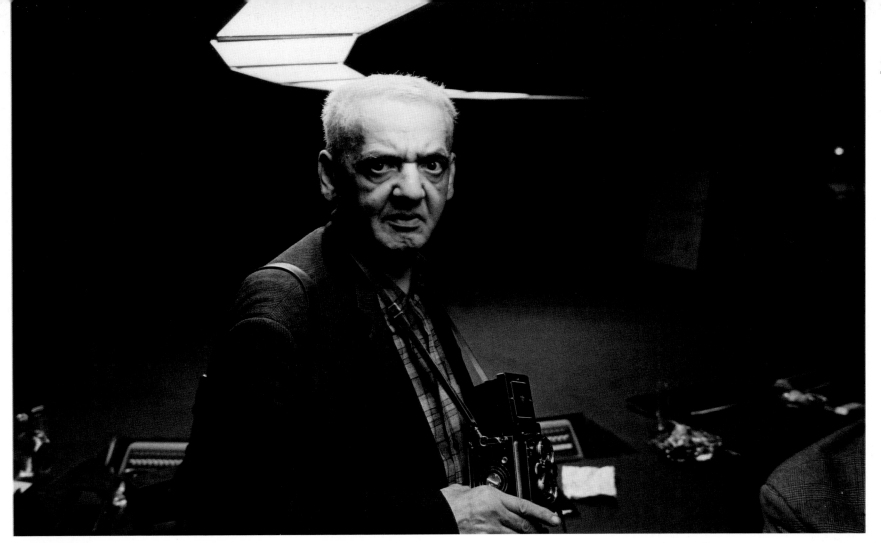

115, 116

Stanley with Weegee on the set of *Dr Strangelove*. And a portrait of Weegee by Stanley.

Weegee (otherwise Arthur H. Fellig) was a photographer Stanley always admired and he invited him over to England to work as the stills photographer on the film.

Peter Sellers was much taken with Weegee's accent – a high-pitched yet muffled amalgam of New Yorkerese and German – and this was the inspiration for the voice Peter created for Dr Strangelove.

Geoffrey Crawley, a former editor of the *British Journal of Photography* and an expert on photo-imaging – one of the very few people Stanley ever deferred to on matters photographic – knew both Stanley and Weegee and has contributed the following:

The photograph of Stanley and Weegee shows them inspecting a Rolleiflex 6 × 6cm format roll camera. In his newspaper days Weegee would have used a 4 × 5in Graphic plate camera, lens set at 10 feet focus, well stopped down for field depth and so requiring powerful flash bulbs to get an acceptable picture. The Rollei camera is in a blimp, a housing which silenced its already enviably quiet mechanism.

The blimp is made from Perspex and is clearly Weegee's own work, though it does somewhat resemble Rollei's own underwater housing.

In the immediate post-war years after 1939–45, the Rolleiflex was the most popular camera for press photography, replacing the older large format systems.

The cap and cigar – he always smoked Dutch – was very much part of Weegee's chosen image as a hobo.

The camera is seen again but without the blimp in Stanley's shot of Weegee – sans cap, sans cigar. He looks as if he may have been caught by surprise. But it shows those powerful, penetrating eyes which, when you met him, seemed to be drilling right through you. In fact he was the gentlest of men.

See also Nos 29, 32, 123.

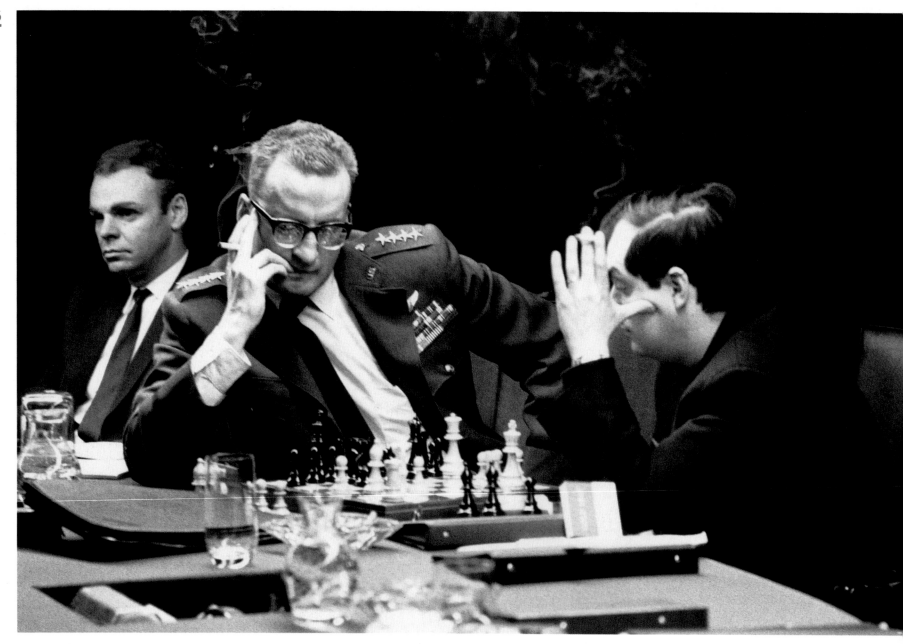

117
Stanley's fondness for a 'little game'
of chess was matched by George C.
Scott who played General 'Buck'
Turgidson in the film, a character
loosely based on Curtis Le May.

118
Stanley and George discussing the
Sicilian defence?

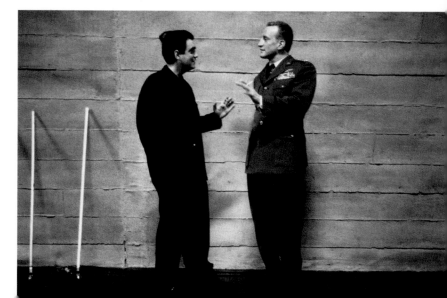

119

Preserve the continuity at all costs! It was as important not to disturb the chessboard as it was the set itself.

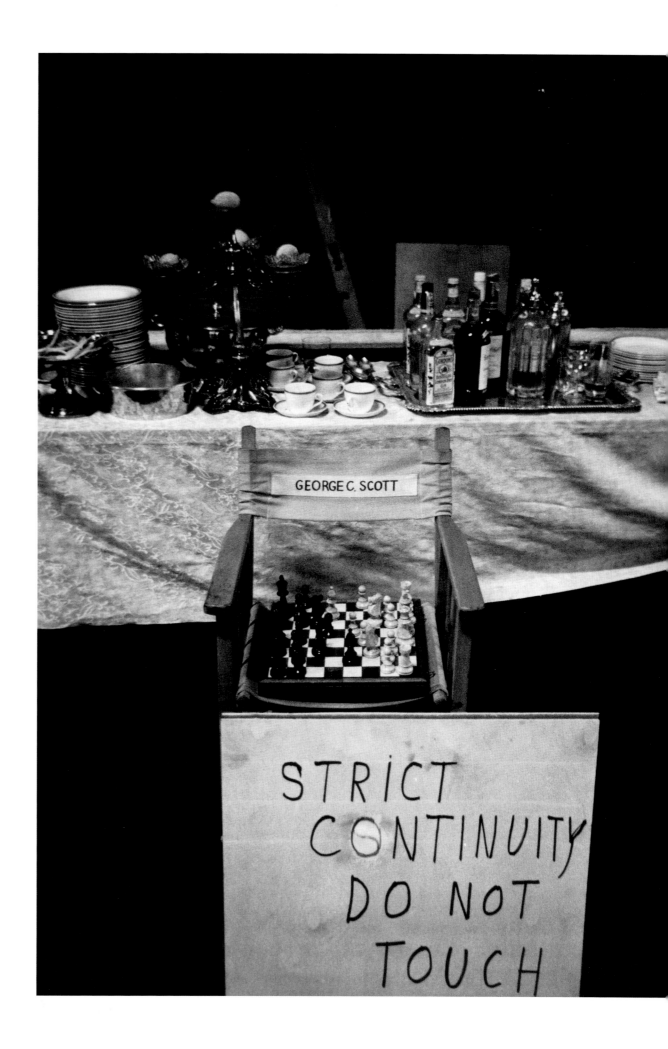

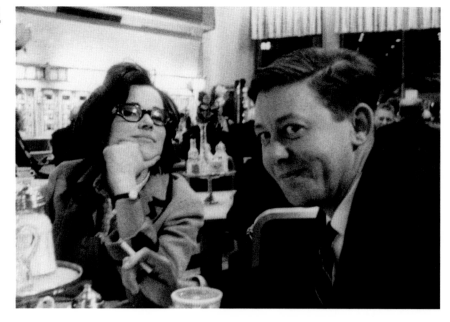

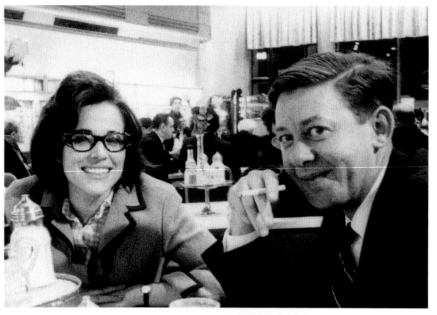

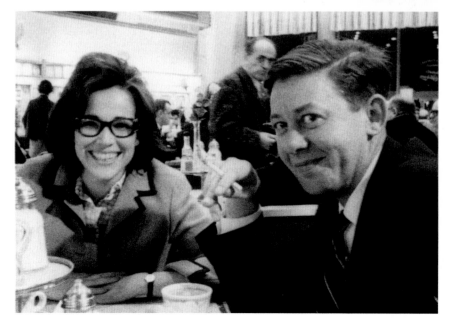

120, 121, 122
Three photographs of me with
Peter George taken by Stanley at
a restaurant that may have been at
Shepperton Studios – I cannot
remember.

 Peter George, an ex-RAF pilot,
was the author of the novel that *Dr
Strangelove* was ultimately based
upon: *Red Alert*.

 George was cheerful and lively
and also a very heavy drinker,
principally whisky and milk. He
died soon after *Dr Strangelove*'s
release.

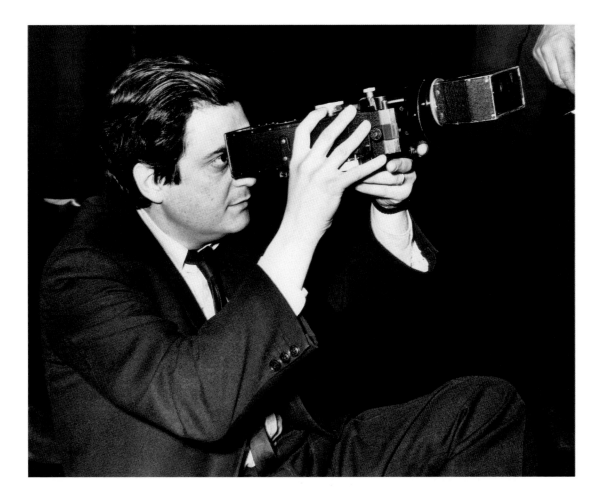

123
A portrait of Stanley taken by
Weegee on the set of *Dr Strangelove*.
See also Nos 29, 32, 115, 116.

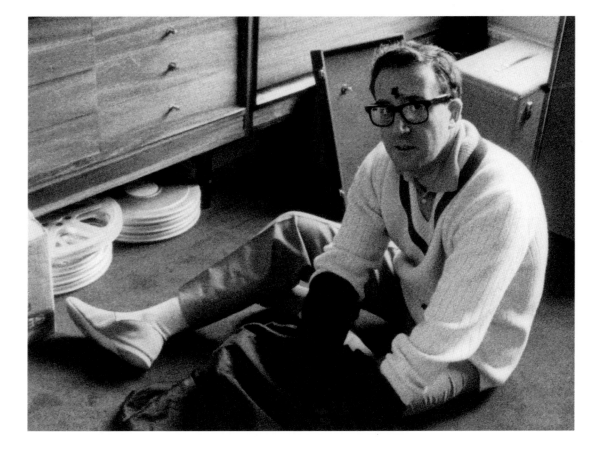

124
Peter by Stanley. I think Peter is
loading his movie camera in a
changing bag.

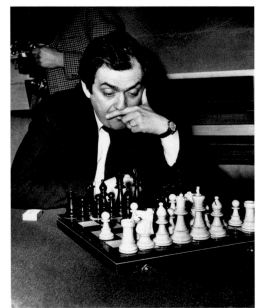

125
A large part of shooting a film is just waiting about, and rather than fritter that time away, Stanley would get a 'little game' going whenever he could.

126
Peter Sellers in a tightly cut 1960s sharp suit points his newly acquired, latest model Nikon at Stanley and George mid-game.
[Bob Penn]

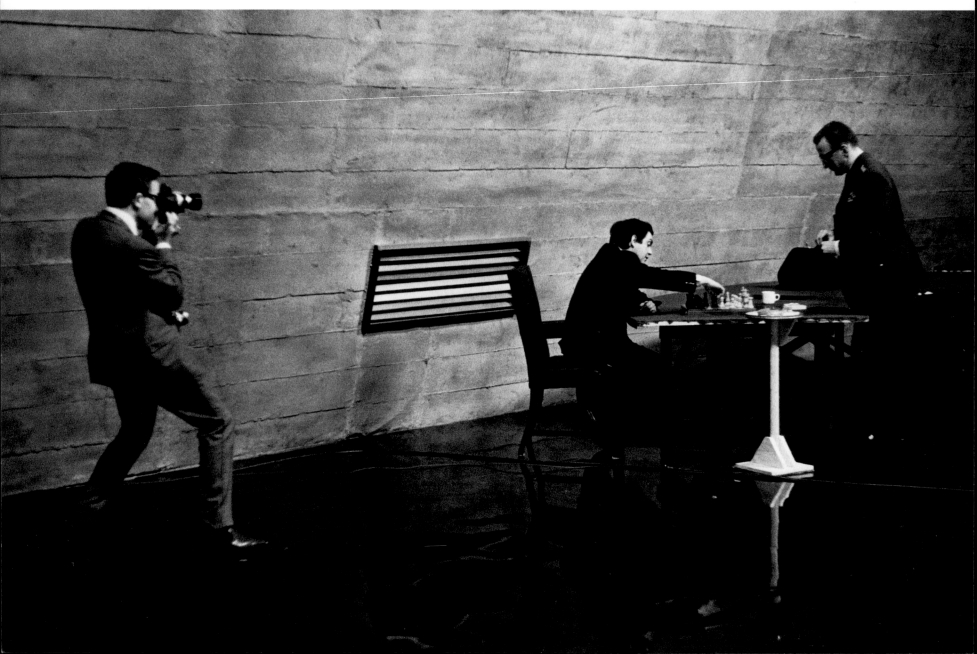

127

A portrait of the writer and satirist Terry Southern, surprisingly without his trademark sunglasses, taken by Stanley near Shepperton Studios early in 1963.

Terry worked on the screenplay of *Dr Strangelove*, his very first film venture, and went on to collaborate on other scripts including *Barbarella* (1968) and *Easy Rider* (1969). He died in 1995.

Stanley once remarked that it was only possible to be a satirist briefly nowadays, as reality soon outstripped you. This is what happened to Terry in the last couple of decades of his life when the world became more outrageous than he had imagined.

128

Another portrait by Stanley, of Ken Adam. This was taken in the perpetually freezing apartment we then rented in Queen's Gate, Kensington.

Ken was the production designer on two of Stanley's films, *Dr Strangelove* and *Barry Lyndon*. His other credits include all of the early James Bond films and, more recently, *The Madness of King George* (1994).

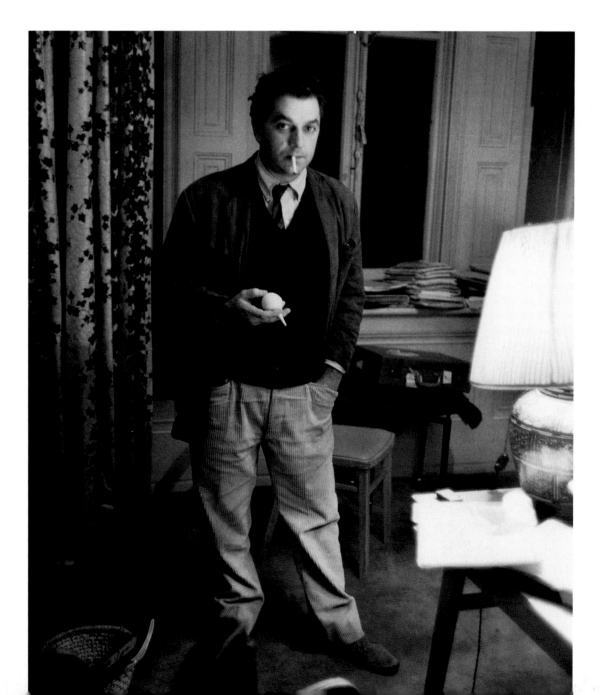

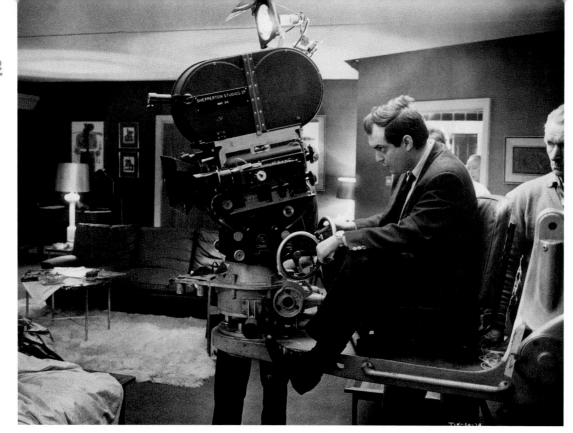

129
Whenever possible, Stanley not only lit the sets himself but also operated the camera. Here the camera is about to roll at Shepperton.

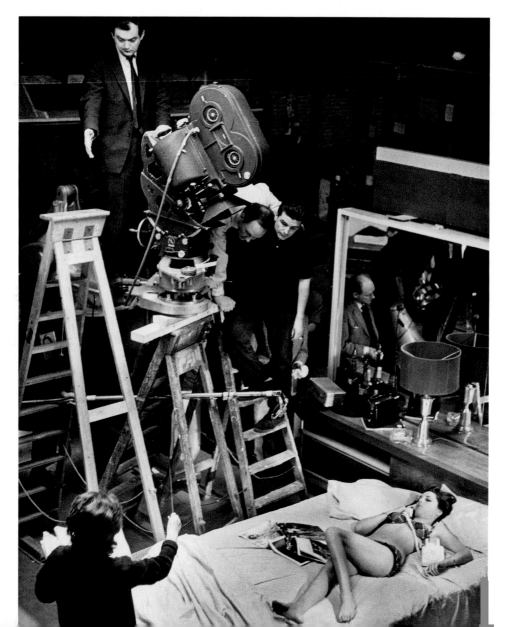

130
Lining up a shot with Tracy Reed's stand-in on *Dr Strangelove*. Tracy Reed played General 'Buck' Turgidson's mistress.

To Stanley's left are Kelvin Pike and Bernie Ford of the camera department, while reflected in the mirror is the bald head of make-up man Stuart Freeborn. Pamela Carlton has her back to the camera in the foreground. She was responsible for what was then known as continuity.

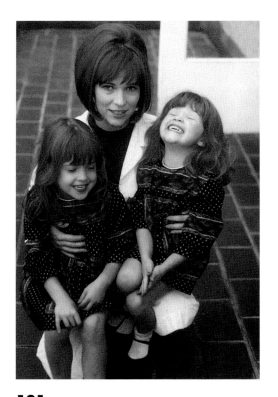

131
Me, with Vivian on the left and
Anya on the right, photographed by
Stanley.

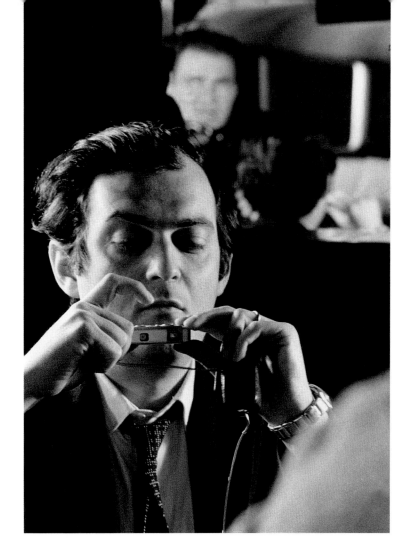

132 *(above right)*
Stanley with one of his favourite
cameras of all time: a Minox 'spy
camera'.

He would shoot reels and reels of
film with it and then have contact
sheets printed up that, owing to the
small width of the film (about 8mm),
were impossible to view without
the help of a strong magnifying
glass.

133 *(right)*
Peter and Stanley with their brand
new Nikon Fs, acquired from Peter's
friend Malcolm Kafetz.

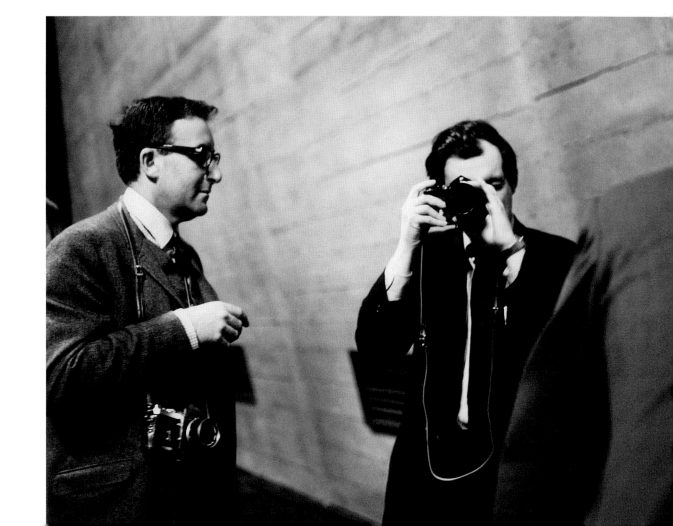

INTERMISSION

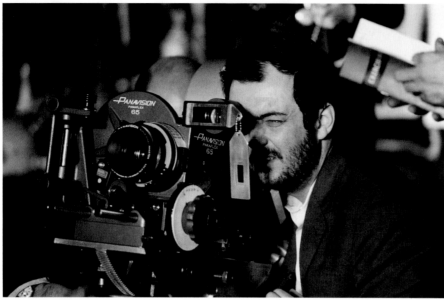

[134]

'The best education in film is to make one . . . anyone seriously interested in making a film should find as much money as he can as quickly as he can and go out and do it.'

– STANLEY KUBRICK

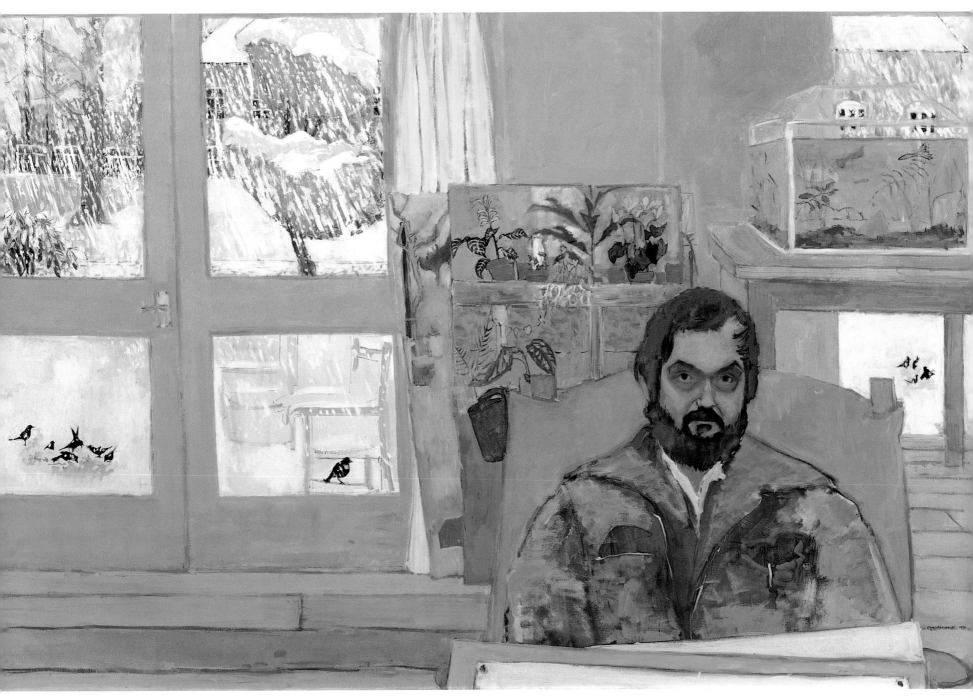

This was my first formal portrait of Stanley. It was painted in the winter of, I think, 1972, at our house, Abbott's Mead, in Elstree.

It was done in my studio, and I had interrupted completing the painting that can be partially seen behind Stanley to do it. Stanley was not always the best of sitters and when he made himself available I had to seize the opportunity.

Stanley, oil on canvas, 1220 × 1830mm.

■
This is from my sketch pad and was
done in our apartment in New York
around 1963–4. Anya is on the left
and Vivian on the right.

Stanley was still a jacket, shirt
and tie guy in the early 1960s.

Watercolour, 280 × 355mm.

■■■
This was in the bedroom of the New York apartment at the same time as the preceding painting.
 Watercolour, 280 × 355mm.

IV *(left)*
From the same sketch pad as the two previous watercolours. Stanley was in our cabin on board the liner going over to England, hence the numbered suitcase in front of him.

Watercolour, 355 × 280mm.

V *(right)*
There was always going to be time to do another formal portrait of Stanley in oils. But the years evaporated and then Stanley was gone.

Thus this portrait was done from memory shortly after Stanley died (though there were some preliminary drawings that helped me). He is sitting on the other side of the pond in our garden with his legs crossed in that characteristic way – essential for writing or reading, which he was invariably doing.

Remembering Stanley, oil on canvas, 980 × 990mm.

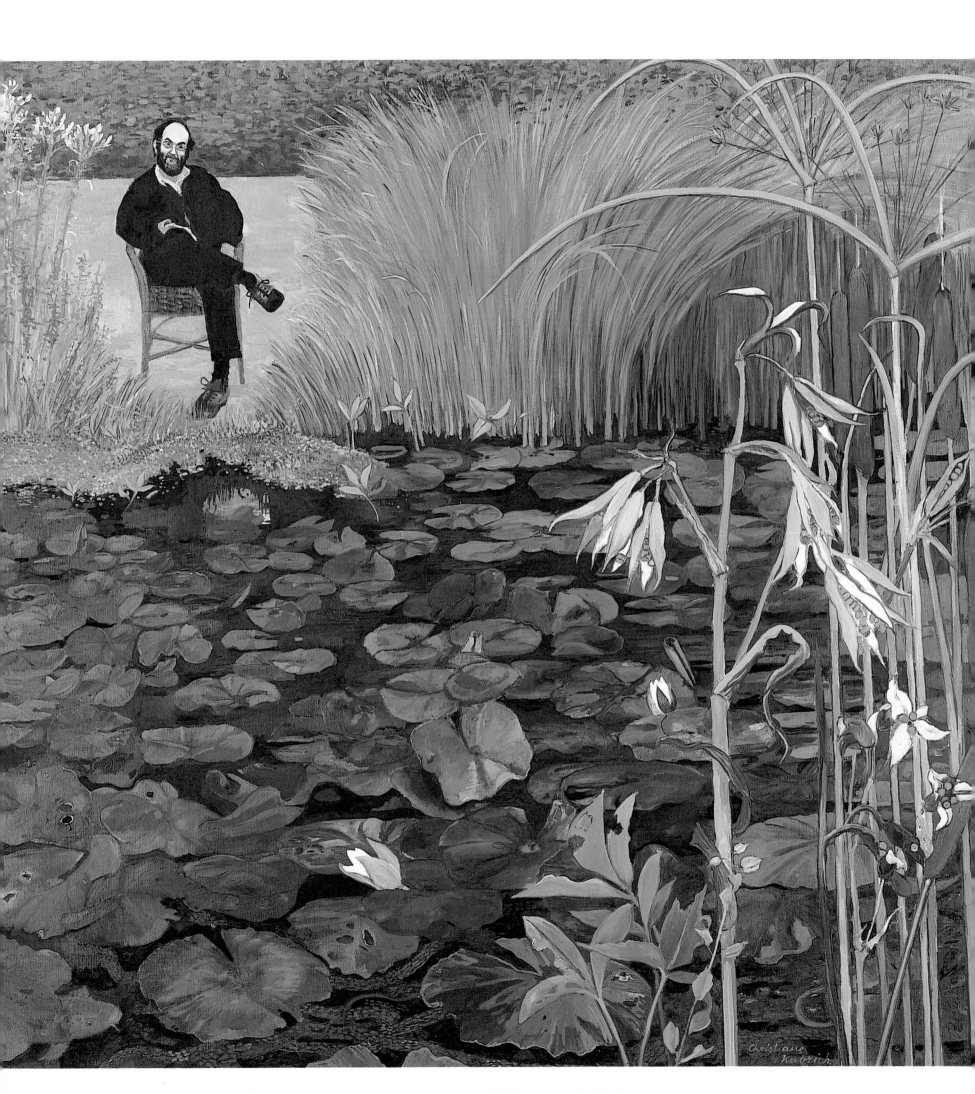

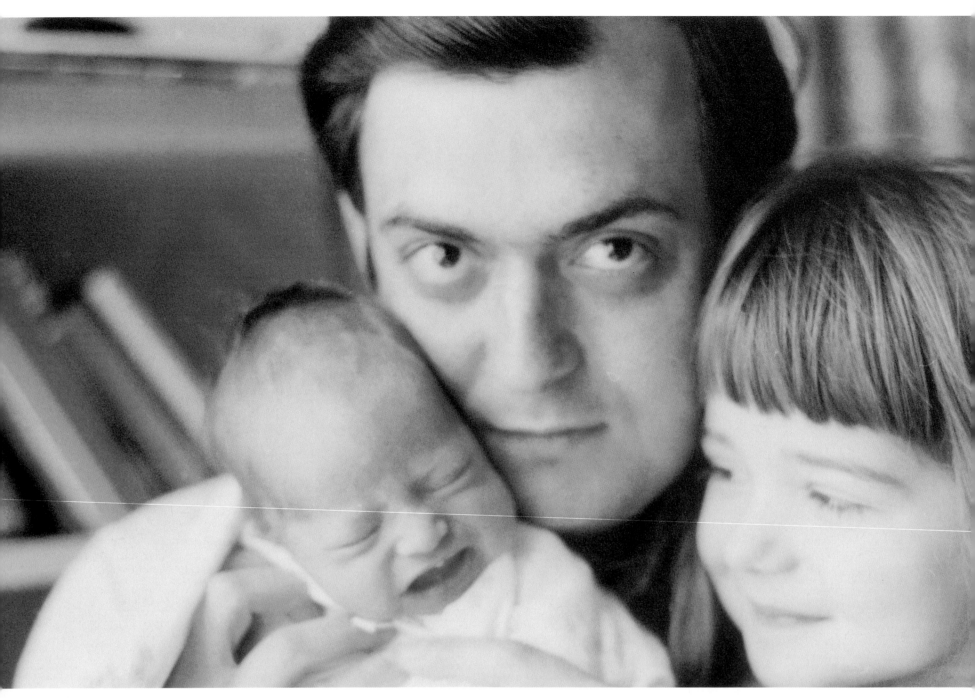

VI

Stanley, the proud father. I took this photograph in our house on South Camden Drive in Beverly Hills a few days after Anya was born in 1959. Katharina is on the right.

VII (right)

Nearly twenty years later, Stanley at the time of *The Shining*. My photographic portrait of him was taken in 1978 at Abbott's Mead, with dear Lola, our golden retriever.

Stanley firmly believed in copper bracelets for scaring off back problems, rheumatism and other ailments, as can be seen from his right wrist. He thought everyone should wear them.

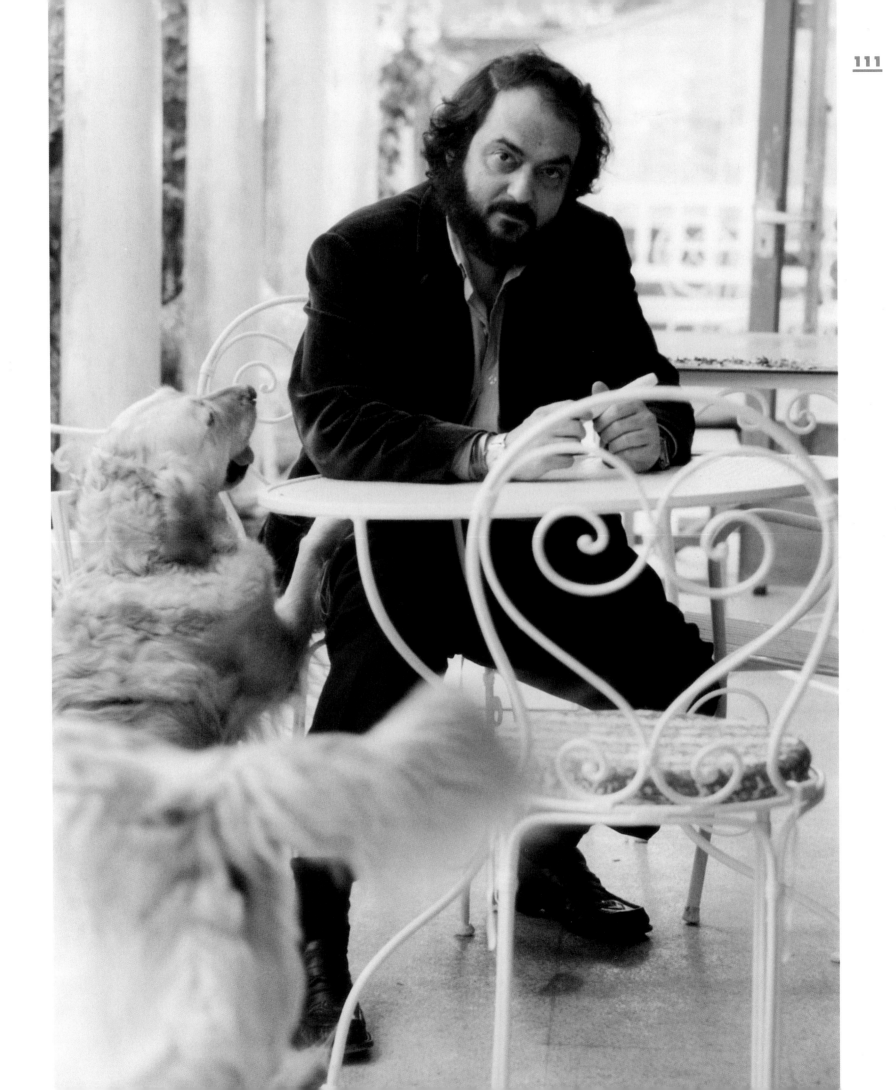

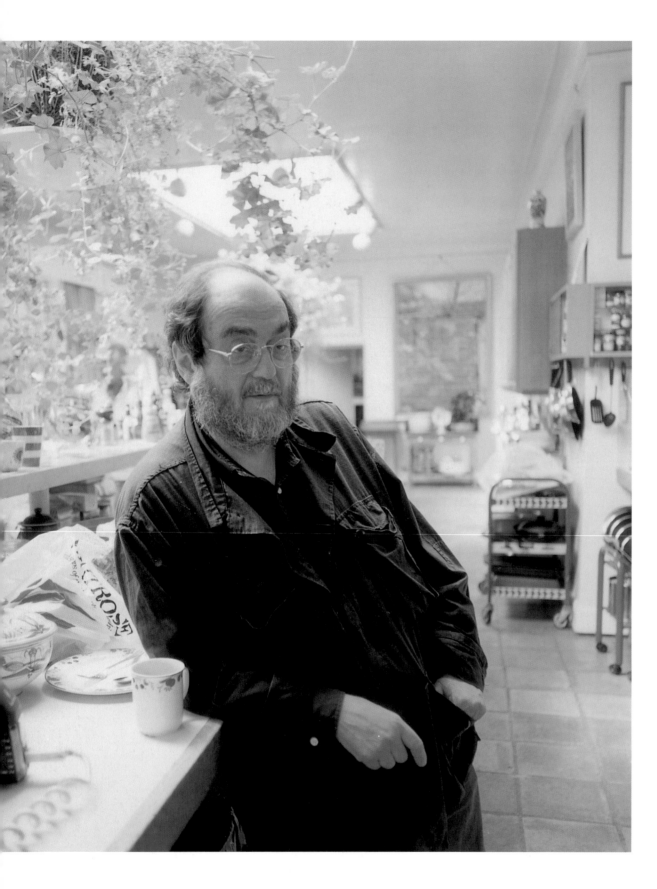

VIII
I took this photo in our kitchen towards the end of 1998 when Stanley was nearing completion of *Eyes Wide Shut.* He had just made himself some filter coffee and had rummaged through my shopping bags looking for something to eat.

Stanley Kubrick
A Life in Pictures

PART TWO
1965–1999

135

Stanley took this photograph in the
Dorchester Hotel in London when
we arrived in early 1965 for the pre-
production of *2001: A Space
Odyssey*. He shot it with one of his
favourite cameras: the 35mm
Widelux. This was a camera with
a 26mm lens that automatically
traversed from left to right resulting
in the wide screen Cinerama-like
effect seen here.

Katharina is on the left, then Anya,
then Vivian, and me in the hat and
pearls. Stanley with the Widelux to
his eye can just be made out on the
far left reflected in the mirror.

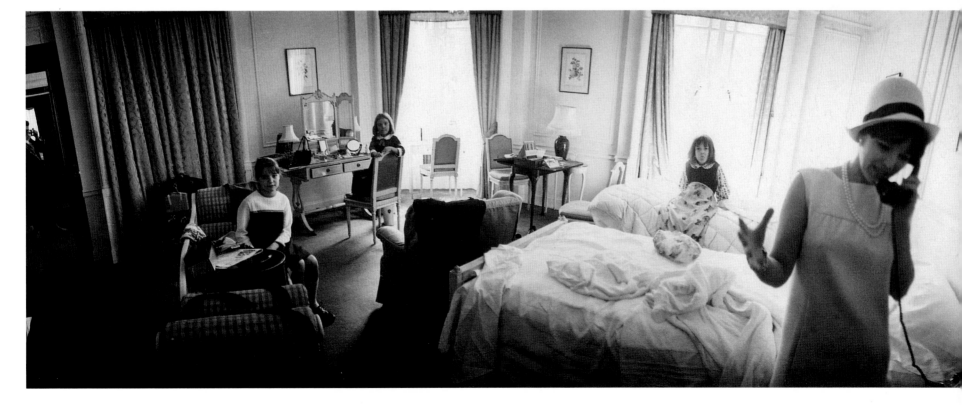

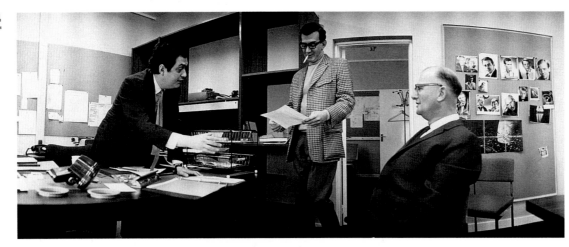

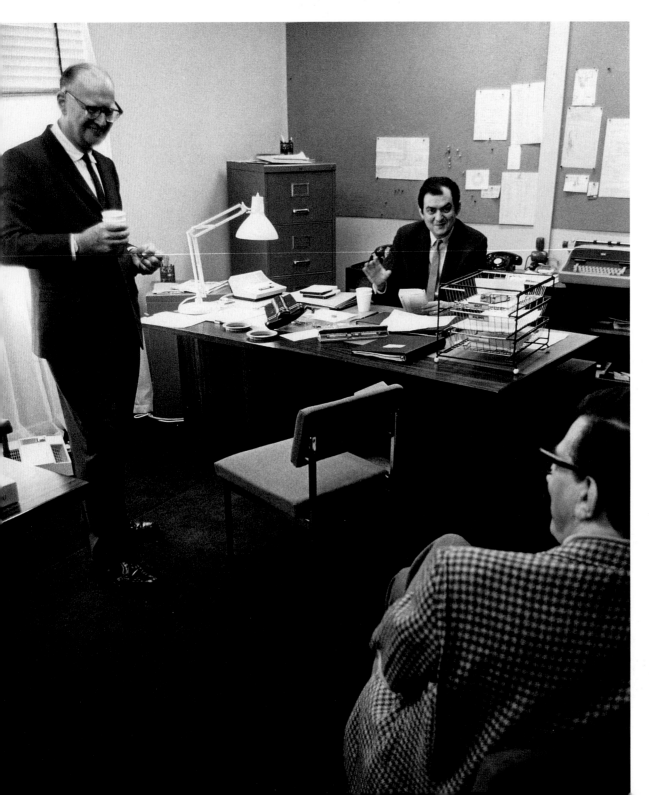

136, 137

Stanley with Victor Lyndon, in the check sports jacket, and Arthur C. Clarke in the suit, in the production offices at MGM Studios in Boreham Wood in 1966 during the pre-production of *2001: A Space Odyssey*.

Victor was the associate producer on *Dr Strangelove* and performed a similar role on the main unit shooting of *2001*. Arthur, of course, is now Sir Arthur.

This was a publicity still taken in the days when Stanley still did publicity stills. The office, however, is not Stanley's, but Victor's. Stanley felt the clutter and seeming untidiness of his own office might not give the right impression so he borrowed Victor's. In the words of a New York interior decorator that Stanley never forgot, as I've noted before, his office was always more for *blow* than *show*. And, besides, Stanley always consoled himself with something he had once been told: a tidy office is a sign of a sick mind.

138, 139

Two of our cats, Leo and Jessica, at the house we bought in Elstree, Abbott's Mead, where we lived from 1965 until 1979. We have always had cats (and dogs) and at one time had sixteen cats, our personal best (and worst!).

Abbott's Mead, below, was a large and spacious family house built at the turn of the century. It was spacious when we bought it but it immediately began to shrink as Stanley and I colonised rooms for our various activities.

MGM Studios was only ten minutes' drive away.

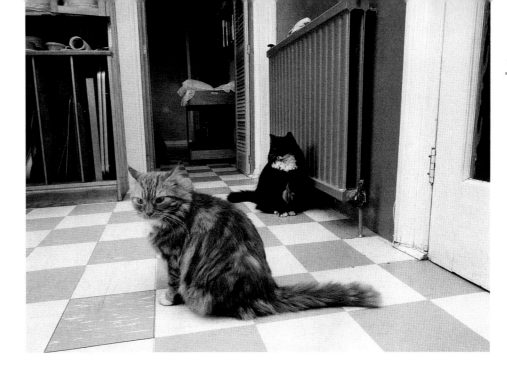

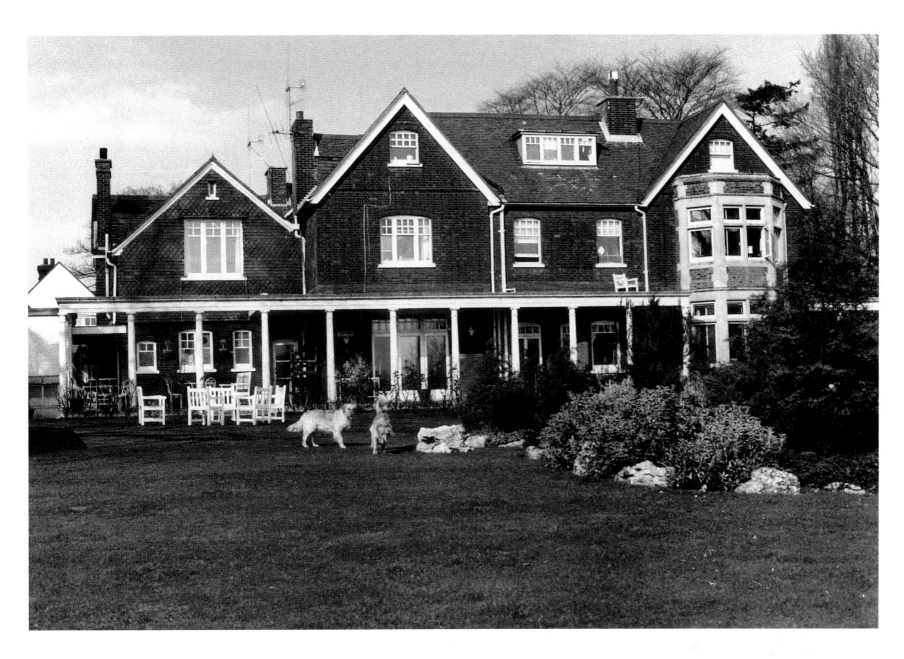

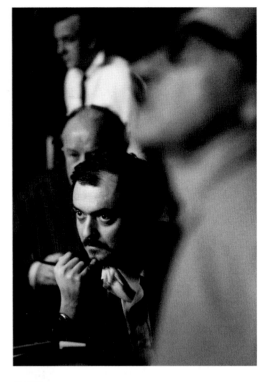

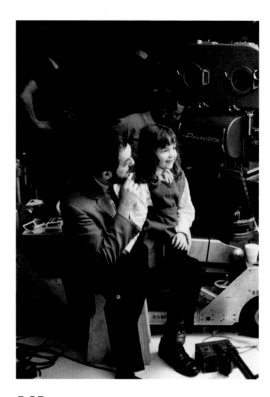

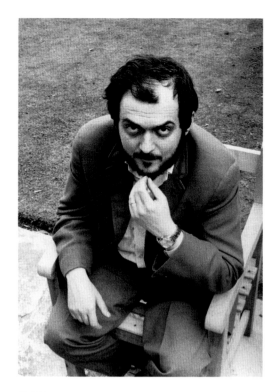

140
With Geoffrey Unsworth, the lighting cameraman, on a *2001* set.

141
With Vivian beside one of the huge 65mm Panavision cameras that were used on *2001*.

142
Off-duty at Abbott's Mead. I took the photograph.

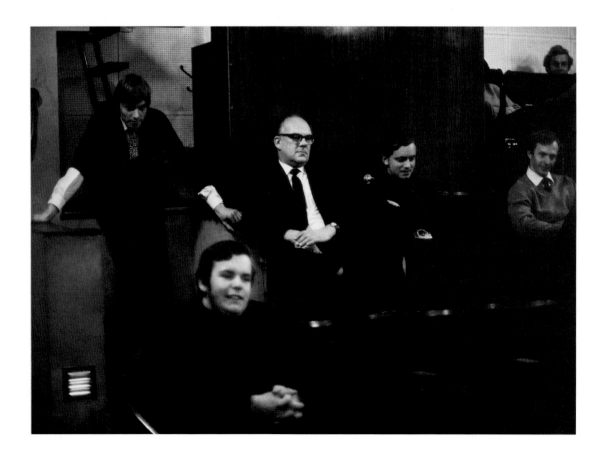

143
A photograph by Stanley of some members of the *2001* unit about to watch rushes in Theatre 1 at MGM Studios.

Left to right: Bryan Loftus, SFX camera unit, now a lighting cameraman; Tony Frewin, Stanley's assistant; Michael Round, stills librarian; Martin Body, camera department; Peter Hannan, camera department, now also a lighting cameraman (*Withnail and I*, and others); William Davis, art department.

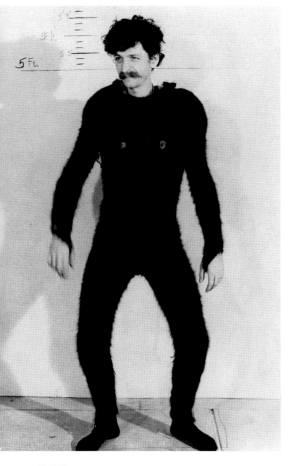

144

Dan Richter, the mime artist and writer who played Moonwatcher in *2001*, in an early prototype ape costume. Photograph by Stanley.

145

On the space station set with John Alcott of the camera department on the right. Partially hidden behind Stanley is Roy Cannon of the props department, father of Danny Cannon, director of *Judge Dredd*.

Stanley is holding his esteemed Polaroid camera. It produced 'instant' black-and-white pictures that he used to check lighting and exposure. I still have thousands of Polaroid stills from *2001* and they have not faded at all in the ensuing thirty years.

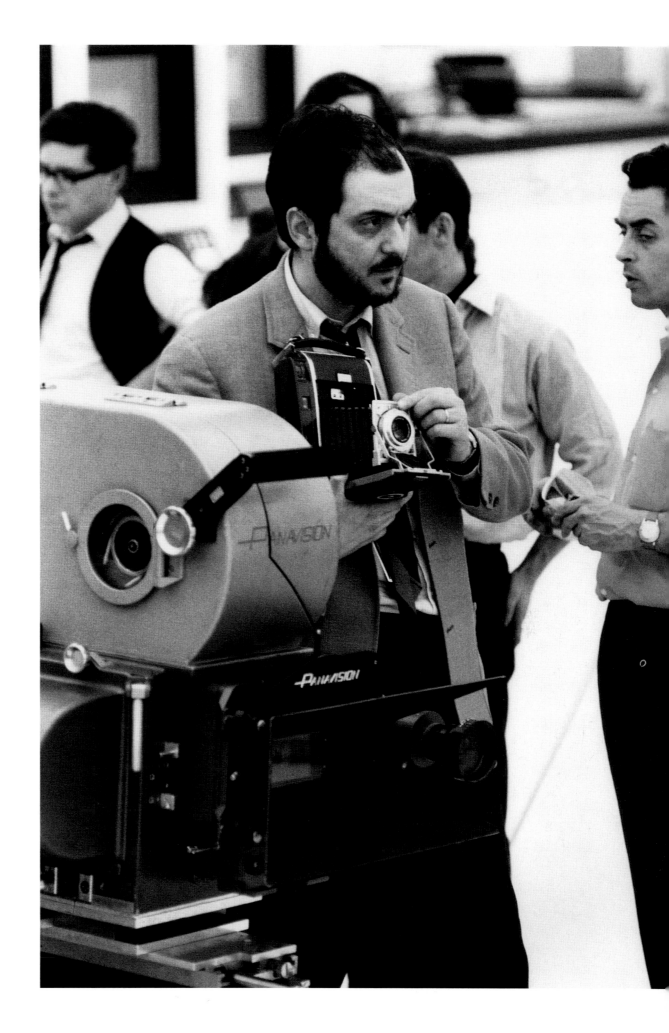

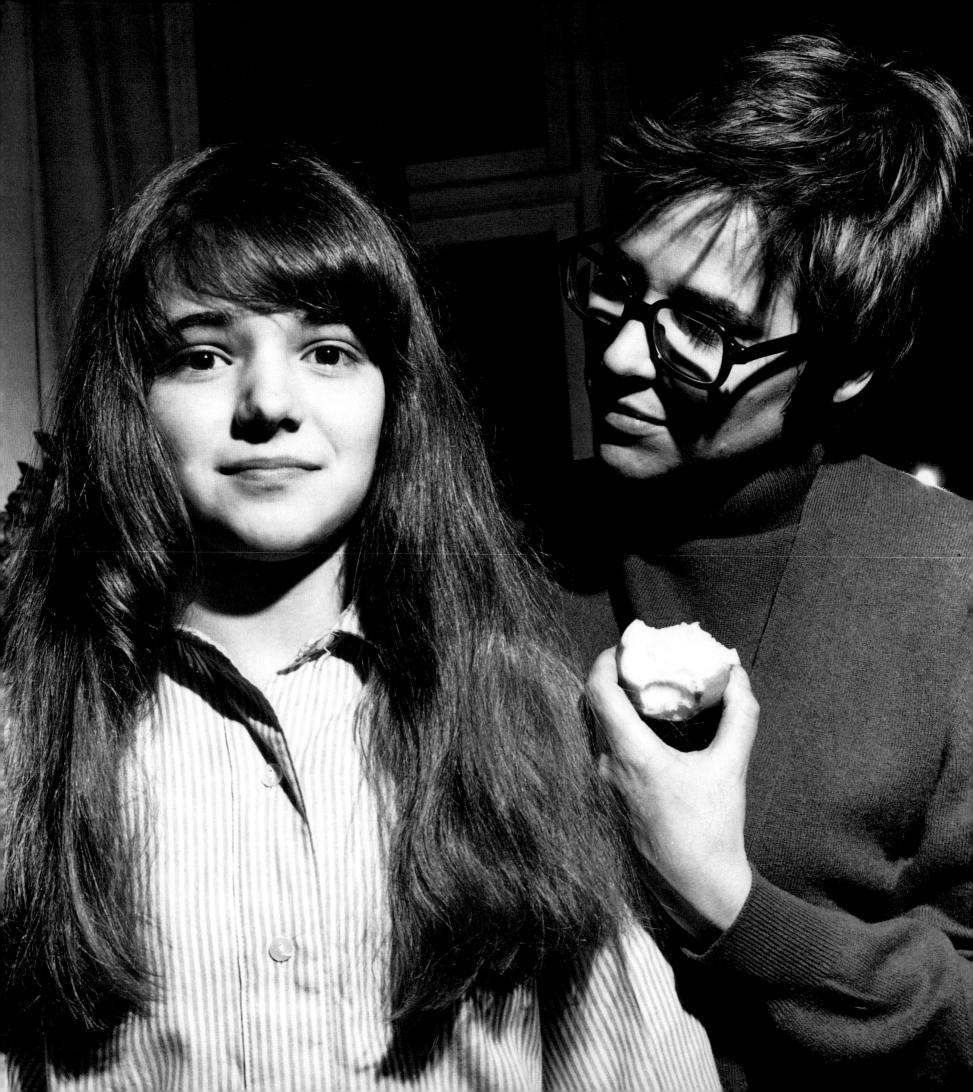

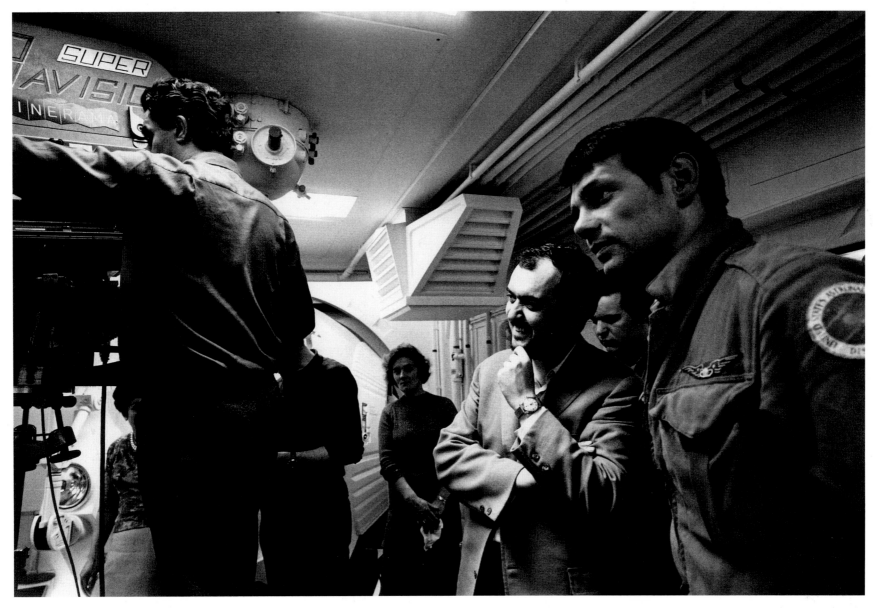

147

The *2001* Pod Bay set at MGM. Left to right: John Alcott; Kathleen Freeborn, make-up; Stanley; Gary Lockwood, who played Frank Poole, the astronaut.

Vignetted between Stanley and Gary is Tony Frewin who is waiting to take Stanley's lunch order (no unimportant job this!). Tony became a novelist and later rejoined Stanley in 1979, and he continues to work for us today.

146

Katharina and me at this time photographed by Stanley at Abbott's Mead.

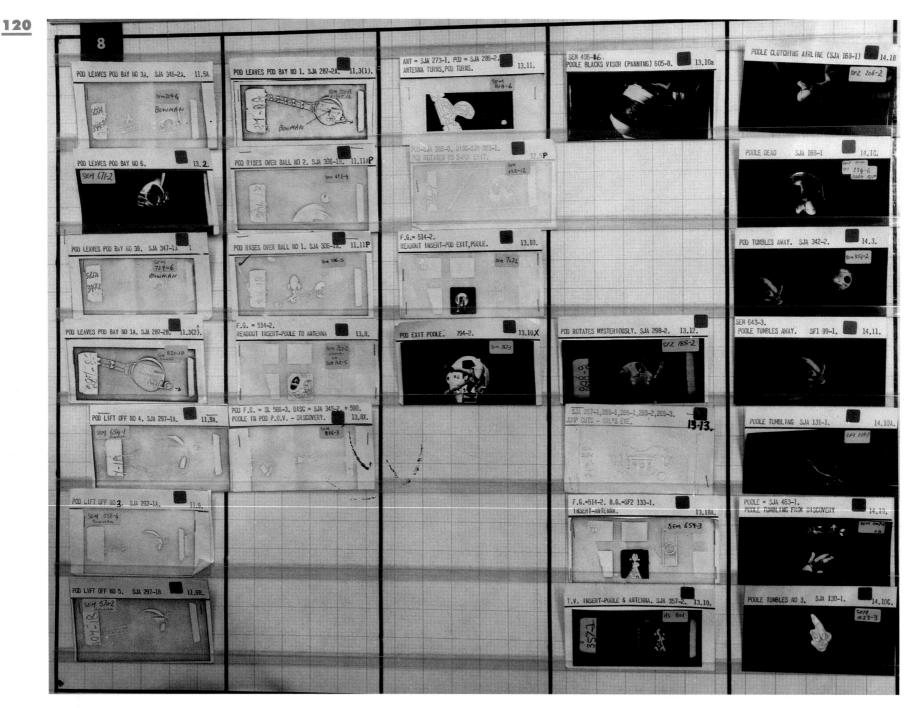

148
In Stanley's office. Just one of the
many dozens of Sasco wall charts
that Stanley used in the planning of
shots on *2001*.

Stanley was very fond of the
Sasco system at the time and came
to rely upon it more and more,
prompting Tony Frewin to dub him
the 'Sasco Kid'.

Stanley's love affair with systems
knew no bounds, and the arrival of
the personal computer was some-
thing he realised he had been
waiting for all his life.

149
Vivian amusing herself in front of a
battery of Sasco charts in Stanley's
office. Photograph by Stanley.

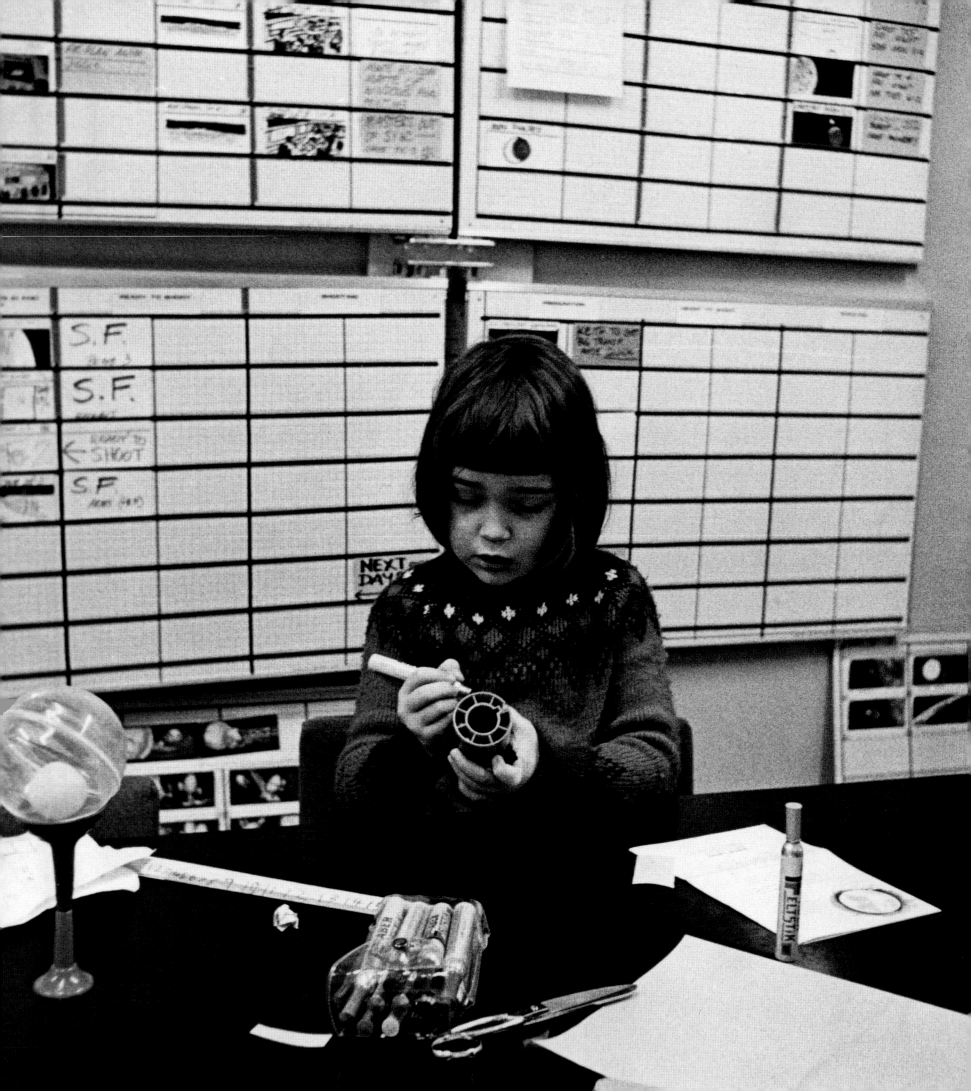

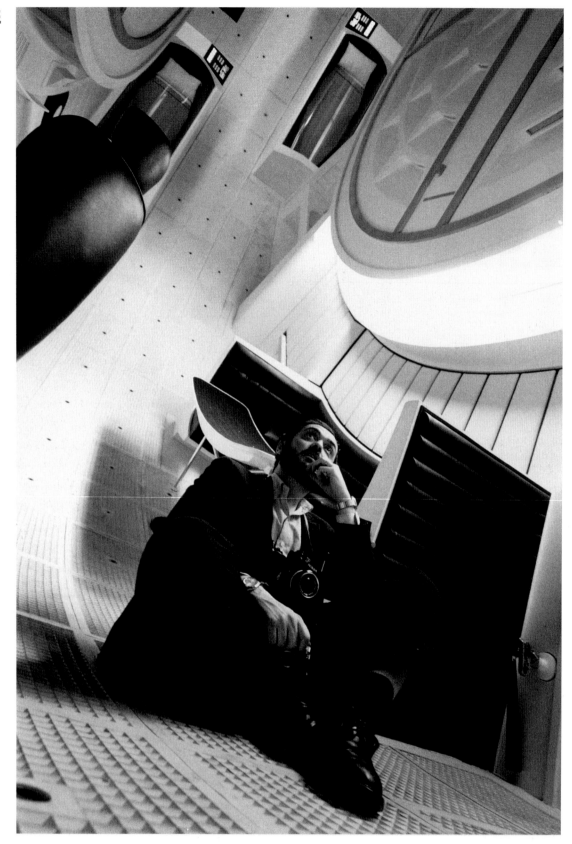

150
Inside the revolving *Discovery* space station centrifuge set.

151
Stanley preparing for a take on the set. The television was linked to a video camera attached to the Panavision camera inside the centrifuge.

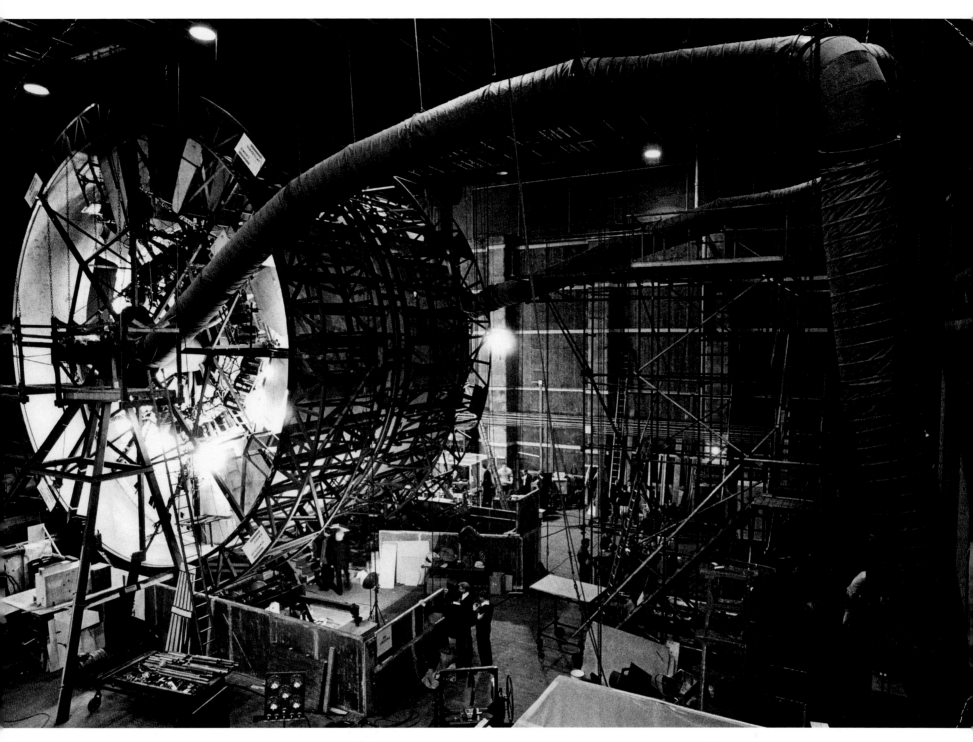

152

A view of the 'exterior' of the centrifuge set. The two 'wheels' rotated in unison, with the camera either stationary within the set on an exterior jib inserted through the floor, or bolted in the set itself and rotating. The end results were spectacular, with the two astronauts seeming to walk and jog around the inside of a 360° set.

The two serpent-like ducts conveyed cold air to the wheels that were heavily laden with heat-producing lights.

The superstructure of the set was especially designed and constructed by Vickers Engineering and the total cost including dressing approached $1 million, an enormous sum for the time and approximately 10% of the film's budget.

[Dmitri Kasterine]

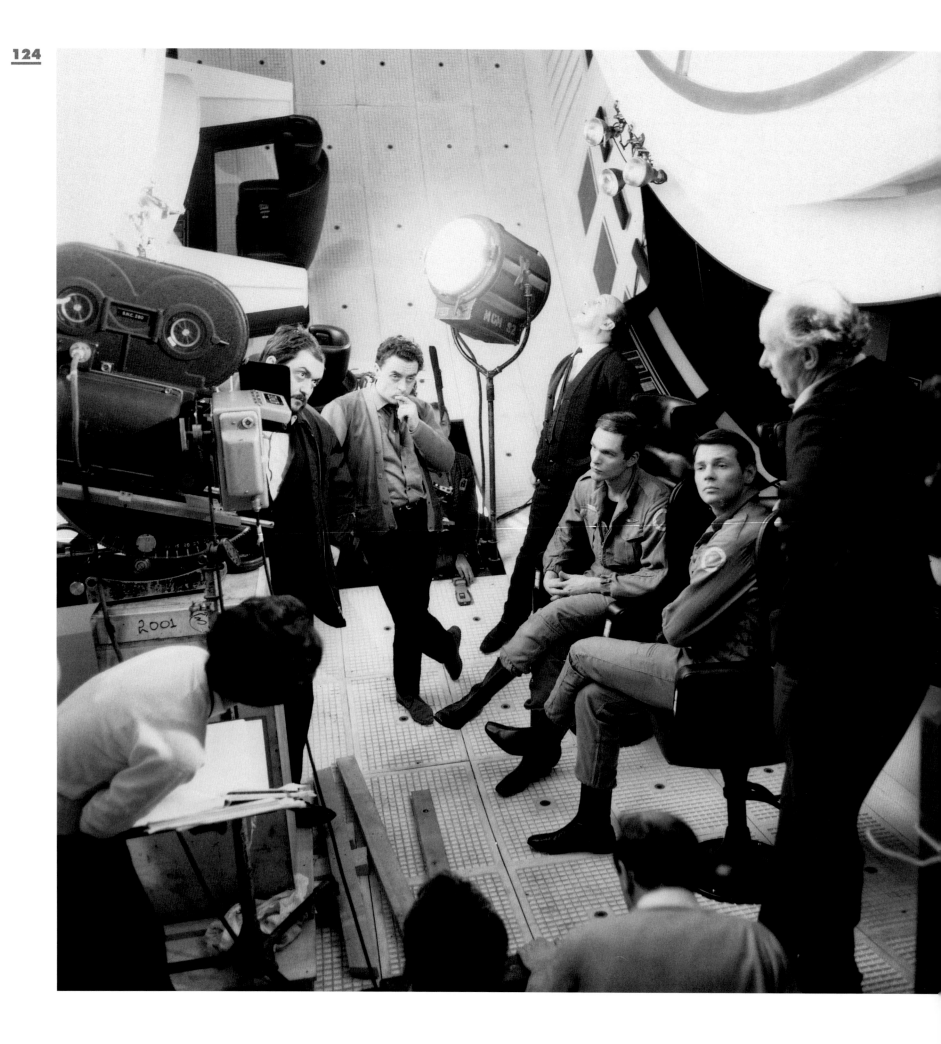

153
Inside the centrifuge set again. Left to right: Pamela Carlton, continuity; Stanley; John Alcott; Ted Creed, construction engineer; Keir Dullea, who played Frank Bowman; Gary Lockwood; Geoffrey Unsworth.

154
Never happier than when behind a camera! Here it is a 65mm Super Panavision Cinerama studio model mounted on a Moy head. This is inside the Pod Bay set.

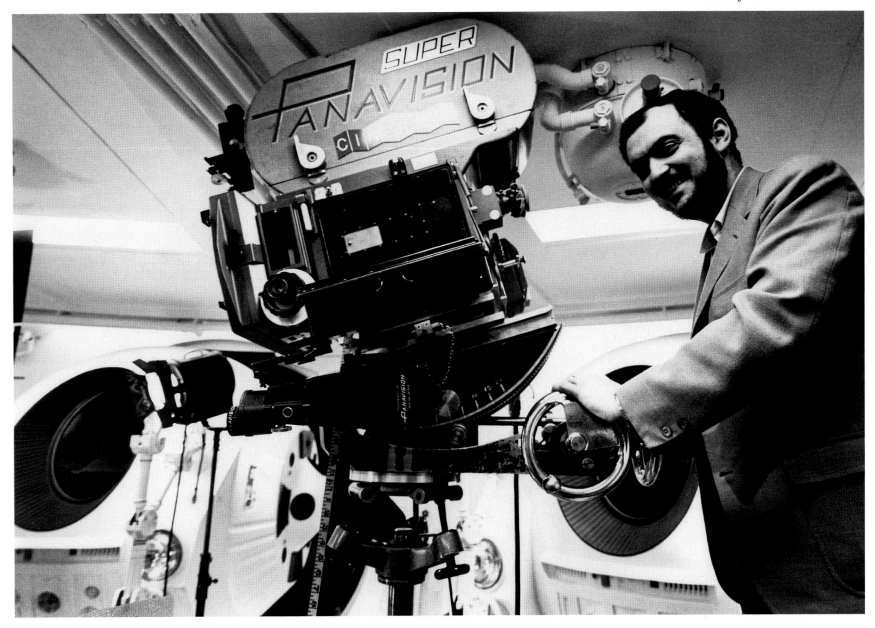

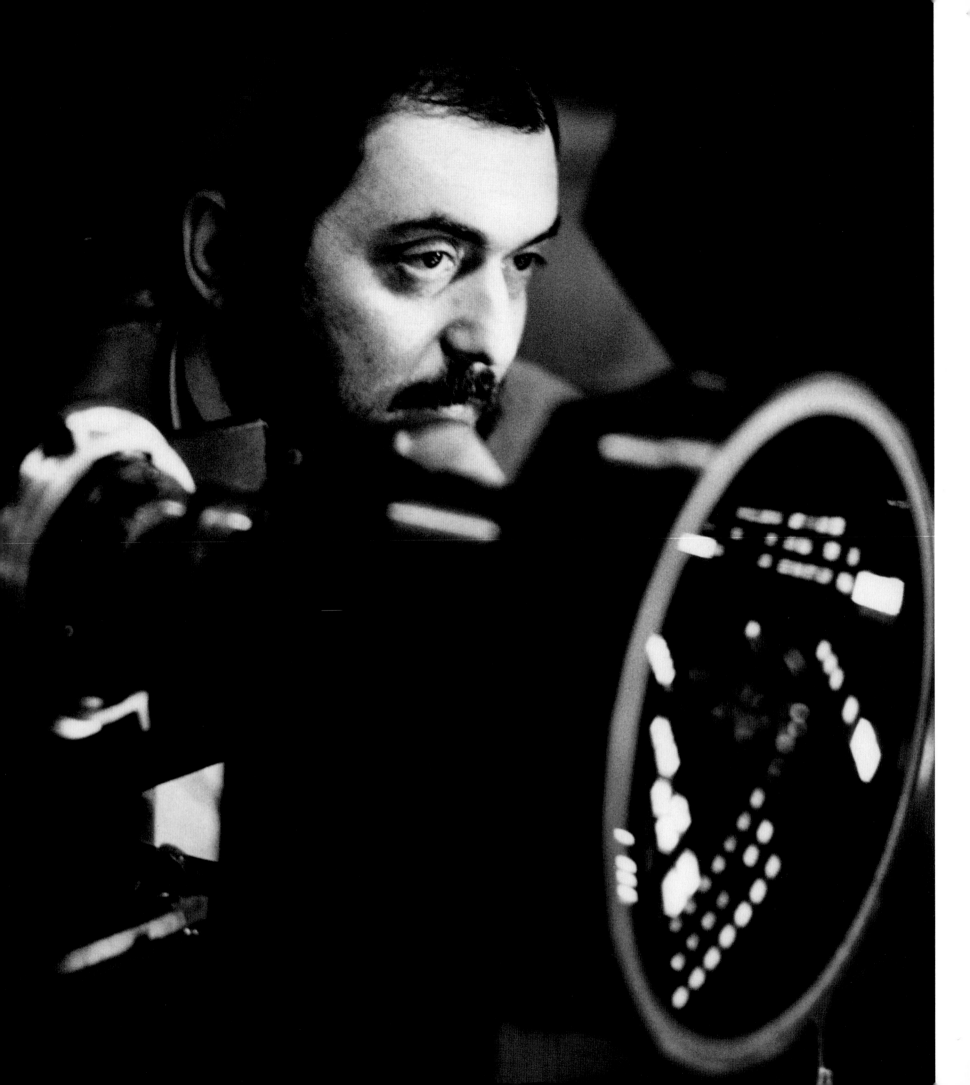

155
A pensive study! Stanley is behind the lens assembly that was designed and constructed by Malcolm Kafetz for HAL, the computer's circular POV shots. Tony Frewin explains:

Panavision could not supply a 'fish-eye' lens that produced a circular image so the problem was solved by borrowing this large and unique 160° mapping lens from Fairchild-Curtis Optical in the US that had been made for NASA. Malcolm Kafetz used this together with a reducing condenser to give a circular image well within the frame of the 65mm film in the Panavision camera.

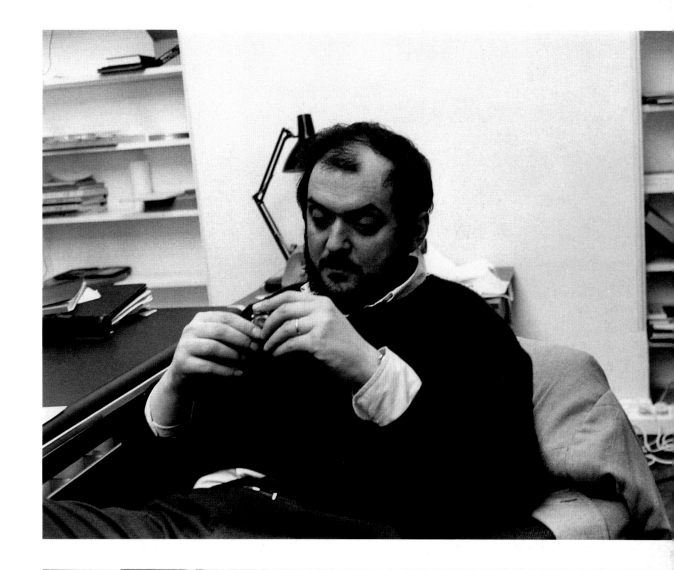

156, 157 *(right)*
I took these two photographs of Stanley in his upstairs study at Abbott's Mead.
 Stanley had just purchased a Dymo tape machine and the drawers on the left can be seen with tapes identifying their contents. One was even marked THINGS for the items that could not find a home elsewhere (THINGS later became IMPONDERABILIA in Stanley's classification system).

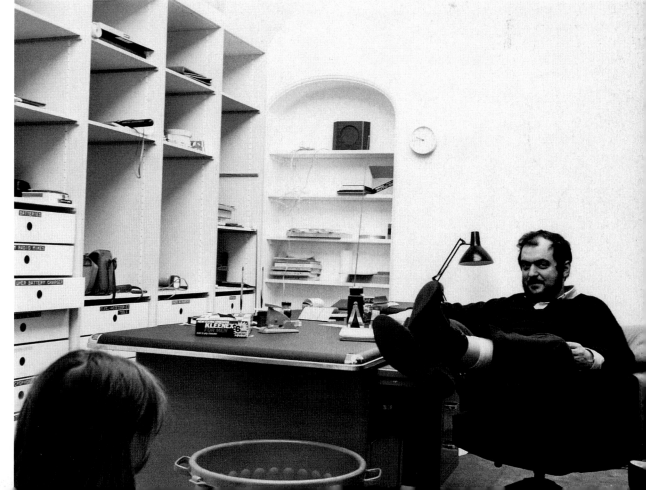

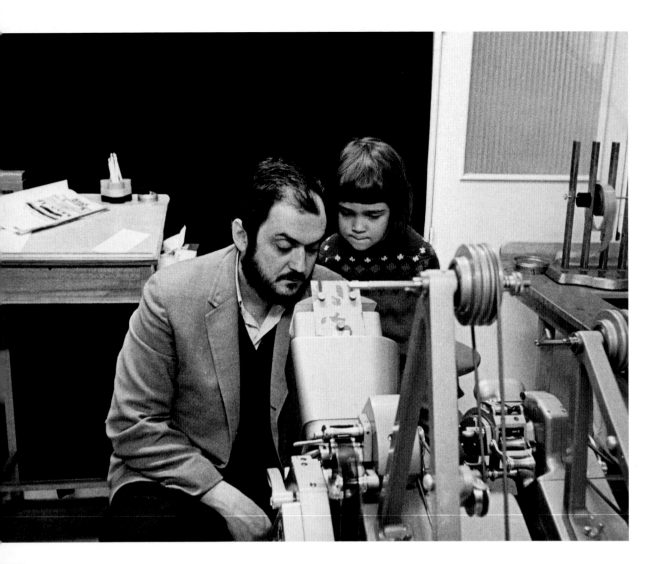

158, 159
The *2001* cutting rooms at MGM
Studios during the post-production
period. Vivian looks on in the top
picture.

The Movieola machine has now
largely been relegated to museums
with the advent of the Avid and
other computer-based editing
systems.

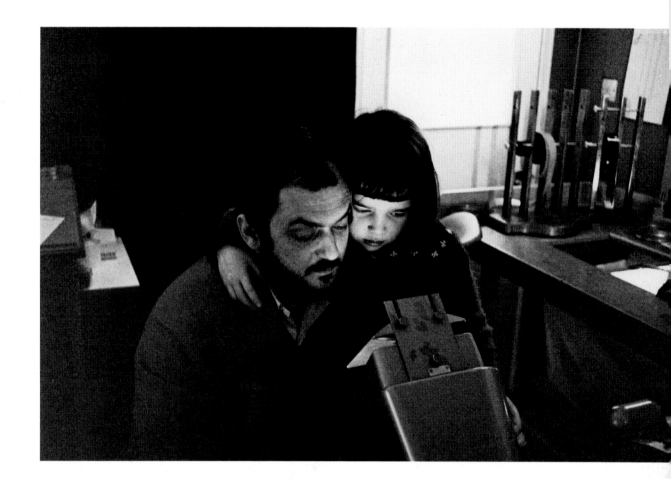

160
Stanley and Vivian illuminated by the light from the Movieola's small viewing screen.

161
We went by ship to New York for the opening of *2001* (Stanley was still cutting the film on board).

The opening of the film started as a disaster and then metamorphosed into a triumph. If you were under thirty you dug the film, and if you were over thirty you came out of the cinema bored and perplexed in equal measure, generally speaking. It was a divisive, generational film.

Here I am with, left to right, Katharina, Anya, and Vivian, photographed by Stanley at the New York shipping terminal waiting to board the *QEII*.

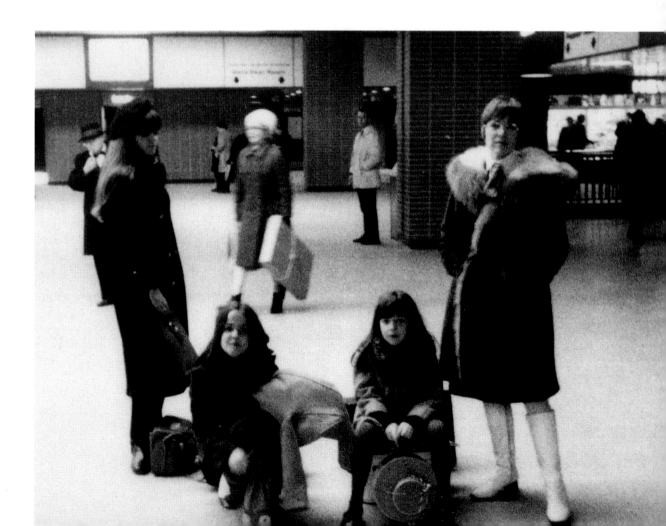

162
A fine portrait of Stanley at the end
of *2001: A Space Odyssey.*

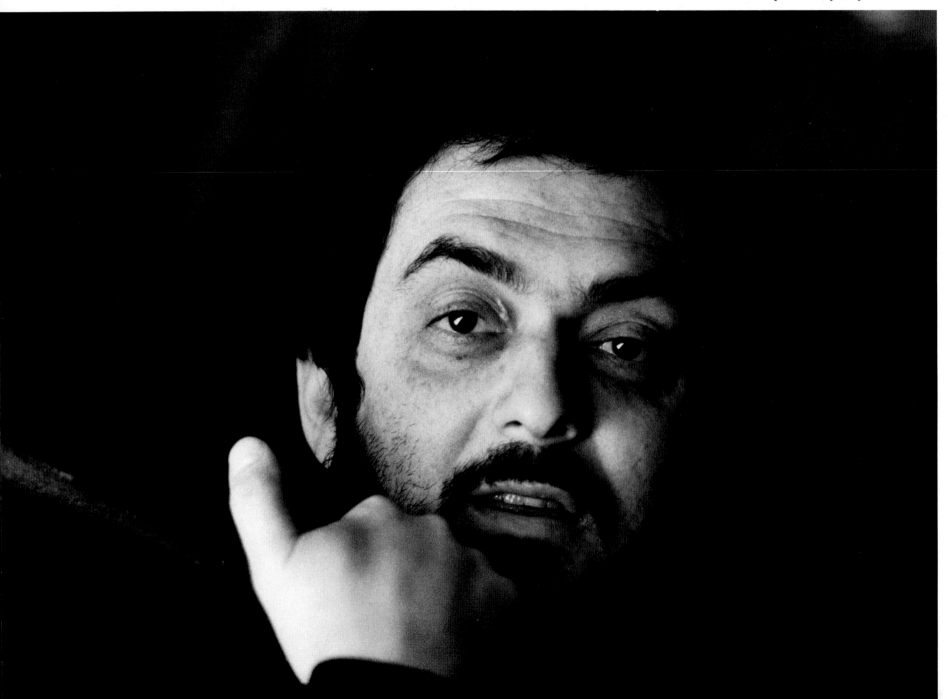

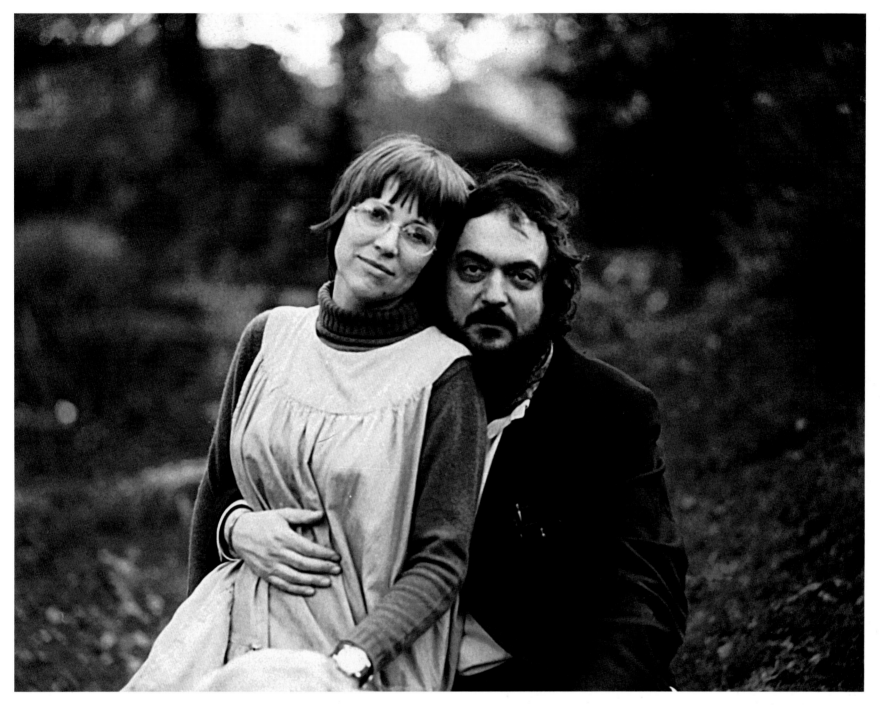

163
I cannot remember who took this
photograph. It could have been my
mother, or my father, or Jan
(Harlan), my brother. But it was
probably one of the children.
 This was just before Stanley
began work on *A Clockwork
Orange*.

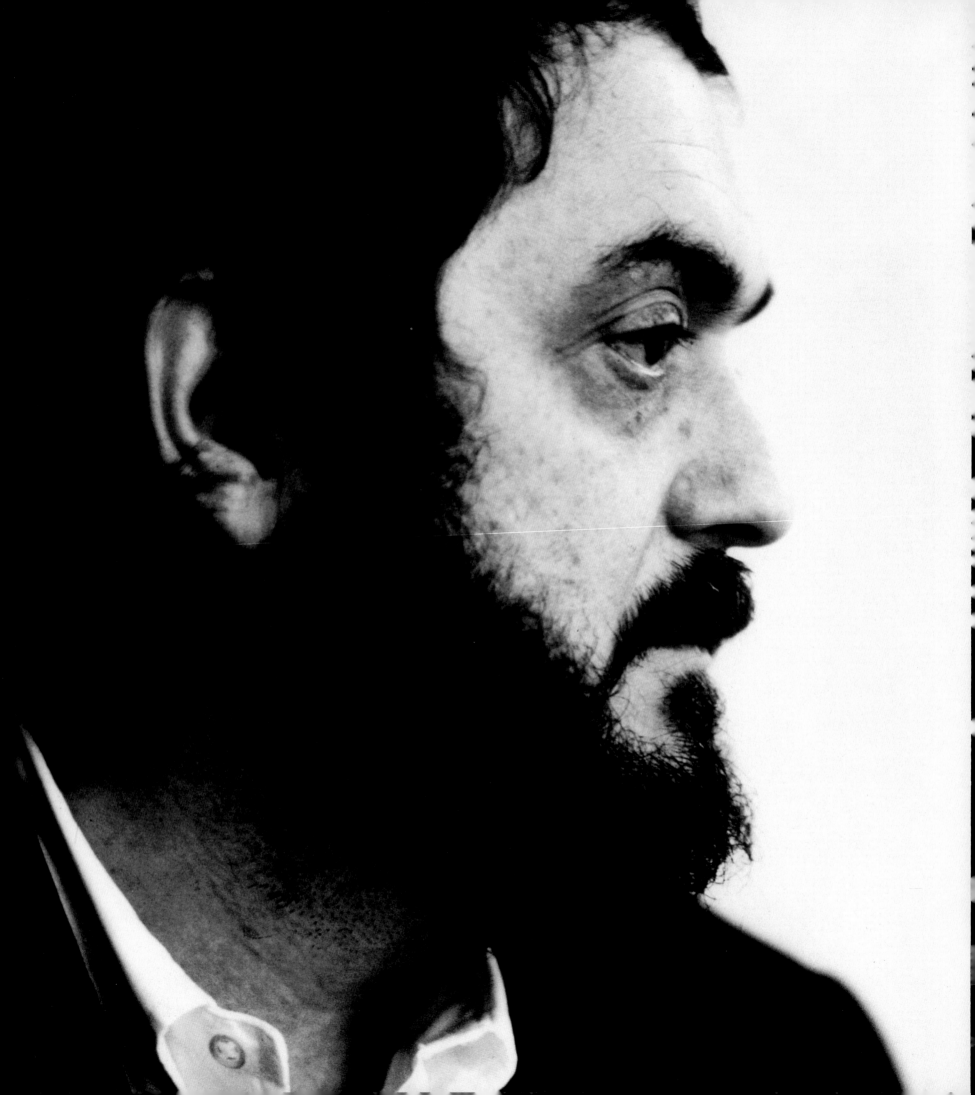

164 *(left)*
Another favourite portrait of
Stanley taken during the filming of
A Clockwork Orange.

165 *(below)*
Warren Clarke (left), who played
Dim in *A Clockwork Orange*, and
Malcolm McDowell as Alex, the
film's protagonist. In the back-
ground is my oil painting
Seedboxes.

166
Stanley would always do his own
hand-held camera work; witness
this picture of him clutching an
Arriflex to his bosom.

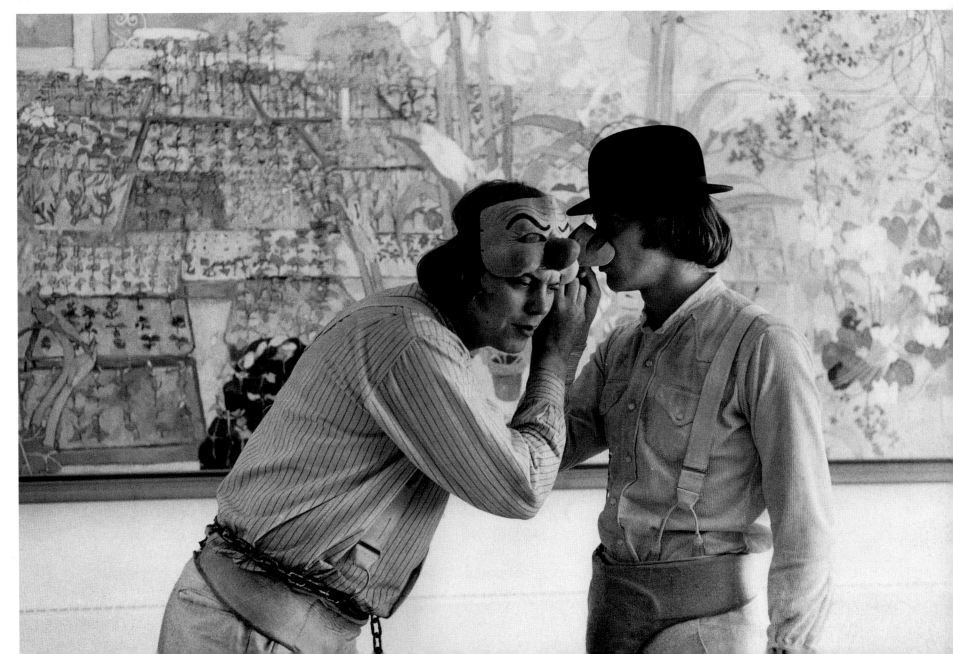

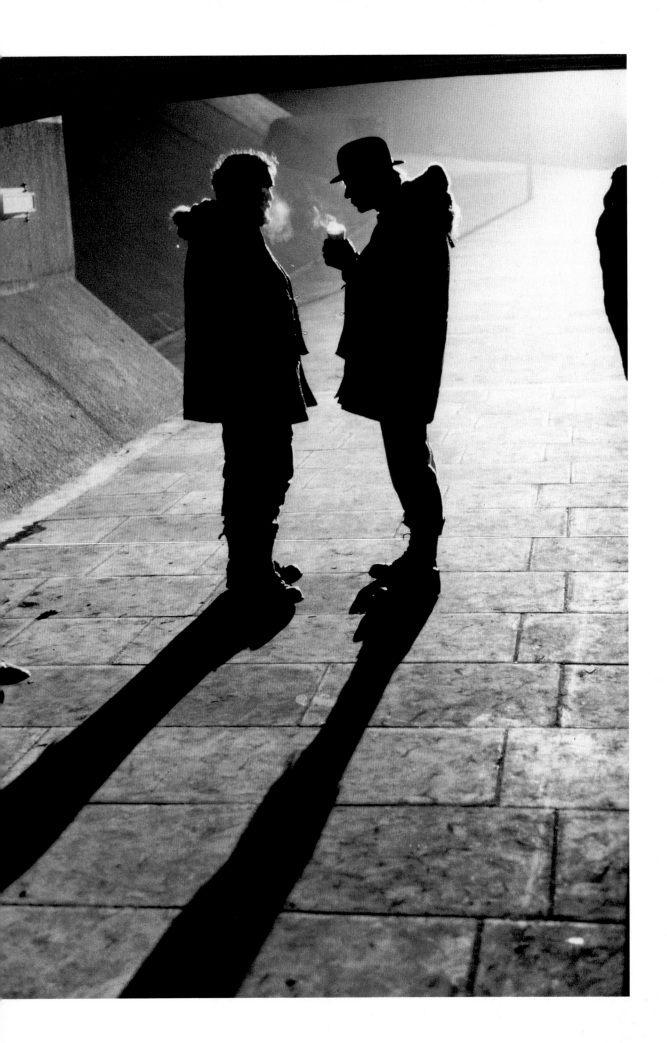

167
A cold night on the Thamesmead estate in East London filming the scene from *A Clockwork Orange* in which Alex and his droogs set about the tramp. This is Stanley with Malcolm McDowell.

168 *(right)*
Filming the 'Cat Lady' scene with the actress Miriam Karlin supine on the floor. Despite Stanley's great love for cats, working with them was very trying.

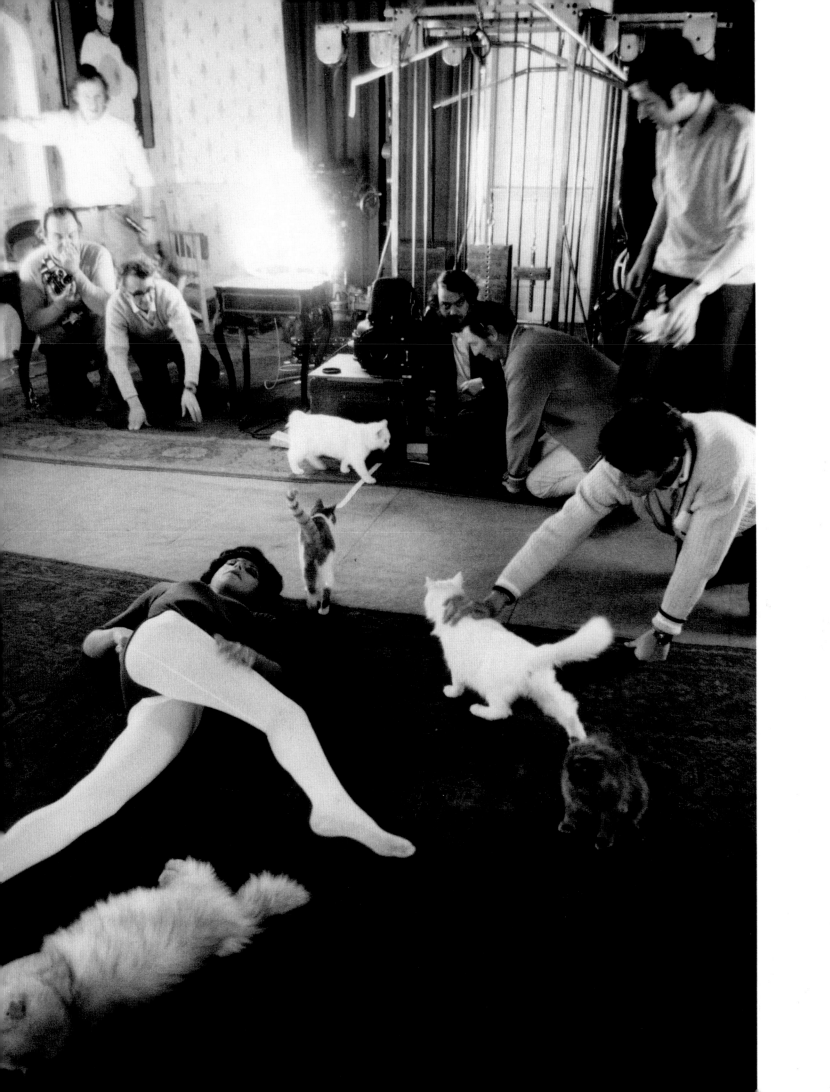

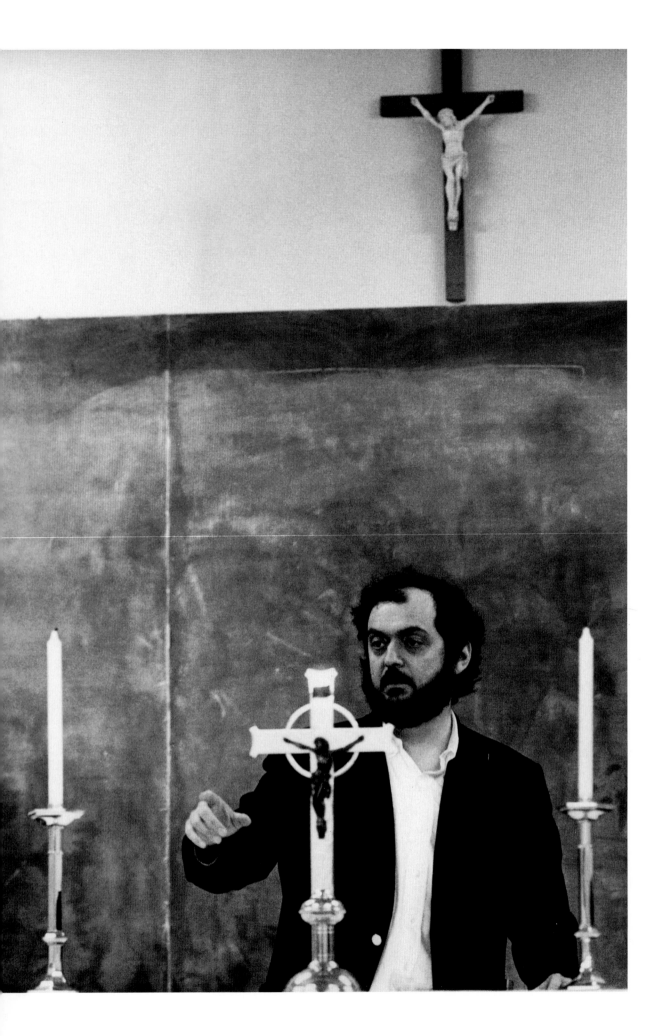

169
This production still from *A Clockwork Orange* has always been very popular in France, where anti-clericalism runs high.

170
Stanley with the 35mm Arriflex and on the left the trusty Polaroid for checking exposures.

171
Stanley shooting the actor Michael Bates, in policeman's uniform, with a hand-held Arriflex. To the left of Stanley is Don Budge, the chief grip, who had also worked on *2001*.

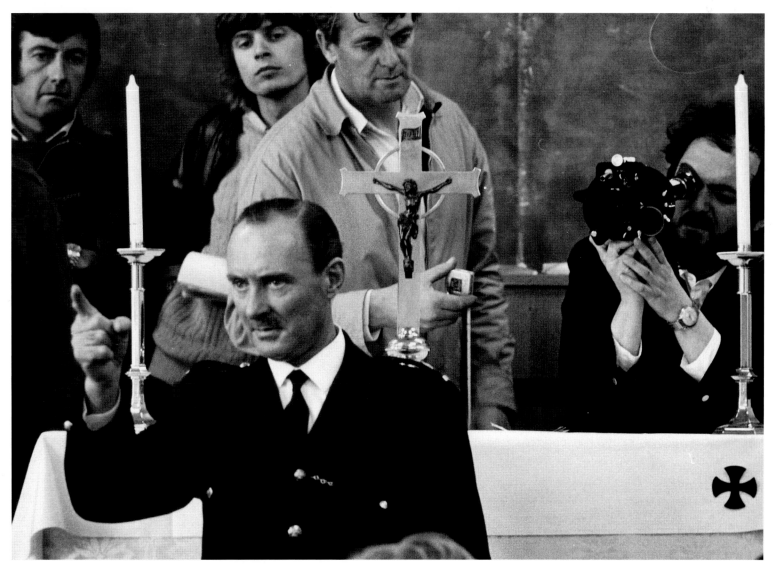

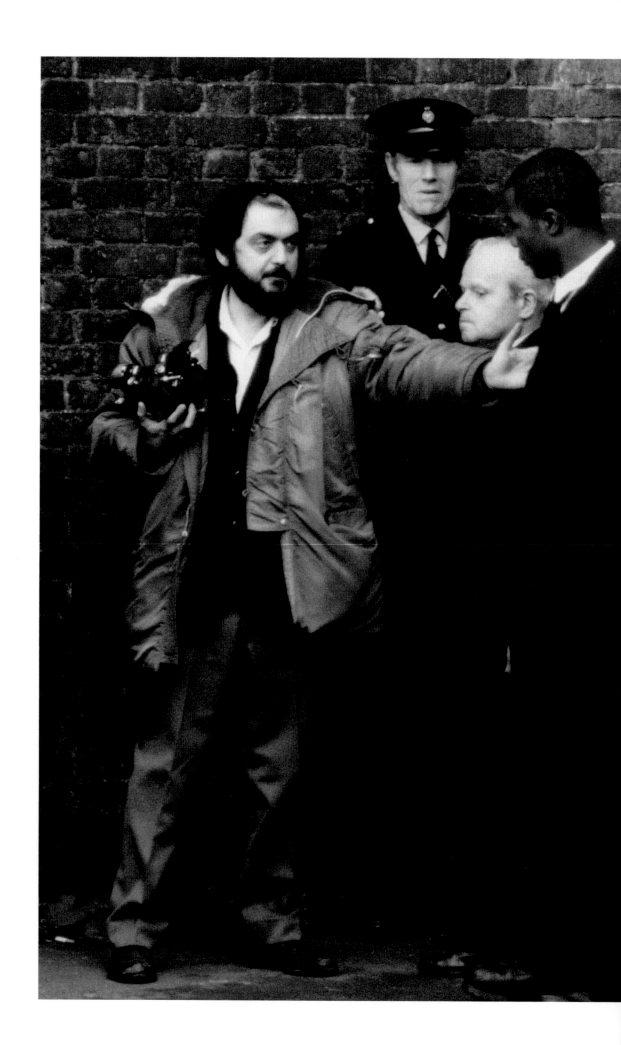

172
This photograph has always
reminded me of one of those prison
engravings by Gustave Doré of the
late nineteenth century. Either that
or a Dutch still life, perhaps. The
faces and stances are frozen in an
almost balletic tableau.

This was taken during filming of
the prison yard sequence in *A
Clockwork Orange.*

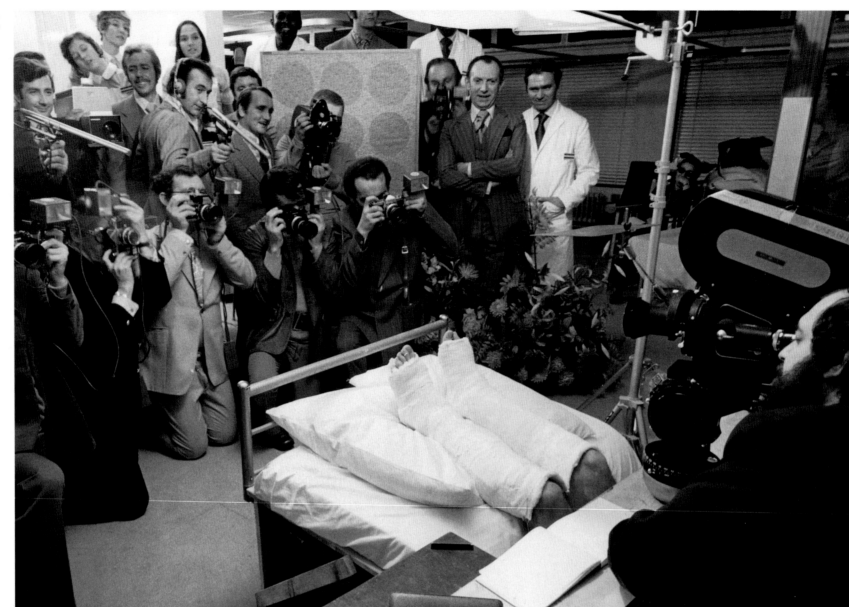

173

A Clockwork Orange was based on Anthony Burgess's novel of the same name and is set in a near future where violence has become endemic. When it was released in England it was blamed unfairly for the increase in crime and there were cries to ban it. We received hate mail and death threats and Stanley responded by withdrawing it from circulation in the United Kingdom, but it continued to play in other countries.

Here, Stanley, behind the Arriflex on the right, is shooting Alex's POV from the hospital bed after his failed suicide attempt jumping from a high window. The press have arrived to publicise Alex's 'cure', and Beethoven's 'glorious' Ninth Symphony blasts out from the speakers.

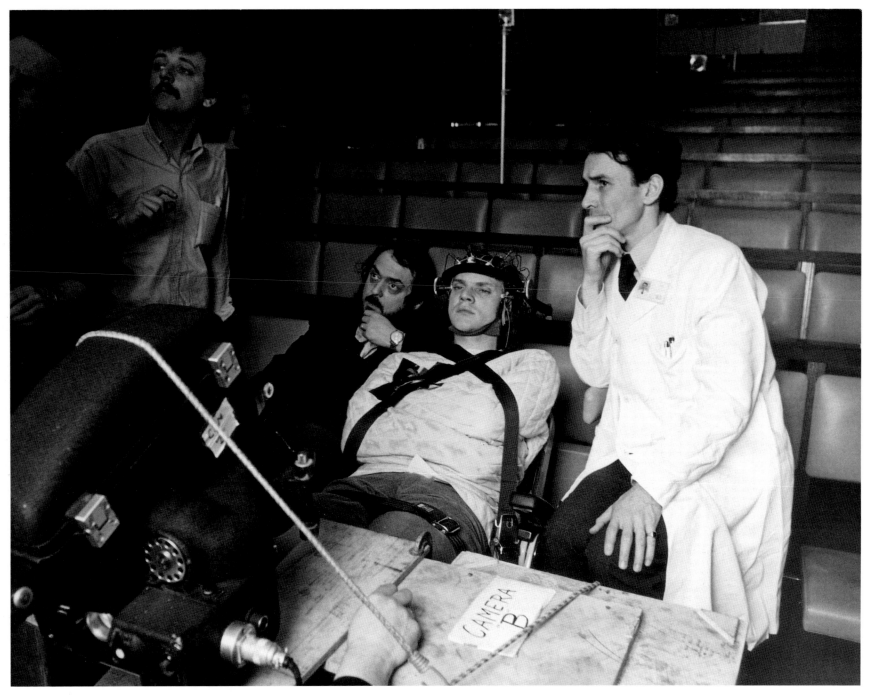

174
Malcolm in a strait-jacket in the aversion therapy sequence. This was a difficult scene to shoot and Malcolm's eyelids were kept open with a device that resembled something from a torture chamber.

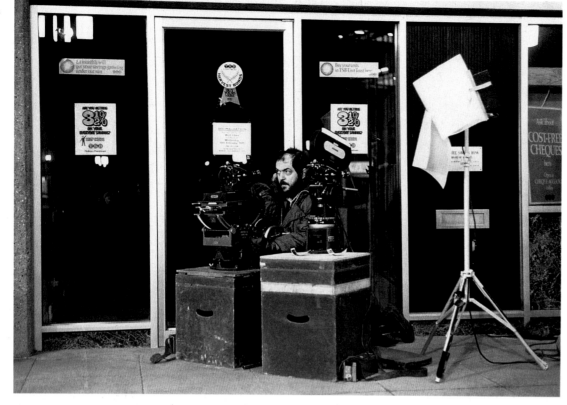

175, 176
One man and his cameras on the set
of *A Clockwork Orange.*

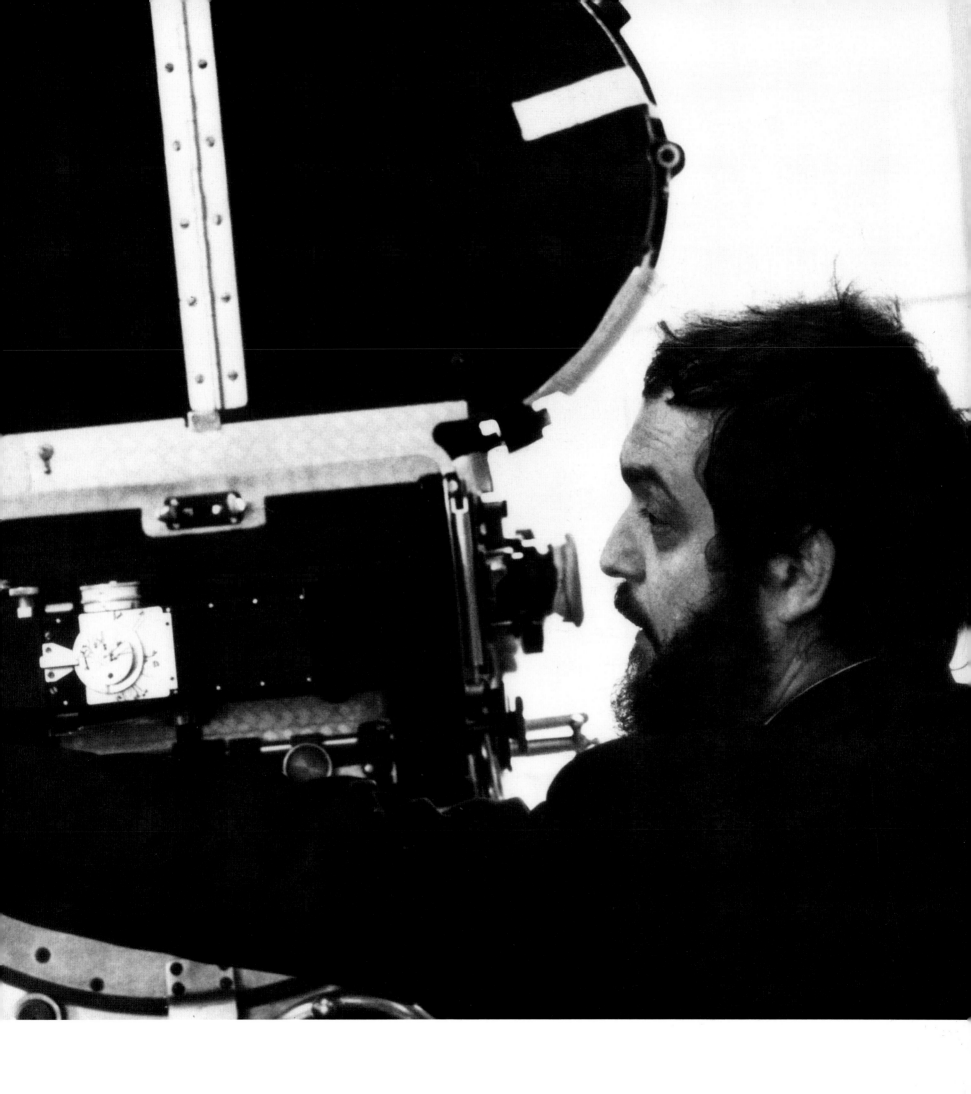

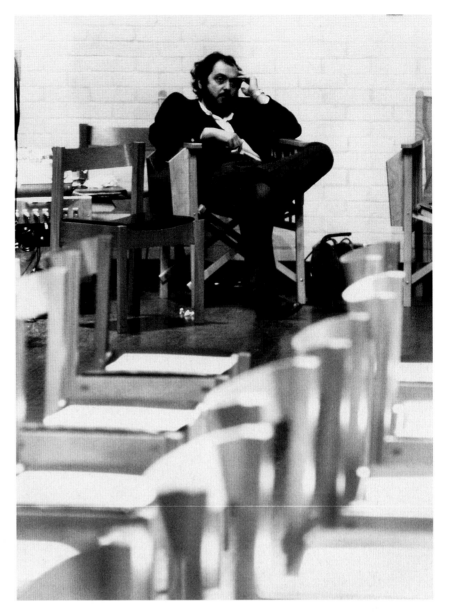

177
Looking resigned but not without hope . . .
This photo was taken in the abandoned theatre where Alex and his droogs encounter Georgie and his gang.

178
Waiting for something – perhaps to go home? Stanley in his characteristic cross-legged position.

179
Freddie the cat on an editing table during the post-production of *A Clockwork Orange*.
 The cats were always a feature of post-production. Stanley felt he should make up the time that he had lost with them during filming.

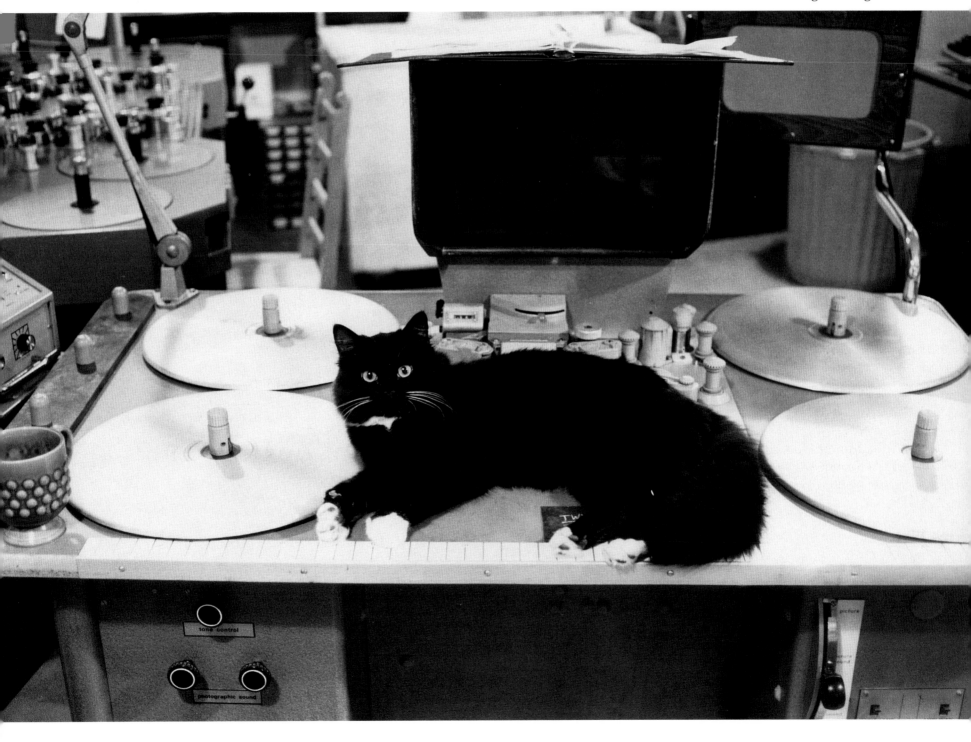

180, 181

Barry Lyndon, released in 1975, was based on Thackeray's novel, *The Memoirs of Barry Lyndon, Esq.*, and recounts the misadventures of Redmond Barry (aka Barry Lyndon), played by Ryan O'Neal, an enterprising young Irishman without scruples who is out to better himself, whatever the cost.

Two shots of Stanley with Ryan O'Neal. In the lower picture Ryan is refreshing himself with oxygen. A resigned look from the Master.
[181 – Jan Harlan]

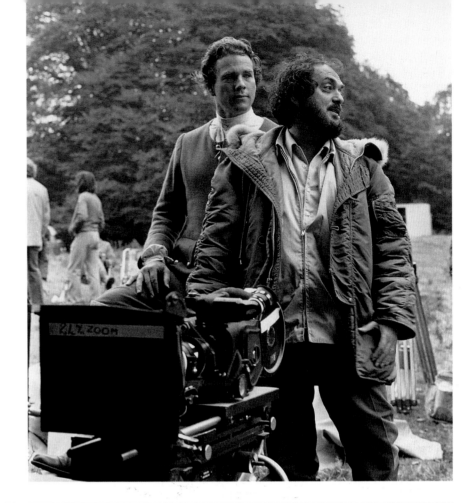

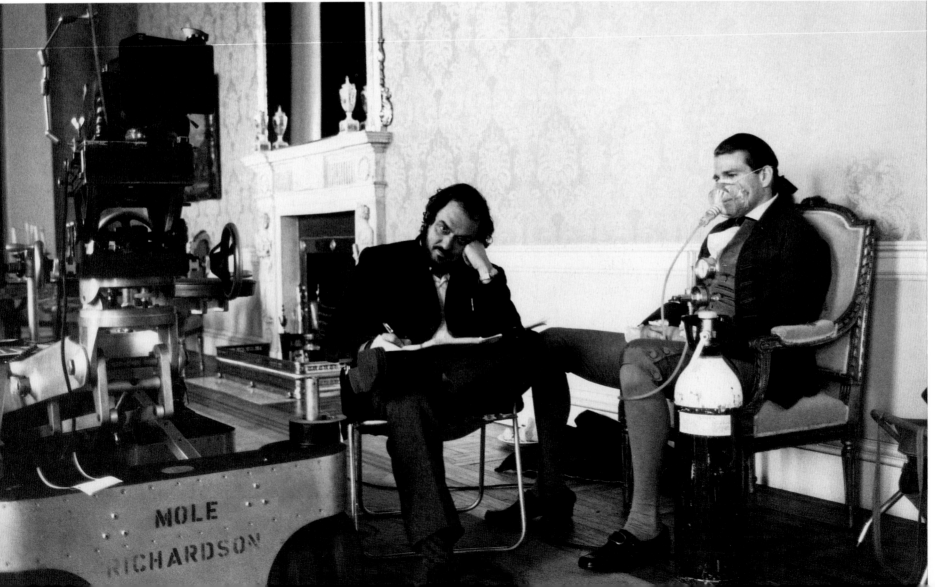

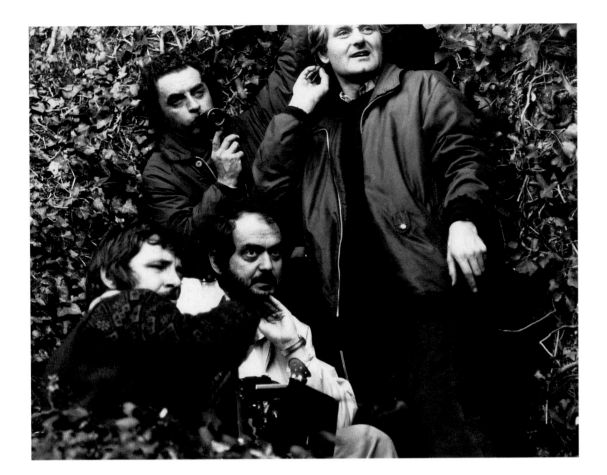

182
Stanley with the camera team.
Above him to the left is John Alcott,
and to the right, Doug Milsome,
now a lighting cameraman but then
a focus puller.

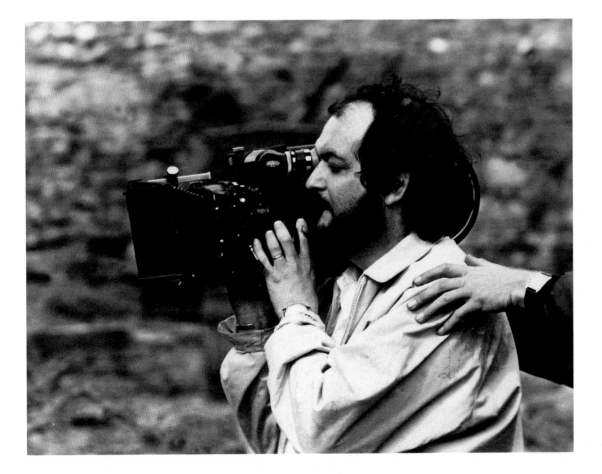

183
Somebody lends a steadying hand
to Stanley on what must have been
a tricky hand-held shot.

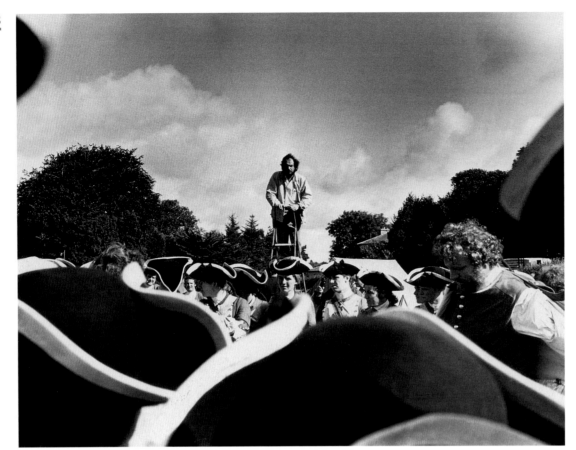

184, 185
Stanley choreographing then film-
ing the famous fight sequence in
Barry Lyndon between Ryan and the
much bigger Pat Roach.

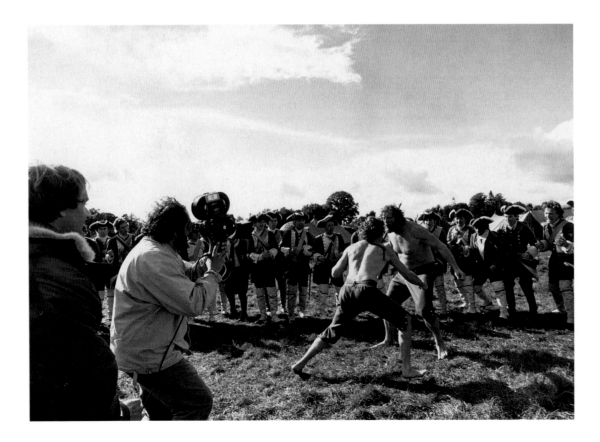

186
Gay Hamilton, who plays Nora Brady, appears to decline the drink Stanley is offering her. On her left is Captain Quin, who was played by Leonard Rossiter (his second appearance in one of Stanley's films; earlier he had been in *2001: A Space Odyssey*).

The young girl on the far left in period costume is a young Vivian.

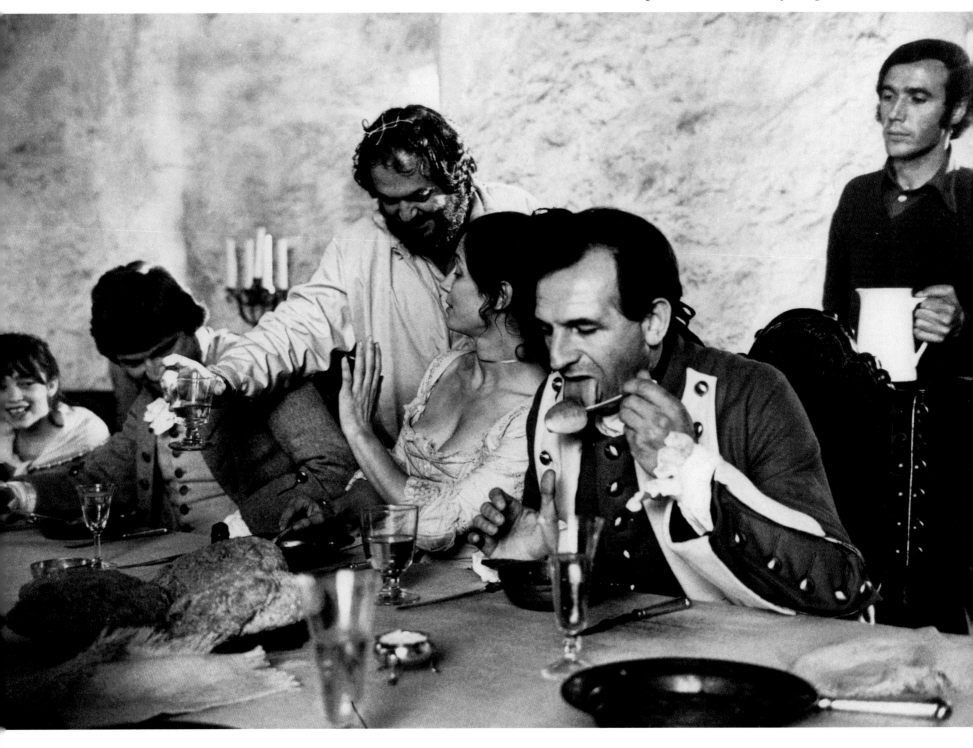

187
Much of *Barry Lyndon* was shot in
Ireland in dozens of different loca-
tions. We travelled about the
country like a band of strolling
players in the Middle Ages. Here I
am on the left with my 1970s crop
haircut waiting patiently as Stanley
gets increasingly impatient with a
camera set-up.

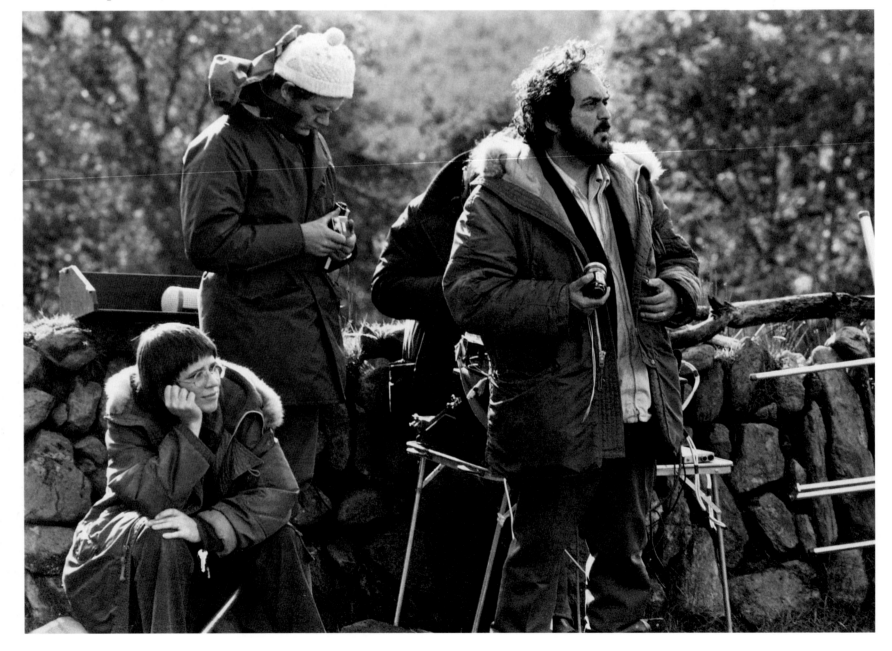

188 *(left)*
The duel scene in *Barry Lyndon* between the young Lord Bullingdon (Leon Vitali) and Redmond Barry was shot in a stone tithe barn in Glastonbury, Somerset.

The rafters of the barn were teeming with pigeons, and their droppings fell fast and furiously, so it was prudent to wear a hat at all times.

189
For the post-production work on *Barry Lyndon* Stanley turned one of our garages at Abbott's Mead into a cutting room.

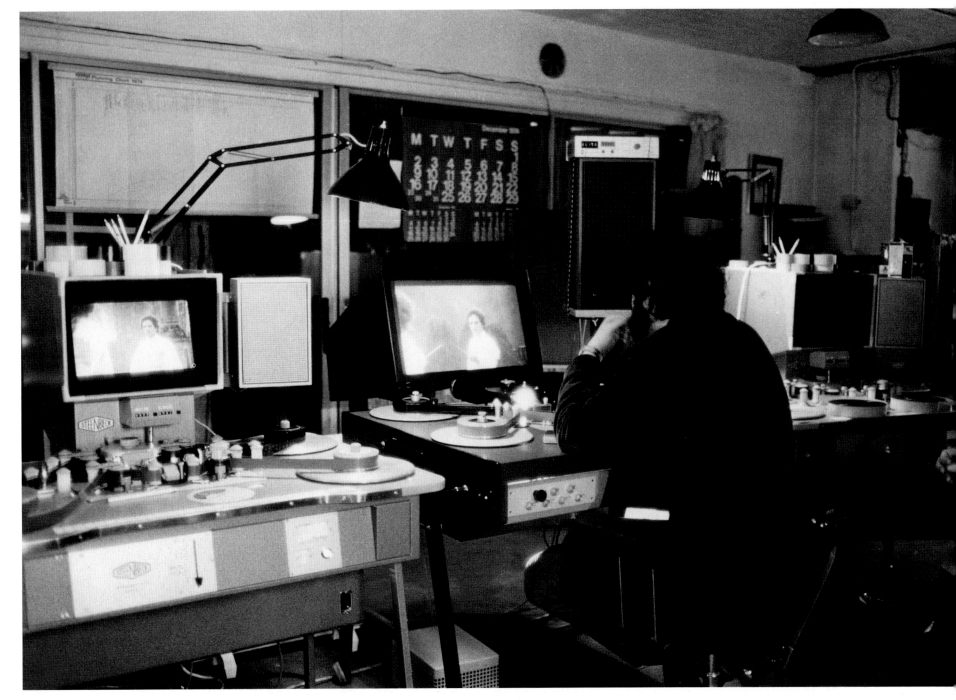

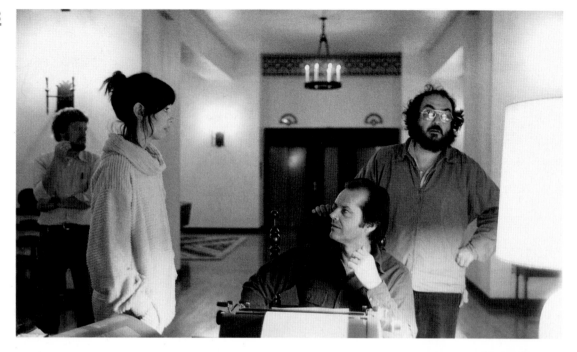

190

The Shining (1980) was based upon Stephen King's best-selling novel of the same title and was shot entirely at EMI Studios in Boreham Wood (the former ABPC Studios), aside from some second unit exteriors in Colorado and Oregon.

Here Shelley Duvall and Jack Nicholson are in the vast Overlook Hotel set that was built 'wall to wall' in the studios' largest stage.

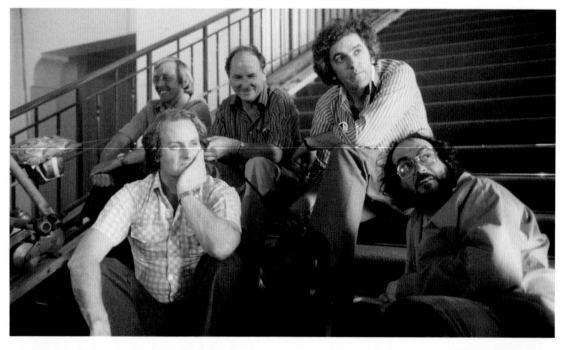

191

On the steps in the Overlook lobby. Behind Stanley is Brian Cook, the assistant director. In the left foreground is Doug Milsome, the focus puller.

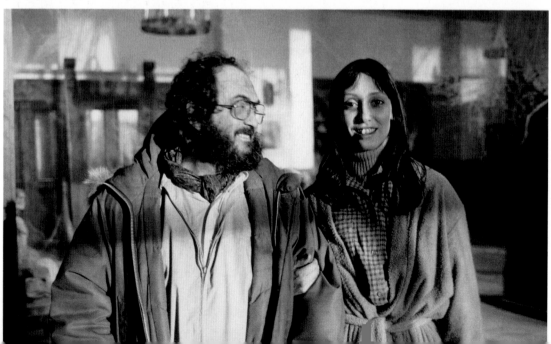

192

Stanley and Shelley Duvall on the set. They had a good working relationship and Stanley was delighted with Shelley's performance in this very demanding and difficult role.

193
In addition to making a documentary about the making of *The Shining*, Vivian also appeared in period costume as a crowd extra. Here she is with Jack Nicholson in the vast ballroom set.

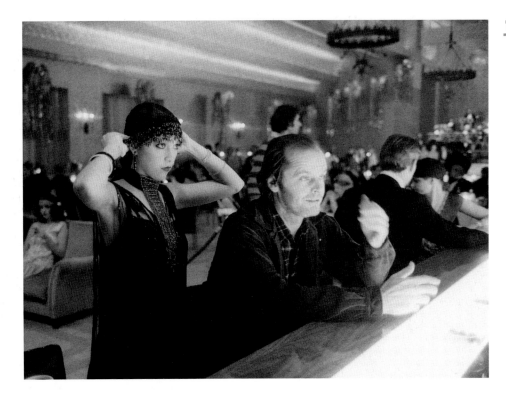

194
Anxious moments viewing rushes on the video playback system. Vivian, again, stands between Stanley and Jack.

Behind Jack to the right is Garrett Brown with his Steadicam mount, an innovatory device for stabilising hand-held shots. Stanley appreciated its importance right away and *The Shining* was the very first feature film to use it throughout shooting.

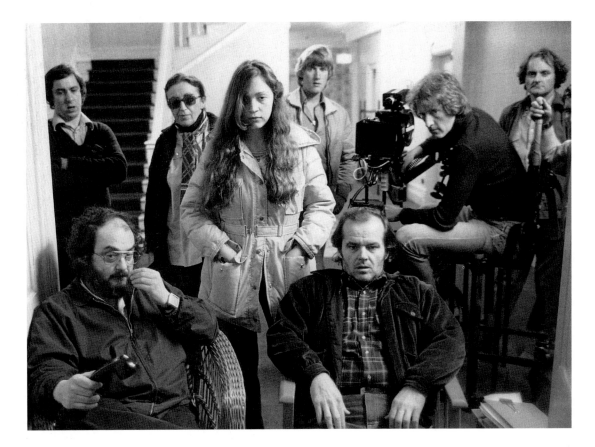

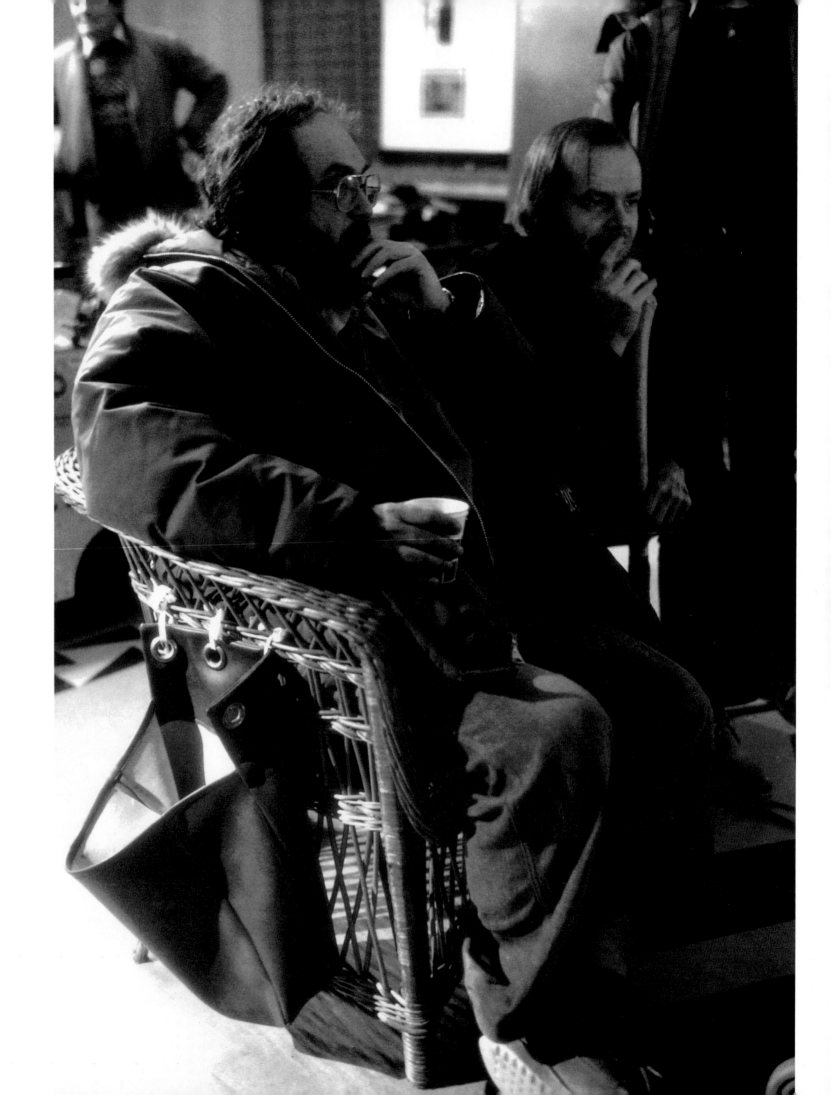

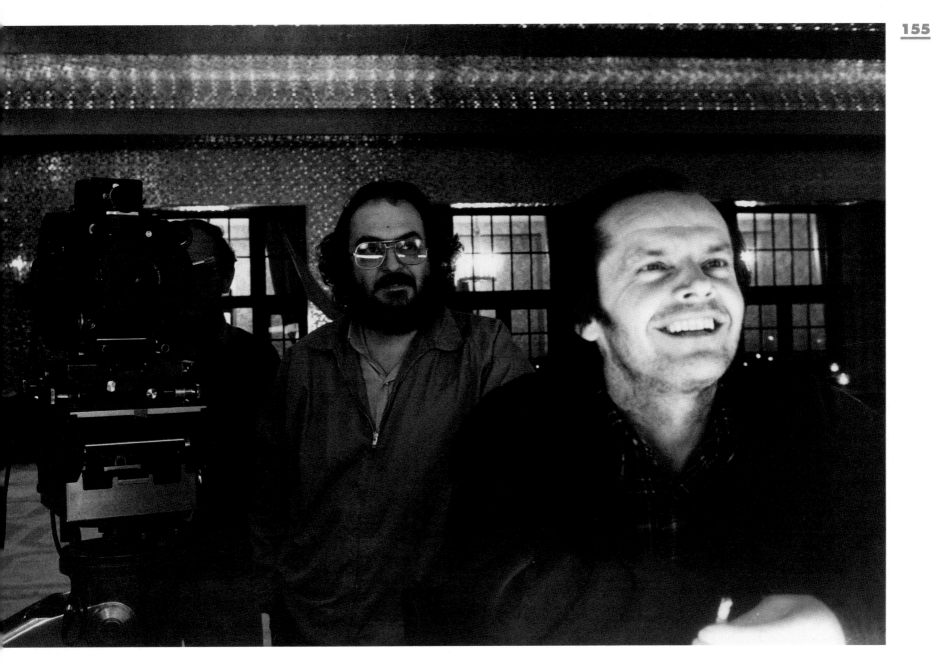

195, 196
Two shots of Stanley and Jack. The
one on the left has always been one
of my favourites.

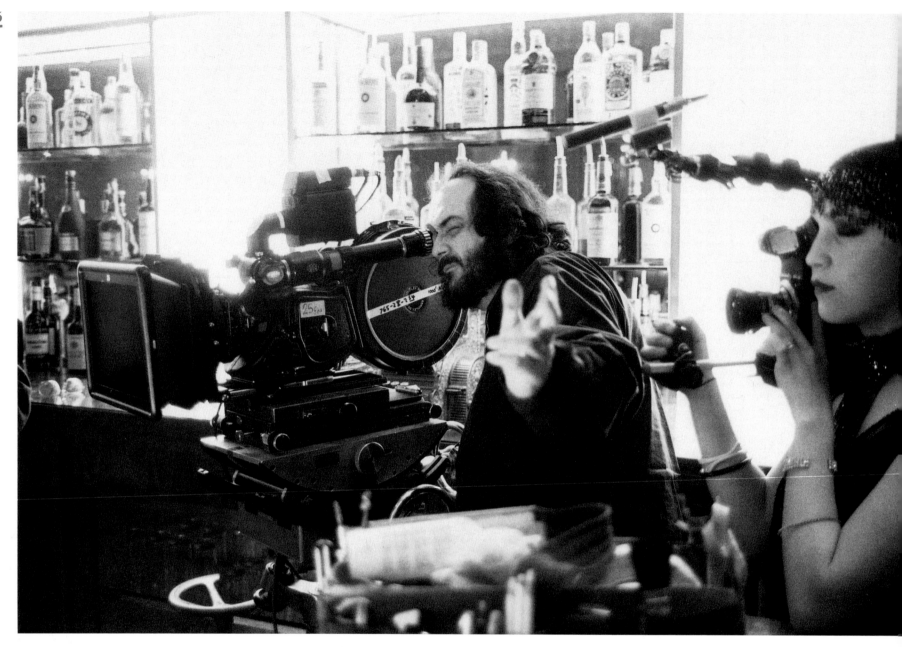

197
Father and daughter behind the
cameras in the ballroom set: Stanley
with his 35mm Arriflex and Vivian
with her 16mm Aaton.

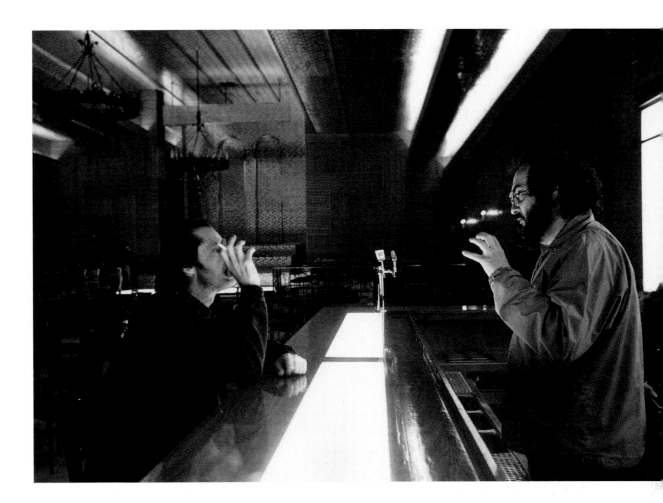

198
Stanley discussing a scene with Jack prior to shooting.

199
The discussions continue. In the foreground is the model of the maze made by the art department that was the basis for the large set in which the film's final scenes take place.

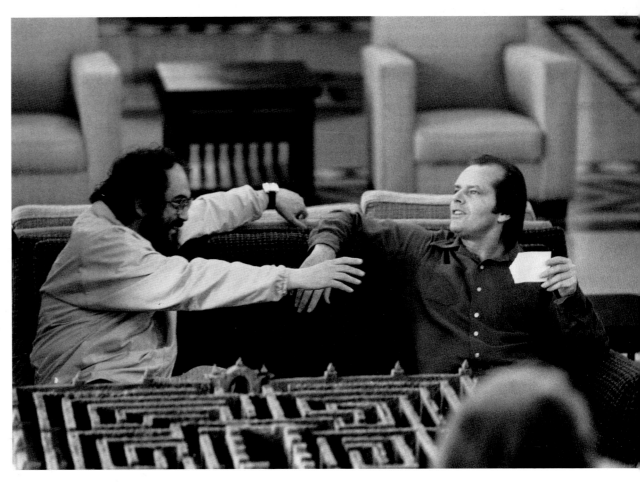

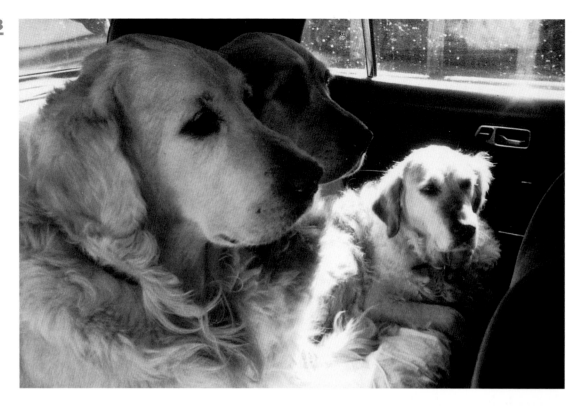

200
Our very spoiled golden retrievers: left to right, Phoebe, the mother, Teddy, and Lola.

Stanley has ushered them into the back of his car for a trip from Abbott's Mead in Elstree up to the house we eventually bought near St Albans.

201
Journey's end and nobody seems enthusiastic about getting out.

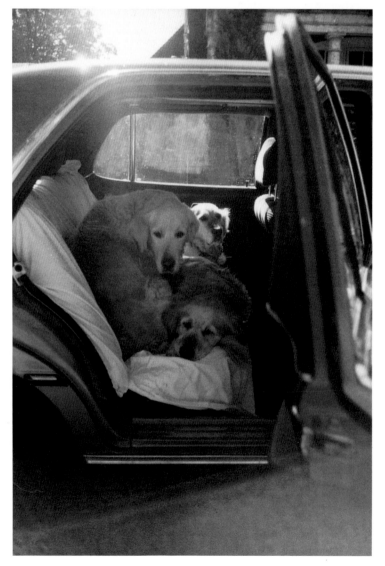

202, 203
Stanley in the maze set with Garrett
Brown and the Steadicam harness.
On the right, Danny Lloyd, the
gifted child actor who played the
son of Jack and Shelley in the film.

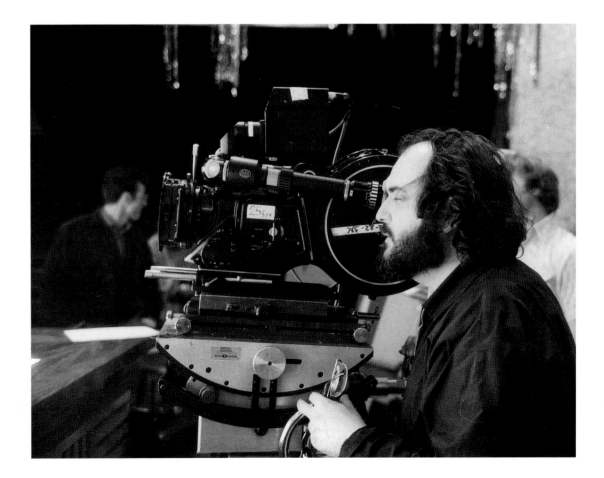

204 *(right)*
Lining up a shot on *The Shining*.

205

Full Metal Jacket, Stanley's film set during the Vietnam war, was released in 1987.

Other film-makers might have found it daunting to contemplate shooting a Vietnam film in England, but Stanley saw it as an interesting challenge.

One of the lucky location breaks on the film was finding the enormous and derelict Beckton gasworks in East London. It looked a war-ravaged scene even before Stanley started 'dressing' it as the city of Hué.

This is Stanley at Beckton with Matthew Modine who played Sgt Joker, the film's central character.

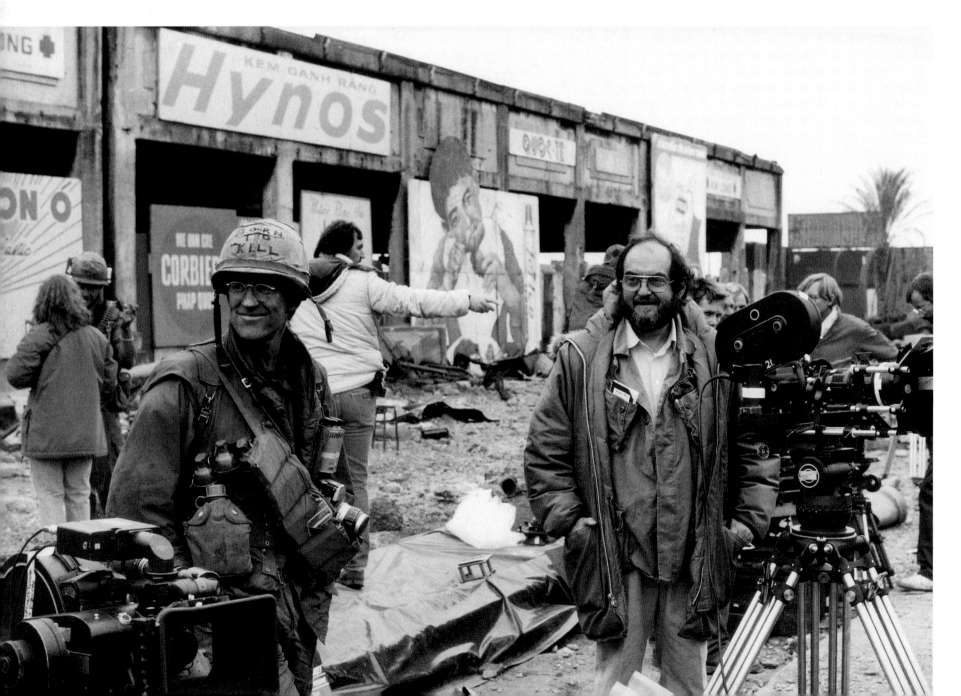

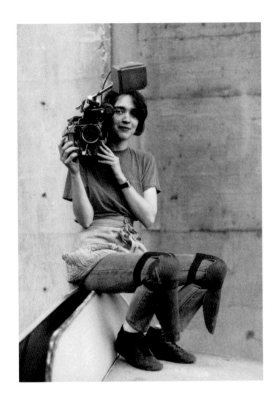

206, 207
After the success of Vivian's documentary about *The Shining*, she decided to make one about the shooting of *Full Metal Jacket*, but it was never completed, though some of the footage she shot was used in *Stanley Kubrick: A Life in Pictures*.

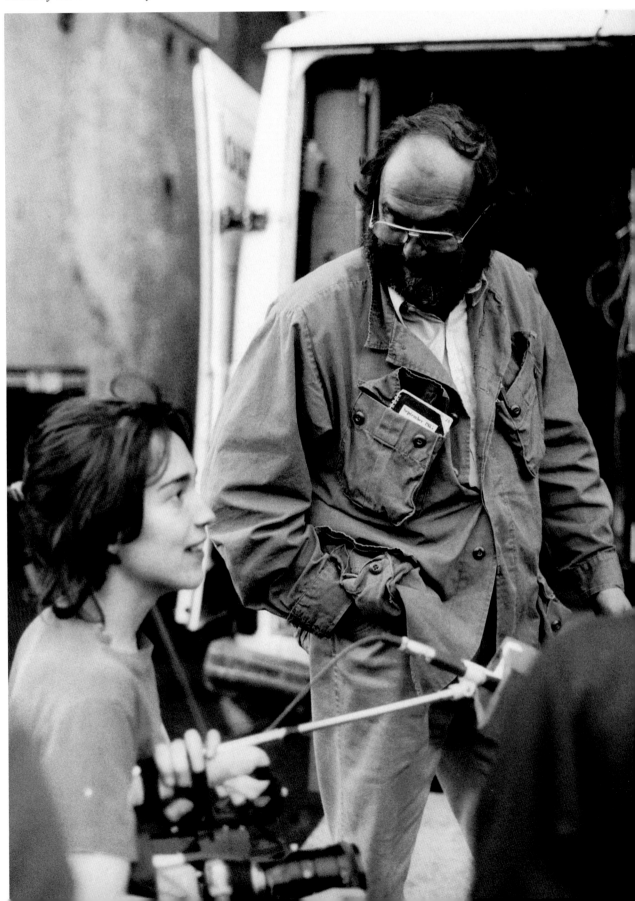

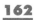

209 *(right)*
At Beckton. The troubled Lord of
All He Surveys.

208
Checking a take on the video play-
back system at Beckton. Doug
Milsome is on the left and Manuel
Harlan, my nephew, on the right.

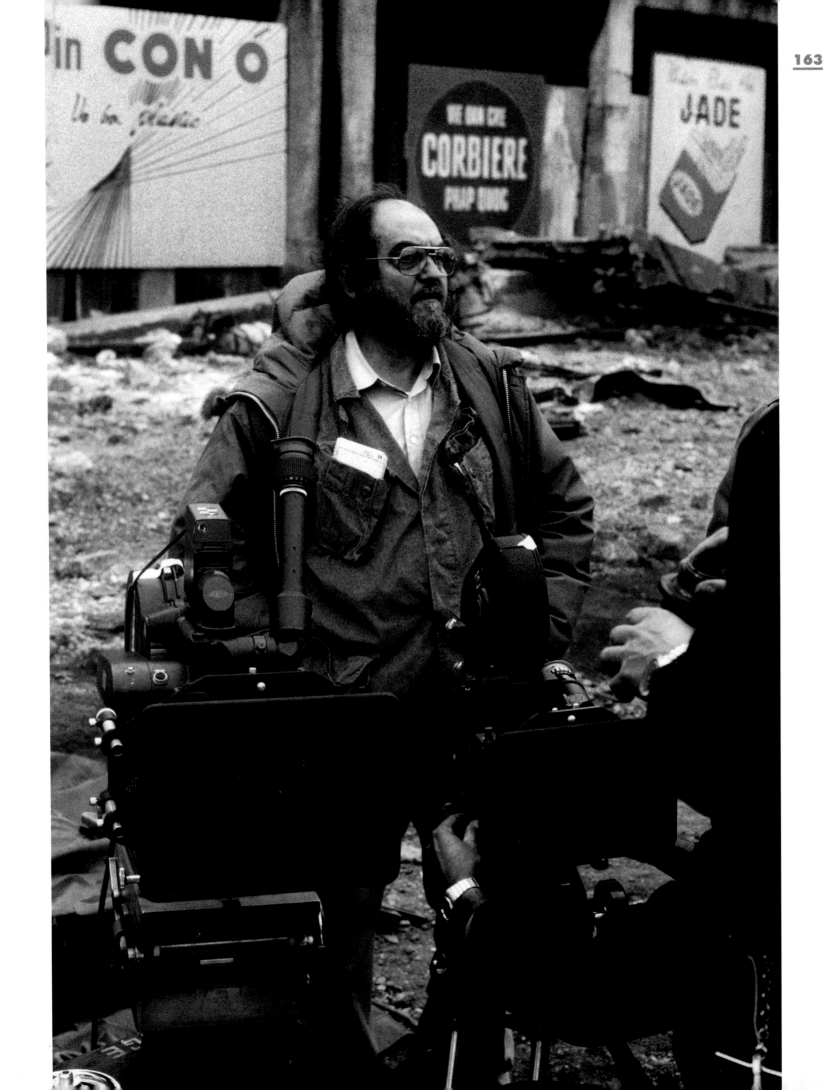

210
The street to street fighting in Hué,
or rather, Beckton gasworks.

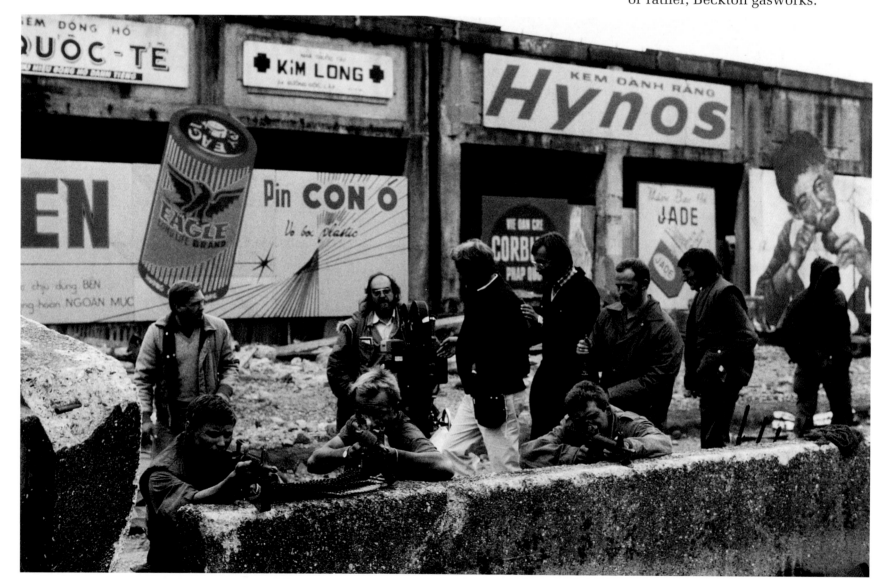

211
With Anya, far right, at Beckton.
The goggles and mask Stanley sports were not to protect against the special effects explosions and rifle fire, but the pernicious dust of Beckton itself, a site saturated with over a hundred years of toxic by-products. The place also had a most dreadful smell, and the fine, black dust permeated everything. Stanley would arrive home looking like a coal miner.

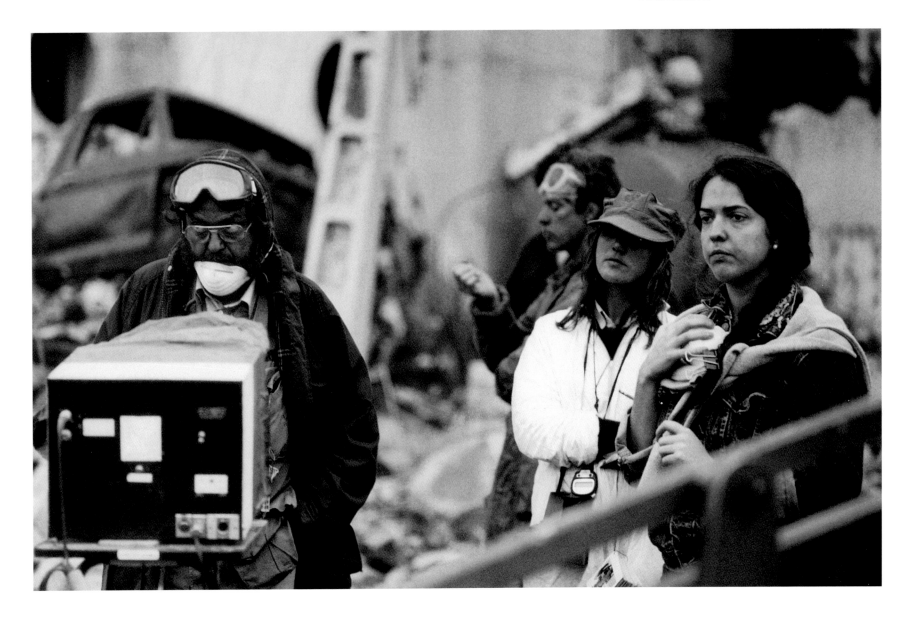

212
With Matthew Modine again.
 Matthew played a Marine combat photographer in the film and was a keen photographer himself. In fact he took the very last picture in this book, No. 233.

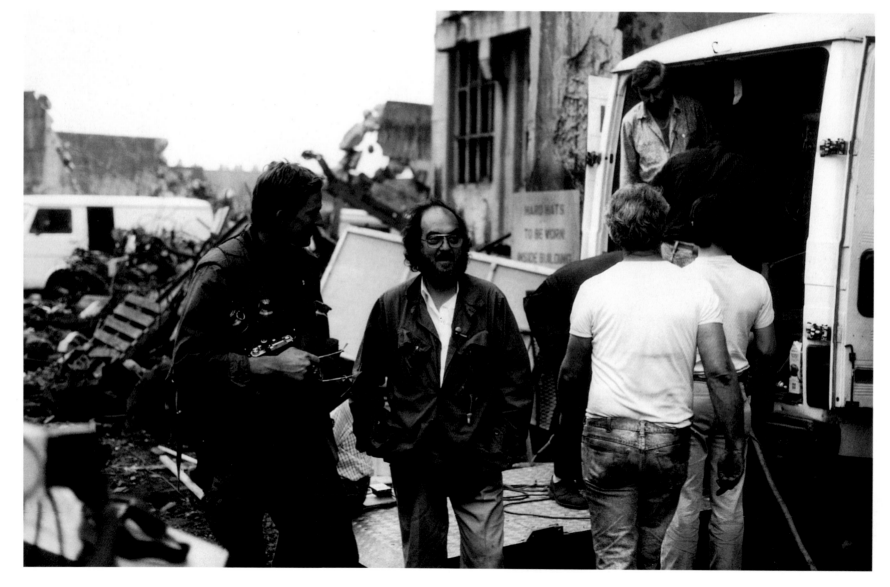

213
'I'm going home. I've had enough.'
 Stanley wanders off into the
dust-strewn sunset at the Beckton
gasworks. The palm trees had been
'root balled' and brought over from
Spain to dress the set.

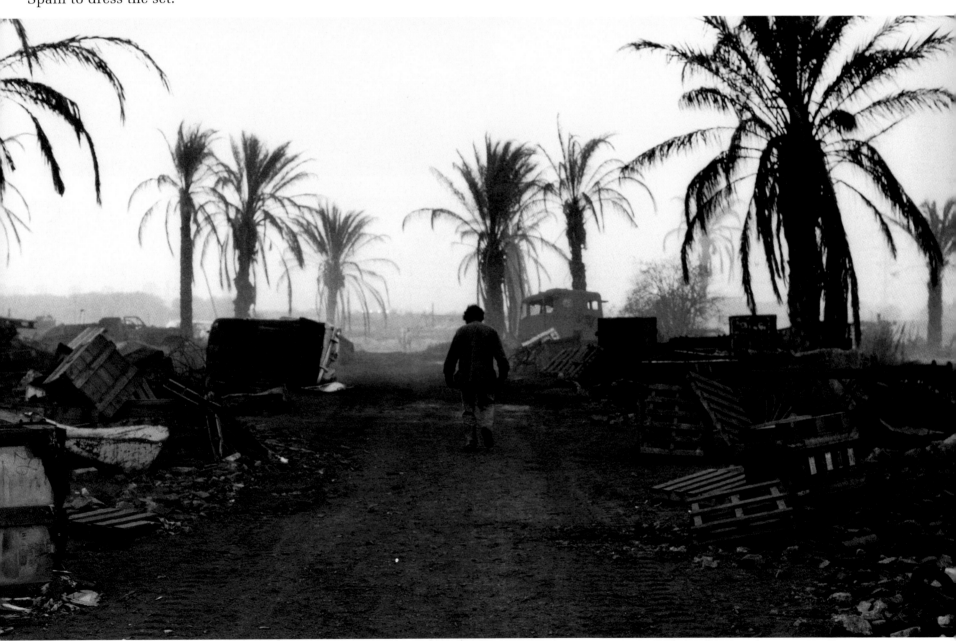

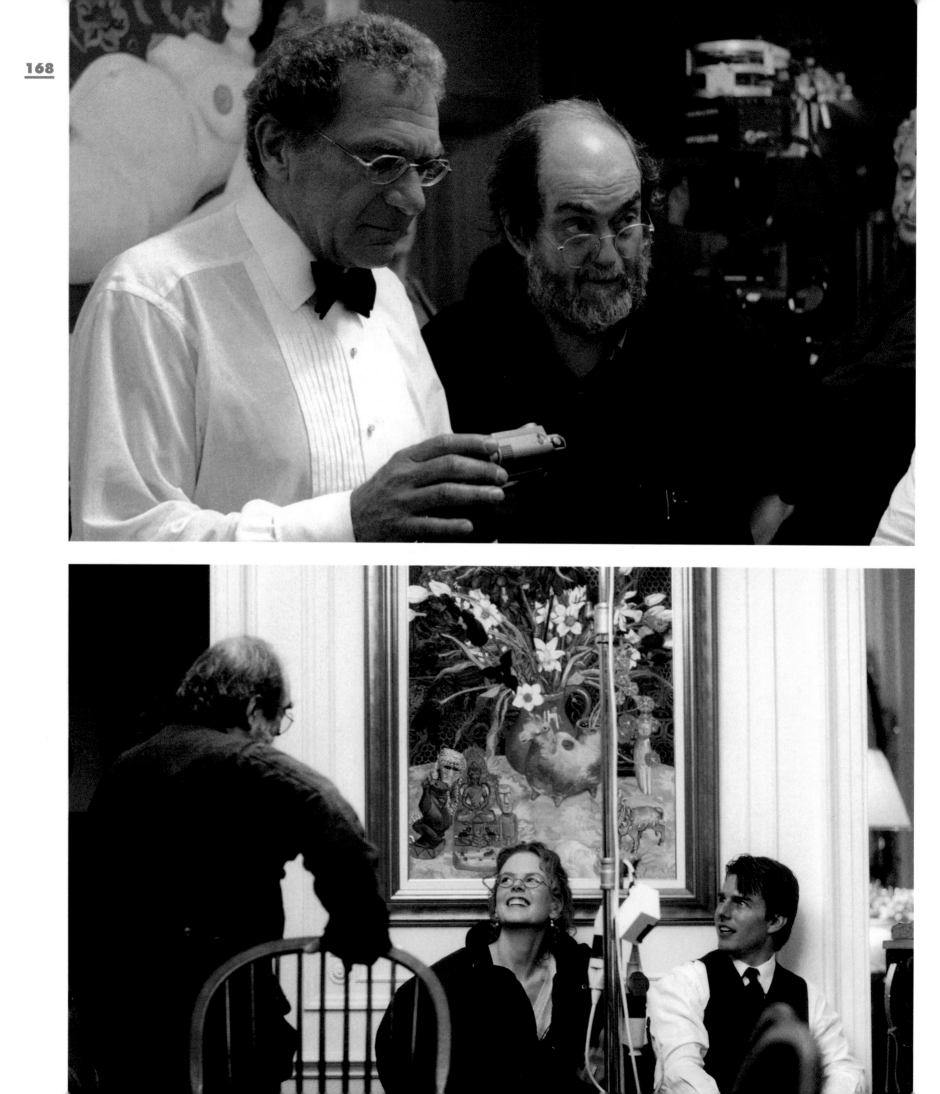

214 *(left)*
Eyes Wide Shut began as a novella by Arthur Schnitzler, the rights of which Jan, my brother and Stanley's associate producer, had purchased in the early 1970s.

Stanley worked on the script on and off between other projects for many years. It was a story of love and marriage – subjects on which we are all experts, or like to think we are.

Here, Stanley is on the set with Sydney Pollack, the fellow film director (*Jeremiah Johnson, Tootsie*, and many more) and actor, who played the role of Victor Ziegler, the member of a clandestine society whose secret meeting Tom Cruise, as Bill Harford, gatecrashes.
[Manuel Harlan]

215 *(left)*
Nicole Kidman and Tom Cruise played Mrs and Dr Harford, and here they are seen in the large set of their apartment that was built at Pinewood Studios. In the background is my oil painting *Presents from Tourists*, one of many Stanley used to dress the set.
[Manuel Harlan]

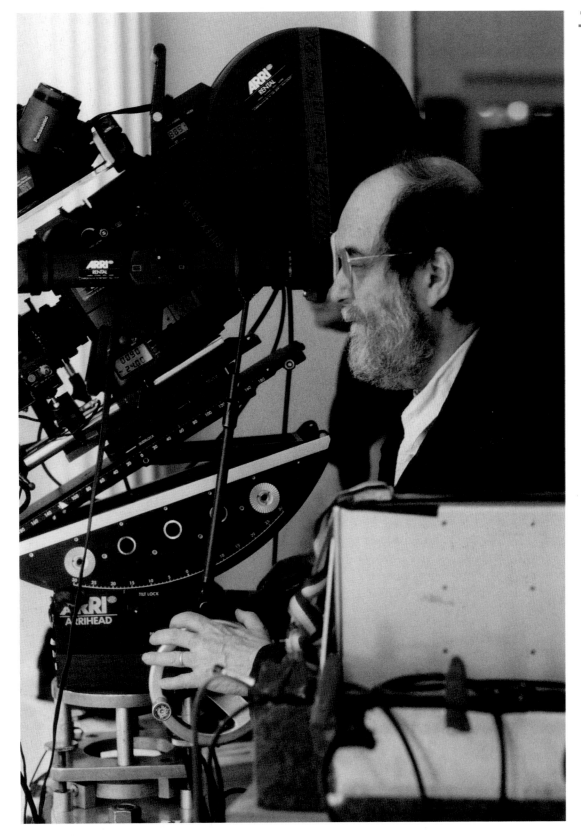

216
One of my favourite photographs of Stanley behind the camera, taken by my nephew, Manuel.

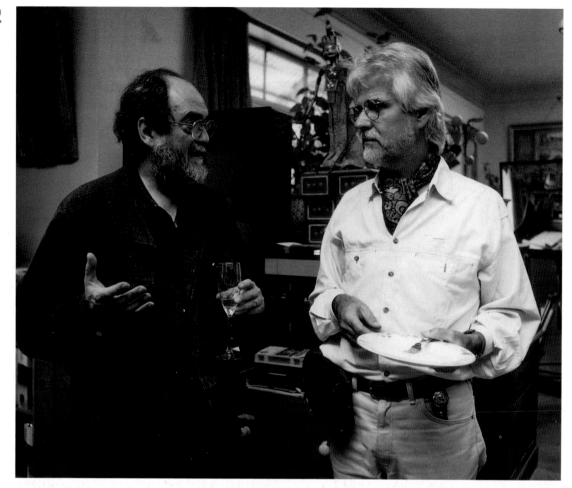

217 *(left)*
Stanley with my brother, Jan Harlan, who served as associate and executive producer on all of Stanley's films from the early 1970s onwards. I took this photo in our kitchen.

218 *(below)*
Tom Cruise and Stanley pondering on the set at Pinewood.
[Manuel Harlan]

219
Sharing a joke with Tom and Nicole
between takes at Hamley's, the toy
store on Regent Street in London,
where the final scene of *Eyes Wide
Shut* was shot (it depped as a New
York store).
[Manuel Harlan]

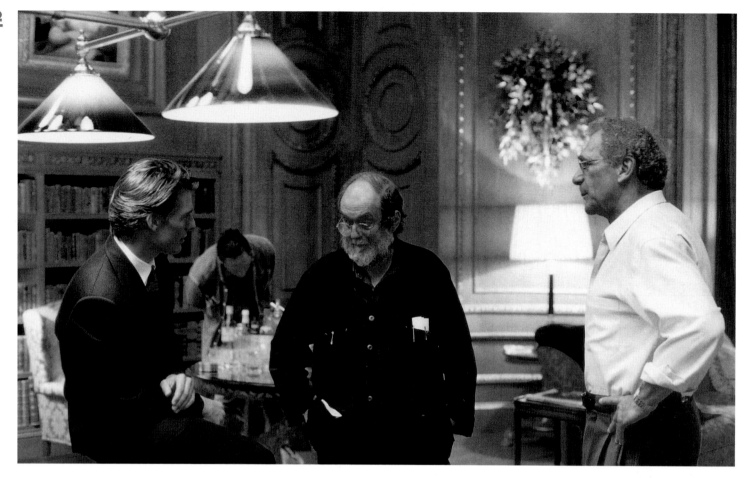

220
With Tom and Sydney in the
billiard room scene, shot on a stage
at Pinewood Studios.
[Manuel Harlan]

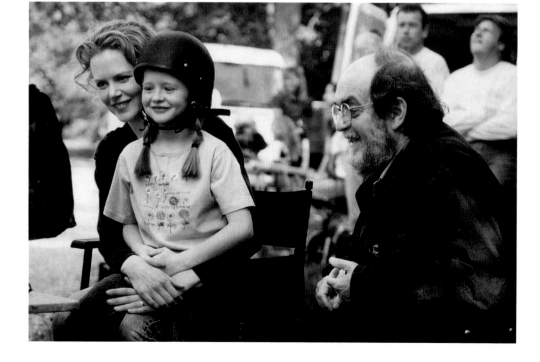

221
Stanley at Pinewood Studios with
Nicole and young Madison Eginton,
who plays Nicole's daughter in the
film.
[Manuel Harlan]

222, 223, 224

Stanley had always admired the British science fiction writer Brian Aldiss, and in 1982 he acquired the film rights of Aldiss's short story, 'Super-Toys Last All Summer Long', which is set in the future and is about a little boy who does not want to acknowledge that he is a robot, and the human parents who adopt him.

The poignancy of the tale appealed greatly to Stanley, as did the underlying currents of artificial intelligence and what constitutes a sentient 'being'.

Stanley worked on adapting the short story for the screen intermittently over several years and even engaged several science fiction writers to help him, including Brian Aldiss himself.

Once the script was approaching an acceptable draft, Stanley decided to begin storyboarding the project and engaged a young artist from Birmingham, Chris Baker, who had been suggested by the science-fiction bookseller Ken Slater.

Chris had never worked in films before and Stanley found him a perfect partner. Tony Frewin recalls Stanley saying, 'I pitch something at Chris and he comes back a week later with fifty variants all perfectly drawn. He never runs out of ideas!' It was a very productive relationship and here are three of Chris's storyboards.

As the project progressed, Stanley came to the opinion that it would be better if he were to *produce* the film and his friend, Steven Spielberg, direct it. This would have been his first co-production, but it was not to be. Stanley died in March 1999 and the torch was passed to Steven who used Stanley's work to both produce and direct *A.I. (Artificial Intelligence)*, a fitting, if posthumous, collaboration and conclusion to Stanley's film-making career.

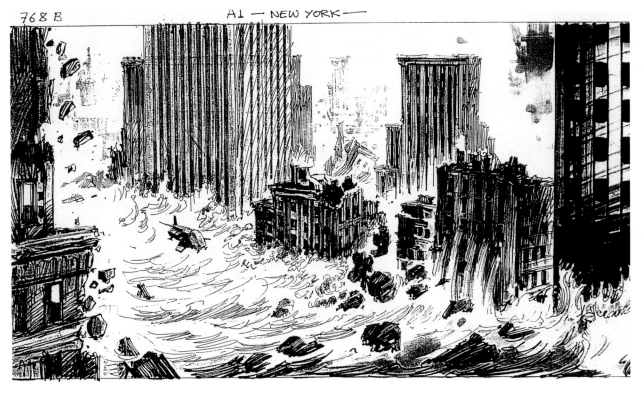

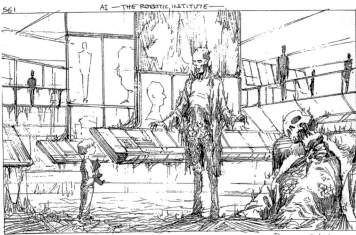

225, 226, 227

Three professional colleagues of Stanley's who were also his close friends. Alphabetically, top to bottom: Louis C. Blau, attorney and advisor, 1958–99; John Calley, former President and Vice-Chairman of Warner Bros, now Chairman and CEO of Sony Pictures; Terry Semel, former Co-Chairman of Warner Bros, now Chairman and CEO of Yahoo.

If one believes, as I do, that the motion picture was the pre-eminent art form of the twentieth century, then it is apparent that Stanley Kubrick has earned a place in the Pantheon of the greatest artists of the period.

It was a privilege and also at times exhausting, though more often exhilarating, to work with Stanley from 1958 until 1999 as both his counsel and his friend.
– LOUIS C. BLAU

A day doesn't pass that I don't think of Stanley and miss him terribly. He was, in my view, the best kind of friend imaginable, incredibly wise, brilliantly talented, wonderfully fun and accessible.

Above all, he was a person whose range of wisdom made possible conversations across the broadest possible spectrum of subjects and feelings. He was loyal, irreplaceable and an inspiration. I loved him.
– JOHN CALLEY

Stanley Kubrick was the most intriguing, intelligent, interesting, insightful, humorous, creative and persistent film-maker that I have ever worked with.

The words 'can't do' were not allowed and he always pushed all of Warner Bros to our greatest heights. Over the twenty-five years I worked with him, from Barry Lyndon *to* The Shining *to* Full Metal Jacket *to* Eyes Wide Shut *and the development of A.I., he was the greatest. I will always miss him.*
– TERRY SEMEL

Appendix

Cast and Credits: The Films of Stanley Kubrick

CAST AND CREDIT lists for Stanley's films have been given in many books, but these frequently contain inaccuracies and omissions. This appendix, it is hoped, will serve as a definitive source.

The reader may find useful an explanation as to how what follows was put together.

The first step was to transcribe all of the titles and credits as they appear in the films themselves. Once this was done a number of problems immediately became apparent.

Often, what works on the screen and is accepted cinematic practice looks out of place in a book. For instance, the Special Photographic Effects Supervisor credits in *2001: A Space Odyssey*. Four individuals received this credit and each had a 'card' to himself, that is to say their name appeared alone on the screen after the repeated credit line. It would have looked strange printing that line four times with a different name at the end of each. So the line appears once only with the four names following.

The wish to remain faithful to the styling of the original screen credits had to be balanced against the need to present a stylistically uniform text that was easy for the reader to navigate. Hence a number of 'silent' changes were also made. These were, chiefly: the elimination of unnecessary punctuation or its standardisation where retained, and the 'global' styling for the cast and crew, whereby the role each of them played or the job they did is in italic followed by their name in roman.

Nonetheless, from time to time these strictures have been disregarded for contextual clarity or fidelity to the original credits.

A further problem relates to the cast credits. On SK's first four theatrical features, namely *Fear and Desire*, *Killer's Kiss*, *The Killing* and *Paths of Glory*, the names of the cast were given but not the names of the characters they played. On *Spartacus*, only the six principal stars had their role names given. With the two films that followed, *Lolita* and *Dr Strangelove*, no character names were given. Thereafter, from *2001: A Space Odyssey* onwards, the cast was fully identified, in line with an SAG ruling. In this listing all roles have been identified, either by character name or role.

Many people work on films and for various reasons go uncredited. At the end of several films an 'uncredited' list is sub-joined. For the sake of convenience in what follows, MAIN TITLES means the material that appears at the beginning of a film, and END CREDITS everything at the end, and both are printed in large caps. In small caps the reader will find CAST and CREW. CAST is self-explanatory, but CREW here takes in *everything* outside of the cast, and while it may result in the occasional appearance of credits and lines that may seem a little incongruous under such a heading, the reader should find it facilitates the journey through the following pages.

Release dates given are those for the USA. All films are colour unless noted as black & white.

The student or interested filmgoer wishing to study SK's life and films is recommended to make the official website their first port of call. This is at *www.kubrickfilms.com*. It is a storehouse of information, and amongst other features contains an annotated bibliography.

The full credits of both Jan Harlan's documentary, *Stanley Kubrick: A Life in Pictures,* and

Vivian Kubrick's *Making 'The Shining'*, are included at the end of this appendix in simplified form.

For help with the 'uncredited' lists I owe debts to Anthony Frewin, David Meeker and Peter Hughes.

1. DAY OF THE FIGHT

[MAIN TITLES]
DAY OF THE FIGHT
A Stanley Kubrick Production
[CREW]
Film Editor Julian Bergman. *Assistant Director* Alexander Singer. *Narration Script* Robert Rein. *Narrator* Douglas Edwards. *Photography* Stanley Kubrick. *Music Composed and Conducted by* Gerald Fried. *Sound* Stanley Kubrick. *Produced and Directed by* Stanley Kubrick. *Screenplay* Stanley Kubrick. All events depicted in this film are true.
[END CREDITS]
THE END.

– Black & white. Running time: 16 minutes. Released 1950.

UNCREDITED
[CAST]
Himself Walter Cartier. *Himself* Vincent Cartier. *Himself* Nate Fleischer (boxing historian). *Walter Cartier's opponent* Bobby James. *Ringside fan* Judy Singer.
[CREW]
Assistant director, 2nd unit director, additional photography Alexander Singer. *Editing, sound* Stanley Kubrick.

2. FLYING PADRE

[MAIN TITLES]
RKO-Pathé Inc presents
FLYING PADRE
an RKO-Pathé Screenliner.
Produced by Burton Benjamin.
Directed by Stanley Kubrick.
Narrated by Bob Hite. Edited by Isaac Kleinerman.

Music by Nathaniel Shilkret.
Recorded by Harold R. Vivian.
[END CREDITS]
THE END
An RKO-Pathé Screenliner.

– Black & white. Running time: 9 minutes. Distributed by RKO Radio. Released: 1951.

UNCREDITED

[CREW]
Screenplay & Photography Stanley Kubrick.

3.
THE SEAFARERS
[MAIN TITLES]
THE SEAFARERS
Presented by Seafarers' International Union, Atlantic & Gulf Coast District AFL. As told by Dan Hollenbeck. Written by Will Chasan. Directed and photographed by Stanley Kubrick. Technical assistance: Staff of the Seafarers' Log. Produced by Lester Cooper.
[END CREDITS]
THE END
Lester Cooper Productions, New York.

– Running time: 30 minutes. Distributed by the Seafarers' International Union/AFI. Released: 1953.

4.
FEAR AND DESIRE
[MAIN TITLES]
Joseph Burstyn presents
FEAR AND DESIRE
[CAST]
Mac Frank Silvera. *Sidney* Paul Mazursky. *Corby* Kenneth Harp. *Fletcher* Steve Coit. *The Girl* Virginia Leith. *Narrator* David Allen.
[CREW]
Assistant Director Robert Dierks. *Unit Manager* Steve Hahn. *Dialogue Director* Toba Kubrick. *Make-up* Chet Fabian. *Art Direction* Herbert Lebowitz. *Title Design* Barney Ettengoff.

Written by Howard Sackler. Music composed and conducted by Gerald Fried. Produced by Stanley Kubrick. Associate producer Martin Perveler. Directed, photographed and edited by Stanley Kubrick.
[END CREDITS]
[CAST]
Mac Frank Silvera. *Lt. Corby & The General* Kenneth Harp. *Sidney* Paul Mazursky. *Fletcher & The Captain* Steve Coit. *The Girl* Virginia Leith. *Narrator* David Allen.
FEAR AND DESIRE
THE END

– Black & white. Running time: 68 minutes. Distributed by Joseph Burstyn Inc. Released: 1 April 1953.

5.
KILLER'S KISS
[MAIN TITLES]
A Minotaur Production
KILLER'S KISS
[CAST]
Starring: *Vincent Rapallo* Frank Silvera.
With: *Davy Gordon* Jamie Smith. *Gloria Price* Irene Kane. *Albert, the fight manager* Jerry Jarret. *Hoodlums* Mike Dana, Felice Orlandi, Ralph Roberts, Phil Stevenson. *Owner of the mannequin factory* Julius 'Skippy' Adelman. *Conventioneers* David Vaughan, Alec Rubin. With: Shaun O'Brien, Barbara Brand, Arthur Feldman, Bill Funaro.
[CREW]
Production Manager Ira Marvin. *Camera Operators* Jesse Paley and Max Glenn. *Chief Electrician* Dave Golden. *Sound Recordists* Walter Ruckersberg and Clifford Van Praag. *Assistant Editors* Pat Jaffe and Anthony Bezich. *Assistant Director* Ernest Nukanen.
Sound by Titra Sound Studio.
Love Theme from the Song 'Once' by Norman Gimbel and Arden Clar. Ballet sequence danced by Ruth Sobotka. Choreography by David Vaughan.
Story by Stanley Kubrick.
Music composed and conducted by

Gerald Fried. Produced by Stanley Kubrick and Morris Bousel. Edited, photographed and directed by Stanley Kubrick
[END CREDITS]
KILLER'S KISS
THE END
A Minotaur Production.

– Black & white. Running time: 67 minutes. Distributed by United Artists. Released: 28 September 1955.

UNCREDITED

[CREW]
Screenplay Howard Sackler, Stanley Kubrick.
[CAST]
Iris Price Ruth Sobotka.

6.
THE KILLING
[MAIN TITLES]
Harris-Kubrick presents
THE KILLING
[CAST]
Starring: *Johnny Clay* Sterling Hayden.
Co-starring: *Fay* Coleen Gray. *Val Cannon* Vince Edwards. Featuring: *Marvin Unger* Jay C. Flippen. *Randy Kennan* Ted DeCorsia. *Sherry Peatty* Marie Windsor. *George Peatty* Elisha Cook. *Mike O'Reilly* Joe Sawyer. *Car park attendant* James Edwards. *Nikki* Timothy Carey. *Maurice* Kola Kwariani. *Leo* Jay Adler. *Tiny* Joseph Turkel.
With: Tito Vuolo, Dorothy Adams, Herbert Ellis, James Griffith, Cecil Elliott, Steve Mitchell, Mary Carroll, William Benedict, Charles R. Cane, Robert B. Williams.
[CREW]
Associate producer Alexander Singer. *Camera operator* Dick Tower. *Gaffer* Bobby Jones. *Head grip* Carl Gibson. *Script supervisor* Mary Gibson. *Sound* Earl Snyder. *Best boy* Lou Cortese. *2nd Assistant cameraman* Robert Hosler. *Construction supervisor* Bud Fine. *Chief carpenter* Christopher Ebsen. *Chief painter* Robert L. Stephen. *Make-up* Robert Littlefield.

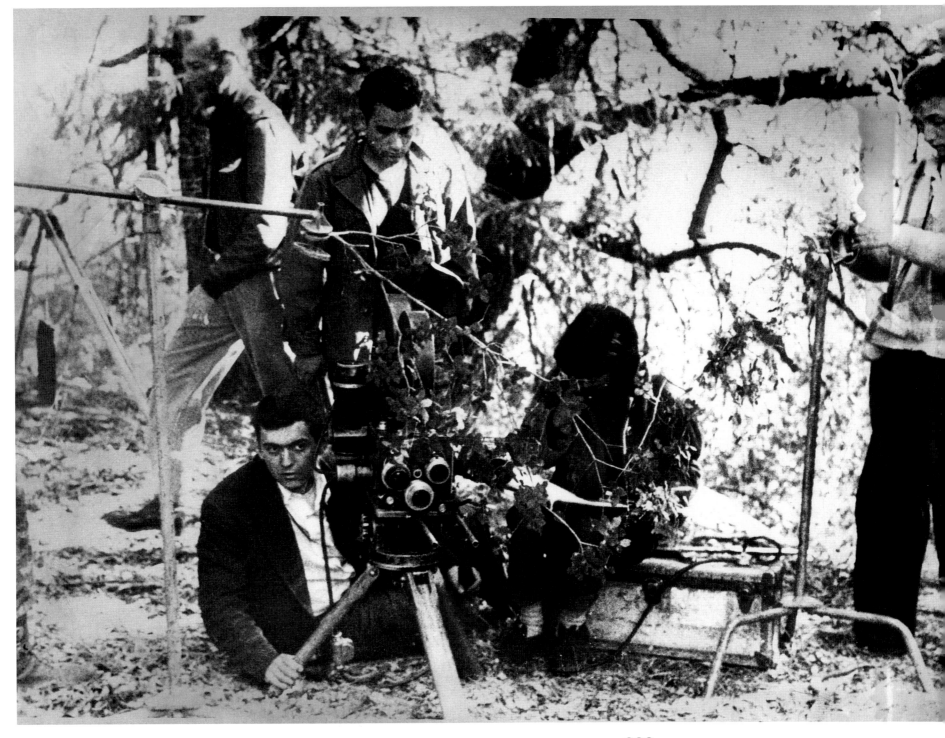

228
On location in California for *Fear and Desire* in the early 1950s.

Wardrobe Jack Masters. *Special effects* Dave Koehler. *Set decorator* Harry Reif. *Assistant set decorator* Carl Brainard. *Music editor* Gilbert Marchant. *Sound effects editor* Rex Upton M.P.S.E. *Assistant director* Milton Carter. *2nd Assistant directors* Paul Feiner, Howard Joslin. *Production assistant* Marguerite Olson. *Prop man* Ray Zambel. *Transportation* Dave Lesser. *Women's wardrobe* Rudy Harrington. *Hairdresser* Lillian Shore. *Process cameraman* Paul Eagler. *Director's assistant* Joyce Hartman. *Miss Windsor's costumes* Beaumelle. *Photographic effects* Jack Rabin and Louis DeWitt. *Director of photography* Lucien Ballard, A.S.C. *Art director* Ruth Sobotka. *Film editor* Betty Steinberg.
Music composed and conducted by Gerald Fried. Screenplay by Stanley Kubrick. Dialogue by Jim Thompson, based on the novel *Clean Break* by Lionel White. Produced by James B. Harris. Directed by Stanley Kubrick.
[END CREDITS]
THE KILLING
THE END
A Harris-Kubrick Presentation. Released through United Artists.

– Black & white. Running time: 83 minutes. Distributed by United Artists. Released 20 May 1956.

UNCREDITED
[CAST]
Racetrack Employees Frank Richards, Dick Reeves.
[CREW]
Production supervisor Clarence Eurist. *Production comptroller* Bessie Epstein. *Sound recordist* Joseph Keener.

7.
PATHS OF GLORY
[MAIN TITLES]
Bryna Productions present
Colonel Dax Kirk Douglas
PATHS OF GLORY

[CAST]
Co-starring: *Corporal Paris* Ralph Meeker and *General Broulard* Adolphe Menjou.
Featuring: *General Mireau* George Macready. *Lieutenant Roget* Wayne Morris. *Major Saint-Auben* Richard Anderson. *Private Arnaud* Joseph Turkel. *German girl* Susanne Christian. *Tavern owner* Jerry Hausner. *Colonel Judge* Peter Capell. *Priest* Emile Meyer. *Sergeant Boulanger* Bert Freed. *Private LeJeune* Kem Dibbs. *Private Ferol* Timothy Carey. *Captain Rousseau* John Stein. *Captain Nichols* Harold Benedict.
[CREW]
Unit manager Helmut Ringelmann. *Assistant directors* H. Stumpf, D. Sensburg, E. Spieker. *Script clerk* Trudy Von Trotha. *Sound* Martin Müller. *Costume designer* Isle Duhois. *Special effects* Erwin Lange. *Military adviser* Baron v. Waldenfels. *Assistant editor* Helene Fischer. *Camera grip* Hans Elsinger. *Make-up* Arthur Schramm.
Produced at Bavaria Filmkurst Studios Munich
Music Gerald Fried. *Art director* Ludwig Reiber. *Photographed by* George Krause. *Camera operator* Hannes Staudinger.
American production manager John Pommer. *German production manager* George von Block. *Film editor* Eva Kroll.
Screenplay by Stanley Kubrick, Calder Willingham and Jim Thompson. Based on the novel *Paths of Glory* by Humphrey Cobb. Produced by James B. Harris. Directed by Stanley Kubrick.
[END CREDITS]
THE END
Released thru United Artists.
[CAST]
Over movie clips: Fred Bell. John Stein. Harold Benedict. Bert Freed. Peter Capell. Emile Meyer. Jerry Hausner. Susanne Christian. Joseph Turkel. Timothy Carey. Richard Anderson. Wayne Morris. George Macready. Adolphe Menjou. Ralph Meeker. Kirk Douglas.

– Black & white. Running time: 86 minutes. Distributed by United Artists. Released 25 December 1957.

8.
SPARTACUS
[MAIN TITLES]
Bryna Productions Inc presents:
Spartacus Kirk Douglas. *Crassus* Laurence Olivier. *Varinia* Jean Simmons. *Gracchus* Charles Laughton. *Batiatus* Peter Ustinov. *Julius Caesar* John Gavin.
SPARTACUS
Co-starring: *Helena* Nina Foch. *Tigranes* Herbert Lom. *Crixus* John Ireland. *Glabrus* John Dall. *Marcellus* Charles McGraw. *Claudia* Joanna Barnes. *David* Harold J. Stone. *Draba* Woody Strode. *Ramon* Peter Brocco. *Gannicus* Paul Lambert. *Captain of the Guard* Robert J. Wilke. *Dionysius* Nicholas Dennis. *Roman Officer* John Hoyt. *Laelius* Frederic Worlock. *Symmachus* Dayton Lummis. And co-starring: Tony Curtis as *Antoninus*.
Screenplay by Dalton Trumbo, based on the novel by Howard Fast. *Director of photography* Russell Metty, A.S.C. Technicolor filmed in Super Technirama – 70. Lenses by Panavision.
Production designer Alexander Golitzen. *Art director* Eric Orbom. *Set decorations* Russell A. Gausman and Julia Heron. *Main titles and design consultant* Saul Bass. *Sound* Waldon O. Watson, Joe Lapis, Murray Spivack, Ronald Pierce. *Historical and technical adviser* Vittorio Nino Novarese. *Unit production manager* Norman Deming. *Additional scene photography* Clifford Stine A.S.C. *Production aide* Stan Margulies. *Wardrobe by* Peruzzi. *Miss Simmons' costumes* Bill Thomas. *Costumes by* Valles. *Film editor* Robert Lawrence. *Assistants to the film editor* Robert Schulte, Fred Chulack. *Score co-conducted by* Joseph Gershenson. *Music editor* Arnold Schwarzwald. *Make-up* Bud Westmore. *Hair stylist* Larry Germain. *Assistant director*

Marshall Green. *Music composed and conducted by* Alex North. Executive producer Kirk Douglas. Produced by Edward Lewis. Directed by Stanley Kubrick.
[END CREDITS]
THE END

– Running time: 196 minutes, subsequently cut to 184 minutes* (and later restored). Distributed by Universal Pictures. Released: 6 October 1960.

* The scene cut was the attempted seduction of Antoninus, the slave, by his master, Crassus (Tony Curtis, Lawrence Olivier, respectively).

UNCREDITED
[CREW]
Director Anthony Mann. *2nd Unit Director* Irving Lerner. *Assistant Directors* Foster H. Phinney, James Welch, Joe Kenny, Charles Scott. *Camera Operators* Harry Wolf, George Dye. *Special Effects* Wes Thompson. *Editorial Consultant* Irving Lerner.
[CAST]
Old Crone Lili Valenty. *Julia* Jill Jarmyn. *Slave Girl* Jo Summers. *Otho* James Griffith. *Marius* Joe Haworth. *Trainer* Dale Van Sickle. *Metallius* Vinton Hayworth. *Herald* Carleton Young. *Beggar Girl* Hallene Hill. *Fimbria* Paul E. Burns. *Garrison Officer* Leonard Penn. *Slaves* Harry Harvey Jr., Eddie Parker, Harold Goodwin, Chuck Robertson. *Slave Leaders* Saul Gorss, Charles Horvath, Gil Perkins. *Gladiators* Bob Morgan, Reg Parton, Tom Steele. *Ad-Lib* Ken Terrell. *Ad-Lib* Boyd Morgan. *Guards* Dick Crockett, Harvey Parry, Carey Loftin. *Pirates* Bob Burns, Seamon Glass, George Robotham, Stubby Kruger. *Soldiers* Chuck Courtney, Russ Saunders, Valley Keene, Tap Canutt, Joe Canutt, Chuck Hayward, Buff Brady, Cliff Lyons, Rube Schaffer. *Legionnaires* Ted De Corsia, Arthur Batanides, Robert Stevenson. *Majordomo* Terence De Marney. *Extra* Gary Lockwood.

9.
LOLITA
[MAIN TITLES]
Metro-Goldwyn-Mayer Presents:
In association with Seven Arts Productions
James B. Harris & Stanley Kubrick's
LOLITA
[CAST]
Humbert Humbert James Mason. *Charlotte Haze* Shelley Winters. And introducing: *Lolita Haze* Sue Lyon. With: *Dick* Gary Cockrell. *John Farlow* Jerry Stovin. *Jean Farlow* Diana Decker. *Nurse Mary Lord* Lois Maxwell. *Physician* Cec Linder. *Mrs Starch* Shirley Douglas. *Vivian Darkbloom* Marianne Stone. *Miss Lebone* Marion Mathie. *Hospital receptionist* Maxine Holden. *Tom* John Harrison. *Charlie* Colin Maitland. *Swine* Bill Greene. *Louise* Isobel Lucas. *Beale* James Dyrenforth. *Lorna* Roberta Shore. *Hospital attendant* Irvin Allen. *Rex* Craig Sams. *Roy* Eric Lane. *Potts* C. Denier Warren. *Bill* Roland Brand. *Mona Farlow* Suzanne Gibbs. And: *Quilty* Peter Sellers. With: Terence Kilburn.
[CREW]
Music composed and conducted by Nelson Riddle. 'Lolita' *theme by* Bob Harris, *orchestrations by* Gil Grau. *Production supervisor* Raymond Anzarut. *Art director* Bill Andrews. *Associate art director* Sidney Cain. *Director of photography* Oswald Morris B.S.C. *Editor* Anthony Harvey. *Production manager* Robert Sterne. *Assistant director* Rene Dupont. *Camera operator* Denys N. Coop. *Continuity* Pamela Davies. *Dubbing editor* Winston Ryder. *Sound recordists* Len Shilton and H.L. 'Dickie' Bird. *Casting director* James Liggat. *Make-up* George Partleton. *Hairdresser* Betty Glasow. *2nd Unit director* Dennie Stock. *Wardrobe supervisor* Elsa Fennell. *Miss Winter's costumes* Gene Coffin. *Assistant editor* Lois Gray. *Titles* Chambers & Partners.
Screenplay by Vladimir Nabokov based on his novel *Lolita*.

Produced by James B. Harris. Directed by Stanley Kubrick.
[END CREDITS]
THE END
Produced at Associated British Studios, Elstree, England.
An Anya Prod. S.A. – Transworld Pictures S.A. Production.

– Black & white. Running time: 153 minutes. Distributed by Metro-Goldwyn-Mayer. Released: 13 June 1962.

UNCREDITED
[CREW]
Production Accountant Jack Smith. *Assistant Accountant* Doreen Wood. *Production Secretary* Joan Parcell. *Producer's Secretary* Josephine Baker. *2nd Assistant Director* Roy Millichip. *3rd Assistant Director* John Danischewsky. *Director's Secretary* Stella Magee. *Assistant Continuity* Joyce Herlihy. *Special Writer* David Sylvester. *Focus Puller* James Turrell. *Clapper Loader* Michael Rutter. *Camera Grip* A. Osborne. *Electrical Gaffer* W. Thompson. *Stills* Joe Pearce. *Assistant Editor* W.W. Armour. *Set Decorator* Andrew Low. *Set Dresser* Peter James. *Chief Draughtsman* Frank Wilson. *Draughtsmen* John Siddall, Roy Dorman. *Scenic Artist* A. Van Montagu. *Production Buyer* Terry Parr. *Construction Manager* Harry Phipps. *Wardrobe Assistant* Wyn Keeley. *Wardrobe Mistress* Barbara Gillett. *Assistant Make-up* Stella Morris. *Sound Maintenance* Dan Grimmel, Jack Lovelace. *Boom Operator* Don Wortham. *Assistant Boom Operators* Peter Carnody, Tommy Staples. *Unit Publicist* Enid Jones. *Publicity Secretary* Amy Allen.
Nelson Riddle orchestra includes: *Trombones* Don Lusher, Jackie Armstrong. *Alto saxophone* Peter Hughes (lead), Bob Burns. *Trumpet* Stan Roderick. *Tenor saxophone* Tommy Whittle.

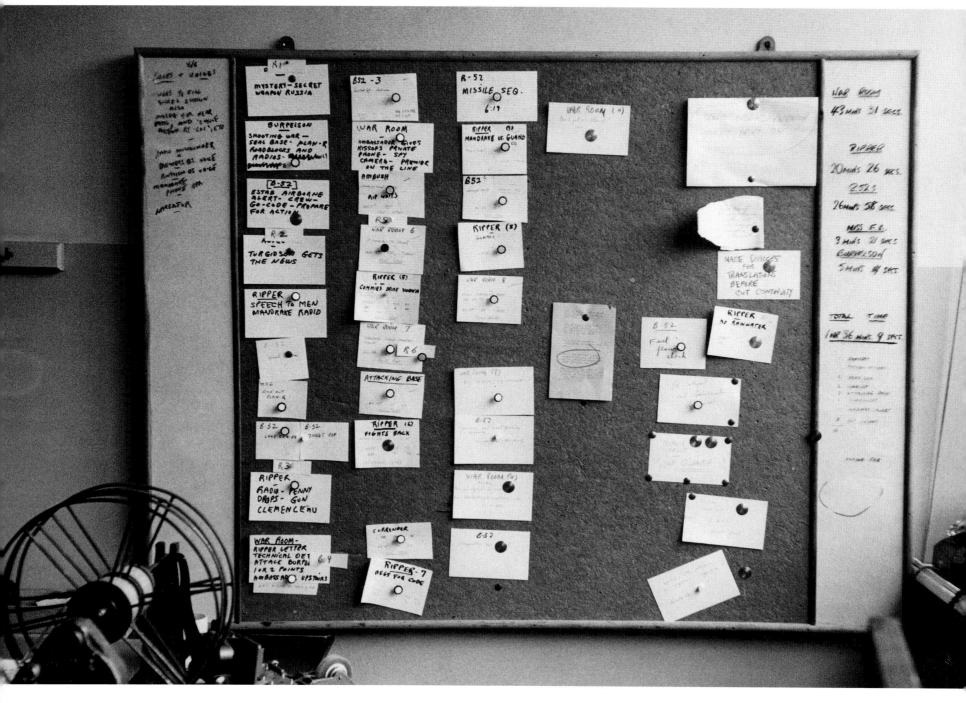

229
Stanley's notes on the pinboard in
the editing rooms of *Dr Strangelove*.
Photograph by Stanley.

10.
DR STRANGELOVE, or: HOW I LEARNED TO STOP WORRYING AND LOVE THE BOMB

[MAIN CREDITS]
Columbia Pictures Corporation
Presents
A Stanley Kubrick Production
[CAST]
Starring: *Group Captain Lionel Mandrake, President Muffley, Dr Strangelove* Peter Sellers. *General Buck Turgidson* George C. Scott. DR STRANGELOVE or: HOW I LEARNED TO STOP WORRYING AND LOVE THE BOMB.
Co-starring: *General Jack D. Ripper* Sterling Hayden. *Colonel Bat Guano* Keenan Wynn. *Major T.J. 'King' Kong* Slim Pickens. With: *Ambassador de Sadesky* Peter Bull. *Lieutenant Lothar Zogg, Bombardier* James Earl Jones. *Miss Scott* Tracy Reed. *Mr Staines* Jack Creley. *Lieutenant H.R. Dietrich, D.S.O.* Frank Berry. *Admiral Randolph* Robert O'Neil. *Lieutenant W.D. Kivel, Navigator* Glen Beck. *Frank* Roy Stephens. *Captain G.A. 'Ace' Owens, co-pilot* Shane Rimmer. *Members of Burpleson Base Defense Corps* Hal Galili, Laurence Herder, John McCarthy. *Lieutenant B. Goldberg, radio operator* Paul Tamarin. *General Faceman* Gordon Tanner.

[CREW]
Art Director Peter Murton. *Camera Operator* Kelvin Pike. *Wardrobe* Bridget Sellers. *Production Manager* Clifton Brandon. *Camera Assistant* Bernard Ford. *Assistant Director* Eric Rattray. *Continuity* Pamela Carlton. *Special Effects* Wally Veevers. *Dubbing Mixer* John Aldred. *Make-up* Stewart Freeborn. *Travelling Matte* Vic Margutti. *Sound Editor* Leslie Hodgson. *Hairdresser* Barbara Ritchie. *Recordist* Richard Bird. *Assistant Editor* Ray Lovejoy. *Assistant Advisor* Capt. John Crewdson. *Sound Supervisor* John Cox. *Assembly Editor* Geoffrey Fry.

Music Laurie Johnson. *Director of Photography* Gilbert Taylor B.S.C. *Film Editor* Anthony Harvey. *Production Designer* Ken Adam. *Associate Producer* Victor Lyndon. Screenplay by Stanley Kubrick, Terry Southern & Peter George. Based on the book *Red Alert* by Peter George. Directed and produced by Stanley Kubrick.
[END CREDITS]
THE END
Made at Shepperton Studios, England, by Hawk Films Ltd.

– Black & white. Running time: 94 minutes (scenes cut, originally 102 minutes). Distributed by Columbia Pictures. Released: 30 January 1964.

UNCREDITED
[CREW]
Unit Manager Leon Minoff.

11.
2001: A SPACE ODYSSEY

[MAIN TITLES]
Metro-Goldwyn-Mayer presents
A Stanley Kubrick Production
2001: A SPACE ODYSSEY
[END CREDITS]
This film was directed and produced by Stanley Kubrick. Screenplay by Stanley Kubrick and Arthur C. Clarke. Presented by Metro-Goldwyn-Mayer in Cinerama.
[cast]
Starring: *David Bowman* Keir Dullea. Starring: *Frank Poole* Gary Lockwood. Starring: *Dr Heywood Floyd* William Sylvester. *Moon-Watcher* Daniel Richter. Featuring: *Smyslov* Leonard Rossiter. *Elena* Margaret Tyzack. *Halvorsen* Robert Beatty. *Michaels* Sean Sullivan. *Voice of HAL-9000* Douglas Rain. *Mission control* Frank Miller. *Poole's father* Alan Gifford. *Stewardess* Penny Brahms. With: Glenn Beck, Edwina Carroll, Bill Weston, Mike Lovell, Edward Bishop, Ann Gillis, Heather Downham. *Apemen:* John Ashley, Jimmy Bell, David Charkham,

Simon Davis (aka Keith Denny), Jonathan Daw, Peter Delmar, Terry Duggan (attacked by leopard), David Fleetwood, Danny Grover, Brian Hawley, David Hines, Tony Jackson, John Jordan, Scott MacKee, Laurence Marchant, Darryl Paes, Joe Refalo, Andy Wallace, Bob Wilyman, Richard Wood (killed by Moon-Watcher).
[CREW]
Special photographic effects, designed and directed by Stanley Kubrick. *Special photographic effects supervisors* Wally Veevers, Douglas Trumbull, Con Pederson, Tom Howard. *Production designed by* Tony Masters, Harry Lange and Ernest Archer. *Film editor* Ray Lovejoy. *Wardrobe by* Hardy Amies. *Director of photography* Geoffrey Unsworth B.S.C. *Additional photography* John Alcott.
Music by Aram Khatchaturian, Gayane Ballet Suite. Performed by the Leningrad Philharmonic Orchestra. Conductor Gennadi Rozhdestvensky. Courtesy Deutsche Grammophon.
Music by György Ligeti, Atmospheres. Performed by the Southwest German Radio Orchestra. Conductor Ernest Bour. Lux Aeterna. Performed by the Stuttgart State Orchestra. Conductor Clytus Gottwald. Requiem. Performed by the Bavarian Radio Orchestra. Conductor Francis Travis.
Music by Johann Strauss, The Blue Danube. Performed by the Berlin Philharmonic Orchestra. Conductor Herbert von Karajan. Courtesy Deutsche Grammophon.
Music by Richard Strauss, Thus Spoke Zarathustra.
First assistant director Derek Cracknell. *Special photographic effects unit* Colin J. Cantwell, Bryan Loftus, Frederick Martin, Bruce Logan, David Osborne, John Jack Malick. In Technicolor and Metrocolor. Approved No. 21197, Motion Picture Association of America. Ars Gratia Artis. A Metro-Goldwyn-Mayer Release. A Metro-Goldwyn-Mayer Production.

Camera operator Kelvin Pike. *Art director* John Hoesli. *Sound editor* Winston Ryder. *Make-up* Stuart Freeborn. *Editorial assistant* David De Wilde. *Sound supervisor* A.W. Watkins. *Sound mixer* H.L. 'Dickie' Bird. *Chief dubbing mixer* J.B. Smith. *Scientific consultant* Frederick I. Ordway III. Filmed in Super Panavision. Made at MGM British Studios Ltd, Borehamwood, England. THE END

– Running time: 141 minutes (reduced from 160 minutes after New York opening). Distributed by Metro-Goldwyn-Mayer. Released: 1 April 1968.

UNCREDITED
This complete listing was put together by Anthony Frewin for the programme notes that accompanied the first screening of the British Film Institute's 70mm print at the National Film Theatre, London, in September 1999. Frewin, who worked on the film, utilised call sheets, production files and unit lists.
Some names appear twice in the overall listing. This is not a mistake; it reflects changing roles over the three year period the film was in production.

[CAST]
Floyd's daughter Vivian Kubrick. *Photographer* Burnell Tucker. *First technician* John Swindell. *Second technician* John Clifford. *Interviewer* Martin Amor. With: Penny Pearl, Julie Croft, Sheraton Blount, Penny Francis, Kim Neill, Ann Bomann, Marcella Markham, Jane Hayward, Jane Pearl. *Hal 9000 voice – replaced* Martin Balsam.
[CREW]
Associate Producer (pre-production and main unit only) Victor Lyndon. *Chief accountant* Ron Phipps. *Assistant accountants* Peter Lancaster, Arthur Porter, Brian Harris. *Accounts inventory clerk*

Shrish Bhatt. *Production co-ordinator* Merle Chamberlin. *Production managers* Clifton Brandon, Robert Watts. *Unit/production manager* Eddie Frewin. *Post-production manager* Ronnie Bear. *Secretary to Ronnie Bear* Betty Parry. *Production assistant* Patrick Clayton. *Assistants to Mr Kubrick* Anthony Frewin, Andrew Birkin. *Production secretary* Iris Rose. *PA/secretary to Mr Kubrick* Christine Mitchell. *Pre-production PA/secretary to Mr Kubrick* Vicky Ward. *PA/secretary to Mr Lyndon* Daphne Paice. *Assistant to Mr Lyndon* Simon Bird. *Assistants to Christine Mitchell* Jill Hollamby, Elizabeth Braby. *Secretary* Margaret Warrington. *Production department secretary* Monica Rogers. *Runner* Michael Murray. *Typists* Domeny Bernie, Margaret Hattam. *2nd Assistant director* Richard Jenkins. *3rd Assistant director* Richard Hoult. *Casting* Jimmy Liggatt. *Additional photography* Michael Wilson. *Rostrum cameraman* Dennie Hall. *Additional matte cinematography* Richard Yuricich. *Assistant camera* Peter MacDonald. *Focus pullers* David Osborne, Bryan Loftus. *Clapper/loaders* John Campbell, Graeme Scaife, Terry Pearce. *Camera maintenance* Norman Godden. *Grips* Don Budge, David Cadwallader. *Chief gaffer* Bill Jeffery. *Assistant gaffer* George 'Geordie' Walker. *Electrician* Jed Murphy. *Unit stills photographer* John Jay. *Stills (MGM):* Ken Bray. *Stills filing clerk* Keith Hamshere. *Stills technician* John Barnett. *Special effects stills printers* Graham Hooper, Dan McGowen. *Darkroom assistant* John Locke. *Matte camera printers* Ron Wooster, Jim Budd, Jack Spooner. *Special effects supervisor (pre-production)* Wally Gentleman. *Additional supervisors* Les Bowie, Charles Shepherd. *Special effects unit* John Jack Malick. *Front projection supervisor* Tom Howard. *Special effects technician* Ron Ballanger. *Special effects co-ordinators* George Pollock, Colin Brewer. *Special effects department*

secretaries Valerie Kent, Delia Tindall. *Special effects special art* Roger Dicken. *Special effects special models* Douglas Potts. *Special effects engineer* Ted Creed. *Special effects assistants* Bob Cuff, Brian Johnson, Joy Seddon, Hilary Ann Pickburn. *Special effects floor camera department* Bernard Ford, Brian Bennett, Peter Hannan, Terry Pearce, Bob Rickerd, Martin Body. *Special effects maintenance* Tom Welford. *Airbrush artists* William Davis, Trevor Lawrence, Alf Levy. *Aerial wire work* Eugene's Flying Ballets. *Special effects runner* Toni Traynor. *Blob artists* Brian Willsher, David Watkins, John Gant, Herbert Bailey, Peter Biggs, Ann Griffiths, John Horton, William Plampton, Hapugoda Premaratne, Dennis Smith, Gary Sinclair, Caird Green, Jenny Foster, Paul Haywood, Sarah Katz, Catherine Philby, Hilary Randall, James Wilkins, Fran Guye, Bob Nadkarni, David Peterson, Livia Rolandini, James Simpson, David Temple, Roger Turner, Nigel Waller. *Miniatures cameraman* John Mackey. *Miniatures assistant* Phil Stokes. *Technical animation specialist* Jimmy Dickson. *Animation stand* Edward Gerald, Martin Goldsmith, Jasjeet Singh, Zoran Perisic. *Animation artists* Bruce Logan, Roy Naisbitt. *Assistant editor (2nd special effects)* Robin McDonnell. *Editing assistant* Robert Mullen. *Art director* John Hoesli. *Art department assistant* Penny Struthers. *Location surveying* Jack Stephens. *Set dressers* Robert Cartwright, Jack Holden. *Draughtsmen* John Graysmark, Alan Tomkins, John Siddall, Tony Reading, Frank Wilson, Peter Childs, Wallis Smith, Martin Atkinson, Brian Ackland-Snow, Alan Fraiser, John Fenner. *Engineering draughtsmen* R. Burton, P. Jaratt. *Scientific design specialist* Roy Carnon. *Technical illustrators* John Rose, John Young. *Sketch artist* Anthony Pratt. *Art department secretary* Theresa Kendall. *Art department typist* Anna Garrett.

Production buyer Bill Isaacs. *Stand-by props* Tommy Ibbetson, Roy Cannon, Phil Lanning. *Property master (MGM)*: Frank Bruton. *Construction manager* Richard Frift. *TMA-1 construction manager – Moon*: Gus Walker. *Construction engineers* Les Hillman, G. Payne. *Stand-by carpenter* Reg Carter. *Stand-by stagehand* James Holmes. *Stand-by painter* Christopher Burke. *Stand-by plasterer* Henry Gomez. *Plasterer's labourer* Stan Ogden. *Stagehand carpenter* Malcolm Legge. *Master plasterer (MGM)*: Wally Bull. *Drapes (MGM)*: Jumbo Miall. *Wardrobe design* Hardy Amies. *Wardrobe master* David Baker. *Wardrobe supervisors* Eileen Sullivan, Mary Gibson. *Wardrobe assistant* Duncan McPhee. *Make-up supervisor* Charles Parker. *Make-up* Graham Freeborn, Colin Arthur. *Make-up assistants* Muriel Rickaby, Kathleen Freeborn, Richard Mills, Hugh Richards. *Chief hairdressers* Carol Beckett, Alice Holmes. *Assistant hairdressers* Daphne Vollmer, Mibs Parker. *Colour timer* Harry V. Jones. *Original music score – replaced* Alex North. *Second music score – replaced* Frank Cordell. *Music editor* Frank J. Urioste. *'Dawn of Man' choreography* Daniel Richter. *Mr Richter's assistants* Adrian Haggard, Roy Simpson. *Recorder* Robin Gregory. *Sound camera operator* Michael Hickey. *Sound maintenance* Neil Stevenson. *Boom operators* Bill Cook, Don Wortham. *Assistant dubbing editor* Ernie Grimsdale. *Neg cutter* Alice Yendell. *Astronautics advisers* Frederick I. Ordway III, Harry Lange, Richard McKenna. *Technical adviser* Ormond G. Mitchell. *Unit car driver/driver to Mr Kubrick* Michael Connor. *Unit car drivers* Ron Coldham, Terry Brown. *Technicolor contacts* Stewart Brown, Doug Haig. *Laboratory assistant* Colin Arthur. *Print librarian* Michael Round. *Chief projectionist (MGM)*: Bert Batt. *Power house (MGM)*: George Dunn. *Engineering shop (MGM)*: George Merritt. *Catering (MGM)*: Sam Nolan. *Additional transport* Mac's Minicabs, Elite Car Hire. *Freight agencies* Ashton Mitchell & Howlett, Barnet International Forwarders (New York). *Stand-ins* John Francis, Eddie Milburn, Gerry Judge, Brian Chutter, Tom Sheppard, Robin Dawson-Whisker. *Leopard trainer* Terry Duggan. *Publicity supervisor* Dan S. Terrell. *MGM publicity* Benn Reyes. *Unit publicist* Edna Tromans. *American publicity representative* Roger Caras. *Secretary to Roger Caras* Elaine Simms. *Publicity artist* Robert McCall. *Publicity/art department liaison* Ivor Powell. *Publicity secretary* Hilary Messenger. *Exploitation designer* Christiane Kubrick. *Stanley Kubrick's chauffeur* Jim Warner.

12.
CLOCKWORK ORANGE
[MAIN TITLES]
Warner Bros. A Kinney Company presents
A Stanley Kubrick Production
A CLOCKWORK ORANGE
[END CREDITS]
Produced and Directed by Stanley Kubrick.
Screenplay by Stanley Kubrick. Based on the novel by Anthony Burgess.
[CAST]
Starring: *Alex* Malcolm McDowell. *Mr Alexander* Patrick Magee. And Featuring in Alphabetical Order: *Chief Guard* Michael Bates. *Dim* Warren Clarke. *Stage Actor* John Clive. *Mrs Alexander* Adrienne Corri. *Dr. Brodsky* Carl Duering. *Tramp* Paul Farrell. *Lodger* Clive Francis. *Prison Governor* Michael Gover. *Catlady* Miriam Karlin. *Georgie* James Marcus. *Deltoid* Aubrey Morris. *Prison Chaplain* Godfrey Quigley. *Mum* Sheila Raynor. *Dr. Branom* Madge Ryan. *Conspirator* John Savident. *Minister of the Interior* Anthony Sharp. *Dad* Philip Stone. *Psychiatrist* Pauline Taylor. *Conspirator* Margaret Tyzack. Also featuring: Steven Berkoff, Lindsay Campbell, Michael Tarn, David Prowse, Barrie Cookson, Jan Adair, Gaye Brown, Peter Burton, John J. Carney, Vivienne Chandler, Richard Connaught, Prudence Drage, Carol Drinkwater, Lee Fox, Cheryl Grunwald, Gillian Hills, Craig Hunter, Shirley Jaffe, Virginia Wetherell, Neil Wilson, Katya Wyeth.
[CREW]
Executive producers Max L. Raab and Si Litvinoff. *Consultant on hair and coloring* Leonard of London. *Associate producer* Bernard Williams. *Assistant to the producer* Jan Harlan.
Electronic music composed and realized by Walter Carlos. Symphony No. 9 in D Minor, Opus 125 by Ludwig Van Beethoven. Overtures 'The Thieving Magpie' and 'William Tell' by Gioachino Rossini. Recorded at Deutsche Grammophon Gesellschaft.
Pomp and Circumstance Marches No. 1 and 4 by Edward Elgar. Conducted by Marcus Dodds.
'Singin' in the Rain' by Arthur Freed and Nacio Herb Brown from the MGM Picture performed by Gene Kelly.
'Overture to the Sun' composed by Terry Tucker.
Song 'I Want to Marry a Lighthouse Keeper' composed and performed by Erika Eigen.
Lighting cameraman John Alcott. *Production designer* John Barry. *Editor* Bill Butler. *Sound editor* Brian Blamey. *Sound recordist* John Jordan. *Dubbing mixers* Bill Rowe, Eddie Haben. *Art directors* Russell Hagg, Peter Sheilds. *Wardrobe supervisor* Ron Beck. *Costume designer* Milena Canonero. *Stunt arranger* Roy Scammell. *Special paintings and sculpture* Herman Makkink, Cornelius Makkink, Liz Moore, Christiane Kubrick. *Casting* Jimmy Liggat. *Location manager* Terence Clegg. *Supervising electrician* Frank Wardale. *Assistant*

directors Derek Cracknell, Dusty Symonds. *Construction manager* Bill Welch. *Prop master* Frank Bruton. *Assistant editors* Gary Shepherd, Peter Burgess, David Beesley. *Camera operators* Ernie Day, Mike Molloy. *Focus-puller* Ron Drinkwater. *Camera assistants* Laurie Frost, David Lenham. *Boom operator* Peter Glossop. *Grips* Don Budge, Tony Cridlin. *Electricians* Louis Bogue, Derek Gatrell. *Prop men* Peter Hancock, Tommy Ibbetson, John Oliver. *Promotion co-ordinator* Mike Kaplan. *Production accountant* Len Barnard. *Continuity* June Randall. *Hairdresser* Olga Angelinetta. *Make-up* Fred Williamson, George Partleton, Barbara Daly. *Production secretary* Loretta Ordewer. *Director's secretary* Kay Johnson. *Production assistant* Andros Epaminondas. *Location liaison* Arthur Morgan. *Technical advisor* Jon Marshall. With special acknowledgement to Braun AG Frankfurt, Dolby Laboratories Inc., Kontakt Werkstaetten, Ryman Conran Limited, Steinheimer Leuchtenindustrie Temde AG. THE END Made at Pinewood Studios, London, England, at EMI-MGM Studios, Borehamwood, Herts, England, and on location in England by Hawk Films Limited. Distributed by Warner Bros. A Kinney Company.

– Running time: 135 minutes. Distributed by Warner Bros. Released: 20 December 1971.

UNCREDITED

[CREW]
Unit/Production manager Eddie Frewin. *Production assistant* Margaret Adams. *Additional photography* Stanley Kubrick.
[CAST]
Marty Barbara Scott. *Bootick Clerk* George O'Gorman. *Milkbar Bouncers* Pat Roach, Robert Bruce.

13.
BARRY LYNDON

[MAIN TITLES]
A WARNER COMMUNICATIONS COMPANY presents a film by Stanley Kubrick
Starring Ryan O'Neal and Marisa Berenson
BARRY LYNDON
[END CREDITS]
Written for the screen, produced and directed by Stanley Kubrick. Based on the novel by William Makepeace Thackeray.
[CAST]
Barry Lyndon Ryan O'Neal. *Lady Lyndon* Marisa Berenson. *The Chevalier* Patrick Magee. And: *Captain Potzdorf* Hardy Kruger. And featuring in alphabetical order: *Lord Ludd* Steven Berkoff. *Nora* Gay Hamilton. *Barry's Mother* Marie Kean. *German Girl* Diana Koerner. *Reverend Runt* Murray Melvin. *Sir Charles Lyndon* Frank Middlemass. *Lord Wendover* Andre Morell. *Highwayman* Arthur O'Sullivan. *Captain Grogan* Godfrey Quigley. *Captain Quin* Leonard Rossiter. *Graham* Philip Stone. *Lord Bullingdon* Leon Vitali. With: John Bindon, Roger Booth, Billy Boyle, Jonathan Cecil, Peter Cellier, Geoffrey Chater, Anthony Dawes, Patrick Dawson, Bernard Hepton, Anthony Herrick, Barry Jackson, Wolf Kahler, Patrick Laffan, Hans Meyer, Ferdy Mayne, David Morley, Liam Redmond, Pat Roach, Dominic Savage, Frederick Schiller, George Sewell, Anthony Sharp, John Sharp, Roy Spencer, John Sullivan, Harry Towb. *Narrator* Michael Hordern.
[CREW]
Music Adapted and Conducted by Leonard Rosenman. From Works by Johann Sebastian Bach, Frederick The Great, Georg Friedrich Handel, Wolfgang Amadeus Mozart, Giovanni Paisiello, Franz Schubert, Antonio Vivaldi.
Irish Traditional Music by The Chieftains. Schubert Piano Trio in E-Flat Op. 100 performed by Ralph Holmes – violin, Moray Welsh – cello, Anthony Goldstone – piano.

Vivaldi Cello Concerto in E-Minor – Pierre Fournier – cello. Recorded on Deutsche Grammophon.
Executive producer Jan Harlan. *Associate producer* Bernard Williams. *Production designer* Ken Adam. *Photographed by* John Alcott. *Costumes designed by* Ulla-Britt Søderlund, Milena Canonero. *Editor* Tony Lawson. *Hairstyles and wigs* Leonard. *Art director* Roy Walker. *Assistant to the producer* Andros Epaminondas. *Assistant director* Brian Cook. *Sound editor* Rodney Holland. *Sound recordist* Robin Gregory. *Dubbing mixer* Bill Rowe. *Assistant editor* Peter Krook. *Sound editor's assistant* George Akers. *Second unit cameraman* Paddy Carey. *Camera operators* Mike Molloy, Ronnie Taylor. *Focus puller* Douglas Milsome. *Colour grading* Dave Dowler. *Camera assistants* Laurie Frost, Dodo Humphreys. *Camera grips* Tony Cridlin, Luke Quigley. *Gaffer* Lou Bogue. *Chief electrician* Larry Smith. *Production managers* Douglas Twiddy, Terence Clegg. *Assistant directors* David Tomblin, Michael Stevenson. *Unit managers* Malcolm Christopher, Don Geraghty. *German production manager* Rudolf Hertzog. *Location liaison* Arthur Morgan, Col. William O'Kelly. *Set dresser* Vernon Dixon. *Assistant art director* Bill Brodie. *German art director* Jan Schlubach. *Property master* Mike Fowlie. *Property man* Terry Wells. *Property buyer* Ken Dolbear. *Construction manager* Joe Lee. *Painter* Bill Beecham. *Drapesmen* Richard Dicker, Cleo Nethersole, Chris Seddon. *Wardrobe supervisor* Ron Beck. *Costume makers* Gary Dahms, Yvonne Dahms, Jack Edwards, Judy Lloyd-Rogers, Willy Rothery. *Hats* Francis Wilson. *Wardrobe assistants* Gloria Barnes, Norman Dickens, Colin Wilson. *Make-up* Ann Brodie, Alan Boyle, Barbara Daly, Jill Carpenter, Yvonne Coppard. *Hairdressing* Susie Hill, Joyce James, Maud Onslow, Daphne Vollmer. *Producer's secretary*

Margaret Adams. *Casting* James Liggat. *Choreographer* Geraldine Stephenson. *Production accountant* John Trehy. *Production secretaries* Loretta Ordewer, Pat Pennelegion. *Assistant accountants* Ron Bareham, Carolyn Hall. *Continuity* June Randall. *Gambling adviser* David Berglas. *Historical adviser* John Mollo. *Fencing coach* Bob Anderson. *Stunt arranger* Roy Scammell. *Horsemaster* George Mossman. *Wrangler* Peter Munt. *Armourer* Bill Aylmore.
With Special Acknowledgements to Corsham Court, Glastonbury Rural Life Museum, Stourhead House, and the National Trust, Castle Howard.
Lenses for candlelight photography made by Carl Zeiss West Germany, adapted for cinematography by Ed Di Giulio. Special Sound Assistance Dolby Laboratories Inc.
A Peregrine Film.
Distributed by Warner Bros. A Warner Communications Company.
THE END
Made on location in England, Eire and Germany by Hawk Films Ltd, and re-recorded at EMI Elstree Studios Ltd, England.

– Running time: 185 minutes.
Distributed by Warner Bros.
Released: December 1975.

14.
THE SHINING
[MAIN TITLES]
A Warner Communications Company presents A Stanley Kubrick film.
Jack Nicholson, Shelley Duvall.
THE SHINING
[CAST]
Featuring Danny Lloyd, Scatman Crothers, Barry Nelson, Philip Stone, Joe Turkel, Anne Jackson, Tony Burton.
[CREW]
Executive producer Jan Harlan.
Based upon the novel by Stephen King. Produced in association with The Producer Circle Company – Robert Fryer, Martin Richards, Mary

Lea Johnson. Screenplay by Stanley Kubrick & Diane Johnson. Produced and directed by Stanley Kubrick.
[END CREDITS]
[CAST]
Jack Torrance Jack Nicholson. *Wendy Torrance* Shelley Duvall. *Danny* Danny Lloyd. *Hallorman* Scatman Crothers. *Ullman* Barry Nelson. *Grady* Philip Stone. *Lloyd* Joe Turkel. *Doctor* Anne Jackson. *Durkin* Tony Burton. *Young woman in bath* Lia Beldam. *Old woman in bath* Billie Gibson. *Watson* Barry Dennen. *Forest ranger 1* David Baxt. *Forest ranger 2* Manning Redwood. *Grady daughter* Lisa Burns. *Grady daughter* Louise Burns. *Nurse* Robin Pappas. *Secretary* Alison Coleridge. *Policeman* Burnell Tucker. *Stewardess* Jana Sheldon. *Receptionist* Kate Phelps. *Injured guest* Norman Gay.
[CREW]
Photographed by John Alcott. *Production designer* Roy Walker. *Film editor* Ray Lovejoy.
Music by Béla Bartók, Music for strings, percussion and celesta. Conducted by Herbert Von Karajan. Recorded by Deutsche Grammophon.
[Music by] Krzysztof Penderecki. Wendy Carlos & Rachel Elkind. György Ligeti.
Production manager Douglas Twiddy. *Assistant director* Brian Cook. *Costumes designed by* Milena Canonero. *Steadicam operator* Garrett Brown. *Helicopter photography* Macgillivray Freeman Films. *Personal assistant to the director* Leon Vitali. *Assistant to the producer* Andros Epaminondas. *Art director* Les Tomkins. *Make-up* Tom Smith. *Hairstyles* Leonard. *Camera operators* Kelvin Pike, James Devis. *2nd unit photography* Douglas Milsome, Macgillivray Freeman Films. *Focus assistants* Douglas Milsome, Maurice Arnold. *Camera assistants* Peter Robinson, Martin Kenzie, Danny Shelmerdine. *Grip* Dennis Lewis. *Gaffers* Lou Bogue, Larry Smith. *Sound editors* Wyn Ryder, Dino Di Campo, Jack Knight.

Sound recordists Ivan Sharrock, Richard Daniel. *Dubbing mixer* Bill Rowe. *Assistant editors* Gill Smith, Gordon Stainforth. *1920s Music Advisors* Brian Rust, John Wadley. *Assistant directors* Terry Needham, Michael Stevenson. *Make-up artist* Barbara Daly. *Continuity* June Randall. *Production accountant* Jo Gregory. *Set dresser* Tessa Dawes. *Construction manager* Len Fury. *Titles* Chapman Beauvais and National Screen Service. *Property master* Peter Hancock. *Décor artist* Robert Walker. *2nd Assistant editors* Adam Unger, Steve Pickard. *Colour grading* Eddie Gordon. *Hotel consultant* Tad Michel. *Casting* James Liggat. *Location research* Jan Schlubach, Katharina Kubrick, Murray Close. *Production secretaries* Pat Pennelegion, Marlene Butland. *Producer's secretary* Margaret Adams. *Production assistant* Emilio D'Alessandro. *Engineering* Norank of Elstree. *Wardrobe supervisors* Ken Lawton, Ron Beck. *Draughtsmen* John Fenner, Michael Lamont, Michael Boone. *Property buyers* Edward Rodrigo, Karen Brookes. *Video operator* Dan Grimmel. *Boom operators* Ken Weston, Michael Charman. *Drapes* Barry Wilson. *Master plasterer* Tom Tarry. *Head rigger* Jim Kelly. *Head carpenter* Fred Gunning. *Head painter* Del Smith. *Property men* Barry Arnold, Philip McDonald, Peter Spencer.
With special acknowledgements to: Timberline Lodge, Mt. Hood National Forest, Oregon; Continental Airlines; State of Colorado Motion Picture Commission; KBTV Channel 9 Denver; WPLG Channel 10 Miami; KHOW Radio Denver; Harrods of London; American Motor Company; Carl Zeiss of West Germany; National Vendors; Music Hire Group Ltd; Cherry Leisure (UK) Ltd; JVC (UK) Ltd.
Filmed with ARRIFLEX Cameras.
Distributed by Warner Bros. A Warner Communications Company.
THE END

230
Getting the positioning of the props just right for the scene where Jack is locked in the pantry in *The Shining*.

231
One of the *Full Metal Jacket* sets at Beckton gasworks. Behind Stanley to the left with his hands in his pockets is Leon Vitali, who started as an actor in *Barry Lyndon*, as the young Lord Bullingdon, and who stayed as an assistant on that and Stanley's subsequent films.

Made by Hawk Films Ltd at EMI Elstree Studios Ltd. England.

– Running time: 145 minutes.
Distributed by Warner Bros.
Released: 23 May 1980.

UNCREDITED
[CREW]
First unit focus (also lighting) Douglas Milsome. *Assistant production accountant* Paul Cadiou. *Production assistant* Ray Andrews. *Special effects* Alan Whibley, Les Hillman, Dick Parker. *Additional art director* Norman Dorme. *Wardrobe assistants* Ian Hickinbottom, Veronica McAuliffe.

15.
FULL METAL JACKET
[MAIN TITLES]
A Stanley Kubrick film.
FULL METAL JACKET
[END CREDITS]
[CREW]
Directed and produced by Stanley Kubrick.
Screenplay by Stanley Kubrick, Michael Herr, Gustav Hasford.
Based on the novel *The Short-Timers* by Gustav Hasford.
Executive producer Jan Harlan. *Co-producer* Philip Hobbs. *Associate producer* Michael Herr. *Assistant to the Director* Leon Vitali.
[CAST]
Starring: *Pvt. Joker* Matthew Modine. *Animal Mother* Adam Baldwin. *Pvt. Pyle* Vincent D'Onofrio. *Gny. Sgt. Hartman* Lee Ermey. *Eightball* Dorian Harewood. *Rafterman* Kevyn Major Howard. *Pvt. Cowboy* Arliss Howard. *Lt. Touchdown* Ed O'Ross. *Lt. Lockhart* John Terry. *Crazy Earl* Keiron Jecchinis. *Payback* Kirk Taylor. *Doorgunner* Tim Colceri. *Doc Jay* John Stafford. *Poge Colonel* Bruce Boa. *Lt. Cleves* Ian Tyler. *T.H.E. Rock* Sal Lopez. *Donlon* Gary Landon Mills. *Da Nang hooker* Papillon Soo Soo. *Snowball* Peter Edmund. *V.C. Sniper* Ngoc Le. *Motorbike hooker* Leanne Hong. *Arvn pimp* Tan Hung Francione.

Hand Job Marcus D'Amico. *Chili Costas* Dino Chimona. *Stork* Gil Kopel. *Daddy Da* Keith Hodiak. *TV journalist* Peter Merrill. *Daytona Dave* Herbert Norville. *Camera thief* Nguyen Hue Phong. *Dead N.V.A.* Duc Hu Ta.

[CREW]
Lighting cameraman Douglas Milsome. *Production designer* Anton Furst. *Original music* Abigail Mead. *Editor* Martin Hunter. *Sound recording* Edward Tise. *Boom operator* Martin Trevis. *Sound editors* Nigel Galt, Edward Tise. *Dubbing mixers* Andy Nelson, Mike Dowson. *Re-recording* Delta Sound, Shepperton. *Special effects supervisor* John Evans. *Special effects senior technicians* Peter Dawson, Jeff Clifford, Alan Barnard. *Casting* Leon Vitali. *Additional casting* Mike Fenton and Jane Feinberg C.S., Marion Dougherty. *Additional Vietnamese casting* Dan Tran, Nguyen Thi My Chau. *1st Assistant director* Terry Needham. *2nd Assistant director* Christopher Thomson. *Production manager* Phil Kohler. *Unit production manager* Bill Shepherd. *Production co-ordinator* Margaret Adams. *Costume designer* Keith Denny. *Wardrobe master* John Birkenshaw. *Wardrobe assistant* Helen Gill. *Co-make-up artists* Jennifer Boost, Christine Allsop. *Dialogue editor* Joe Illing. *Assistant sound editors* Paul Conway, Peter Culverwell. *Montage editing engineer* Adam Watkins. *Video operator* Manuel Harlan. *Camera trainees* Vaughan Matthews, Michaela Mason. *Editing trainee* Rona Buchanan. *Hair by* Leonard. *Art directors* Rod Stratfold, Les Tomkins, Keith Pain. *Set dresser* Stephen Simmonds. *Assistant art directors* Nigel Phelps, Andrew Rothschild. *Technical adviser* Lee Ermey. *Art department research* Anthony Frewin. *Armourers* Hills Small Arms Ltd, Robert Hills, John Oxlade. *Modeller* Eddie Butler. *Prop master* Brian Wells. *Construction manager*

George Crawford. *Asst. construction manager* Joe Martin. *Prop buyer* Jane Cooke. *Colour* Rank Film Laboratories, Denham. *Steadicam operators* John Ward, Jean-Marc Bringuier. *Follow focus* Jonathan Taylor, Maurice Arnold, James Ainslie, Brian Rose. *Grip* Mark Ellis. *Camera assistant* Jason Wrenn. *Chief electrician* Seamus O'Kane. *Helicopter pilot* Bob Warren. *Continuity* Julie Robinson. *Production accountant* Paul Cadiou. *Assistants to the producer* Emilio D'Alessandro, Anthony Frewin. *Producer's secretary* Wendy Shorter. *Production assistant* Steve Millson. *Assistant accountant* Rita Dean. *Accounts computer operator* Alan Steele. *Production runners* Michael Shevloff, Matthew Coles. *Nurses* Linda Glatzel, Carmel Fitzgerald. *Special computer editing programs* Julian Harcourt. *Unit drivers* Steve Coulridge, Bill Wright, James Black, Paul Karamadza. *Helicopter* Sykes Group. *Laboratory contact* Chester Eyre. *Louma crane technician* Adam Samuelson. *Louma crane and montage video editing system* Samuelsons, London. *Aerial photography* Ken Arlidge, Samuelsons Australia. *Optical sound* Kay-Metrocolor Sound Studios. *Sound transfers* Roger Cherrill. *Titles* Chapman Beauvais. *Catering* The Location Caterers Ltd. *Transport* D&D International, Dave Croucher, Ron Digweed, Chalky White. *Facilities* Willies Wheels, Ron Lowe. *Unit transport* Focus Cars. *Action vehicle engineer* Nick Johns. *Chargehand prop* Paul Turner. *Standby props* Danny Hunter, Steve Allett, Terry Wells. *Propmen* R. Dave Favell Clarke, Frank Billington-Marks. *Dressing props* Marc Dillon, Michael Wheeler, Winston Depper. *Supervising painter* John Chapple. *Painters* Leonard Chubb, Tom Roberts, Leslie Evans Pearce. *Riggers* Peter Wilkinson, Les Phipps. *Carpenters* Mark Wilkinson, A.R. Carter, T.R. Carter. *Plasterers* Dominic Farrugia, Michael Quinn. *Stagehands* David

Gruer, Michael Martin, Stephen Martin, Ronald Boyd. *Standby construction* George Reynolds, Brian Morris, Jim Cowan, Colin McDonagh, John Marsella.
[CAST]
Parris Island Recruits and Vietnam Platoon: Martin Adams, Kevin Aldridge, Del Anderson, Philip Bailey, Louis Barlotti, John Beddows, Patrick Benn, Steve Boucher, Adrian Bush, Tony Carey, Gary Cheeseman, Wayne Clark, Chris Cornibert, Danny Cornibert, John Curtis, Harry Davies, John Davis, Kevin Day, Gordon Duncan, Phil Elmer, Colin Elvis, Hadrian Follett, Sean Frank, David George, Laurie Gomes, Brian Goodwin, Nigel Goulding, Tony Hague, Steve Hands, Chris Harris, Bob Hart, Derek Hart, Barry Hayes, Tony Hayes, Robin Hedgeland, Duncan Henry, Kenneth Head, Liam Hogan, Trevor Hogan, Luke Hogdal, Steve Hudson, Tony Howard, Sean Lamming, Dan Landin, Tony Leete, Nigel Lough, Terry Lowe, Frank McCardle, Gary Meyer, Brett Middleton, David Milner, Sean Minmagh, Tony Minmagh, John Morrison, Russell Mott, John Ness, Robert Nichols, David Perry, Peter Rommely, Pat Sands, Jim Sarup, Chris Schmidt-Maybach, Al Simpson, Russell Slater, Gary Smith, Roger Smith, Tony Smith, Anthony Styliano, Bill Thompson, Mike Turyansky, Dan Weldon, Dennis Wells, Michael Williams, John Wilson, John Wonderling.
[CREW]
'Hello Vietnam' performed by Johnny Wright. Courtesy of MCA Records. Written by Tom T. Hall. Unichappell Music Inc., Morris Music Inc.
'These Boots Are Made For Walking' performed by Nancy Sinatra. Courtesy of Boots Enterprises Inc. Written by Lee Hazelwood, Criterion Music Corp.
'Wooly Bully' performed by Sam the Sham and the Pharaohs. Courtesy of Polygram Special Products, a Division of Polygram Records Inc.

Written by Domingo Samudio, Beckle Publishing Co. Inc.
'The Marines Hymn' performed by The Goldman Band. Courtesy of MCA Records.
'Chapel of Love' performed by The Dixie Cups by arrangement with Shelby Singleton Enterprises c/o Original Sound Entertainment. Written by Jeff Barry, Ellie Greenwich & Phil Spector. Trio Music Co. Inc. Mother Bertha Music Inc.
'Paint It Black' written by Mick Jagger and Keith Richards. Performed by the Rolling Stones. Produced by Andrew Loog Oldham. Courtesy of ABKCO Music and Records Inc.
Cameras by Arri, Munich. Fairlight Digital Audio-Post Music System. Lexicon Time Compressor/Expander. With grateful acknowledgement to – Depot Queens Division Bassingbourn, PSA Bassingbourn Barracks, British Gas PLC North Thames, The Vietnamese Community, National Trust Norfolk. THE END
Filmed on location and at Pinewood Studios, Iver, Bucks.
Distributed by Warner Bros. A Warner Communications Company.

– Running time: 112 minutes.
Distributed by Warner Bros.
Released: 26 June 1987.

16.
EYES WIDE SHUT
[MAIN TITLES]
Warner Bros. Presents
Tom Cruise
Nicole Kidman
A film by Stanley Kubrick
EYES WIDE SHUT
[END CREDITS]
Produced and directed by Stanley Kubrick.
Screenplay by Stanley Kubrick and Frederic Raphael. Inspired by 'Traumnovelle' by Arthur Schnitzler. *Executive producer* Jan Harlan. *Co-producer* Brian W. Cook. *Assistant to the director* Leon Vitali.

[CAST]
Tom Cruise, Nicole Kidman, Sydney Pollack, Marie Richardson, Rade Sherbedgia, Todd Field, Vinessa Shaw, Alan Cumming, Sky Dumont, Fay Masterson, Leelee Sobieski, Thomas Gibson, Madison Eginton.
[CREW]
Lighting cameraman Larry Smith. *Production designers* Les Tomkins and Roy Walker. *Editor* Nigel Galt. *Original music composed by* Jocelyn Pook, performed by Electra Strings.
György Ligeti, Musica ricercata II, Dominic Harlan, piano.
Dmitri Shostakovich, Waltz 2 from Jazz Suite No. 2, Royal Concertgebouw Orchestra, conducted by Riccardo Chailly.
Costume designer Marit Allen. *Costume supervisor* Nancy Thompson. *Wardrobe mistress* Jacqueline Durran. *Hair* Kerry Warn. *Make-up* Robert McCann. *Sound recordist* Eddie Tise. *Supervising sound editor* Paul Conway. *Sound maintenance* Tony Bell. *Re-recording mixers* Graham V. Hartstone AMPS, Michael A. Carter, Nigel Galt, Tony Cleal. *Production manager* Margaret Adams. *Script supervisor* Ann Simpson. *Assistant to Stanley Kubrick* Anthony Frewin. *Casting* Denise Chamian, Leon Vitali. *1st Assistant director* Brian W. Cook. *2nd Assistant director* Adrian Toynton. *3rd Assistant directors* Becky Hunt, Rhun Francis. *Location managers* Simon McNair Scott, Angus More Gordon. *Location research* Manuel Harlan. *Location assistant* Tobin Hughes. *Supervising art director* Kevin Phipps. *Art director* John Fenner. *Draughtsperson* Joe Billington. *Assistant draughts-person* Pippa Rawlinson. *Art department assistants* Samantha Jones, Kira-Anne Pelican. *Original paintings by* Christiane Kubrick, Katharina Hobbs. *Venetian masks research* Barbara Del Greco. *Production accountant* John Trehy. *Assistant accountant* Lara Sargent. *Accounts assistants* Matthew Dalton, Stella

Wycherley. *Set decorators* Terry Wells Snr, Lisa Leone. *Production buyers* Michael King, Jeanne Vertigan, Sophie Batsford. *First assistant editor* Melanie Viner Cuneo. *Editorial assistant* Claire Ferguson. *Avid assistant editor* Claus Wehlisch. *Foley editor* Becki Pontin. *Assistant sound editor* Iain Eyre. *Steadicam operators* Elizabeth Ziegler, Peter Cavaciuti. *Camera operator* Martin Hume. *Focus pullers* Rawdon Hayne, Nick Penn, Jason Wrenn. *Clapper loaders* Craig Bloor, Keith Roberts. *Camera grips* William Geddes, Andy Hopkins. *Back projection supervisor* Charles Staffel. *Camera technical advisor* Joe Dunton. *Translites* Stilled Movie. *Translite photography* Gerald Maguire. *Stills photography* Manuel Harlan. *Video co-ordinator* Andrew Haddock. *Video assistant* Martin Ward. *Gaffers* Ronnie Phillips, Paul Toomey. *Best boy* Michael White. *Electricians* Ron Emery, Joe Allen, Shawn White, Dean Wilkinson. *Dialect coach to Ms Kidman* Elizabeth Himelstein. *Choreographer* Yolande Snaith. *Production Associate* Michael Doven. *Assistants to Ms Kidman* Andrea Doven, Kerry David. *Assistant to Mr Kubrick* Emilio D'Alessandro.
[CAST]
Cast in order of appearance:
Dr William Harford Tom Cruise.
Alice Harford Nicole Kidman.
Helena Harford Madison Eginton.
Roz Jackie Sawiris. *Victor Ziegler* Sydney Pollack. *Ilona* Leslie Lowe.
Bandleader Peter Benson. *Nick Nightingale* Todd Field. *Sandor Szavost* Sky Dumont. *Victor Ziegler's secretary* Michael Doven. *Gayle* Louise Taylor. *Nuala* Stewart Thorndike. *Harris* Randall Paul. *Mandy* Julienne Davis. *Lisa* Lisa Leone. *Lou Nathanson* Kevin Connealy. *Marion* Marie Richardson. *Carl* Thomas Gibson. *Rosa* Mariana Hewett. *Rowdy college kids* Dan Rollman, Gavin Perry, Chris Pare, Adam Lias, Christian Clarke, Kyle Whitcombe.

Naval officer Gary Gobo. *Domino* Vinessa Shaw. *Maître d' Café Sonata* Florian Windorfer. *Milich* Rade Sherbedgia. *Japanese Man 1* Togo Igawa. *Japanese Man 2* Eiji Kusuhara. *Milich's daughter* Leelee Sobieski. *Cab driver* Sam Douglas. *Gateman 1* Angus Mac-Innes. *Mysterious woman* Abigail Good. *Tall butler* Brian W. Cook. *Red cloak* Leon Vitali. *Waitress at Gillespie's* Carmela Marner. *Desk clerk* Alan Cumming. *Sally* Fay Masterson. *Stalker* Phil Davies. *Waitress at Sharkey's* Cindy Dolenc. *Hospital receptionist* Clarke Hayes. *Morgue orderly* Treva Etienne. *Masked party principals:* Karla Ashley, Kathryn Charman, James Demaria, Anthony Desergio, Janie Dickens, Laura Fallace, Vanessa Fenton, Georgina Finch, Abigail Good, Peter Godwin, Joanna Heath, Lee Henshaw, Ateeka Poole, Adam Pudney, Sharon Quinn, Ben de Sausmarez, Emma Lou Sharratt, Paul Spelling, Matthew Thompson, Dan Travers, Russell Trigg, Kate Whalin.

[CREW]

Chargehand standby propman Jake Wells. *Standby propman* John O'Connell. *Property master* Terry Wells Jnr. *Property storeman* Ken Bacon. *Dressing propmen* Todd Quattromini, Gerald O'Connor. *Construction manager* John Maher. *Standby carpenter* Roy Hansford. *Standby stagehand* Desmond O'Boy. *Standby painter* Steve Clark. *Standby rigger* Anthony Richards. *Production co-ordinator* Kate Garbet. *Unit nurse* Clare Litchfield. *Catering* The Location Caterers Ltd. *Security* Alan Reid. *Extras casting* 20-20 Productions Ltd. *Medical advisor* Dr. C. J. Scheiner M.D., Ph.D. *Journalistic advisor* Larry Celona. *Secretary* Rachel Hunt. *Computer assistant* Nick Frewin. *Production Assistant* Tracy Crawley. *Action vehicle mechanic* Tom Watson. *Action vehicle co-ordinator* Martin Ward. *Equipment vehicles* Lays International Ltd. *Facility vehicles* Location Facilities Ltd. *Action vehicles* Dream Cars. *Facilities*

supervisor David Jones. *Fire cover* First Unit Fire and Safety Ltd. Soundtrack Album on Warner Sunset Records/Warner Bros. Records Inc.
Music consultant Didier de Cottignies.
Music contractor Peter Hughes.
Second unit production manager Lisa Leone. *Cinematography* Patrick Turley, Malik Sayeed, Arthur Jaffa. *Steadicam operator* Jim C. McConkey. *Grip* Donavan C. Lambert. *Camera assistants* Carlos Omar Guerra, Jonas Steadman. *Production assistant* Nelson Pena. Jazz Suite, Waltz 2. Performed by Royal Concertgebouw Orchestra. Conducted by Riccardo Chailly. Courtesy of The Decca Record Company Limited. Under licence from Universal Music Special Markets.
Dmitri Shostakovich. Published by Boosey & Hawkes Music Publishers Ltd.
'CHANSON D'AMOUR' Performed by The Victor Silvester Orchestra. Courtesy of Castle Copyrights Ltd. Written by Wayne Shanklin. Administered by Hill & Range Songs, Inc. & Carlin Music Corporation.
'I'M IN THE MOOD FOR LOVE' Performed by The Victor Silvester Orchestra. Courtesy of Castle Copyrights Ltd. Written by Jimmy McHugh and Dorothy Fields. Published by Famous Music Corporation.
'IT HAD TO BE YOU' Performed by Tommy Sanderson and The Sandmen. Courtesy of Maestro Records Ltd. Written by Gus Kahn and Isham Jones. Published by EMI Music Publishing Ltd, Gilbert Keyes Music and Bantam Music.
'OLD FASHIONED WAY' Performed by The Victor Silvester Orchestra. Courtesy of Castle Copyrights Ltd. Written by Georges Garvarentz and Charles Aznavour. Published by Chappell Aznavour Ltd.
'WHEN I FALL IN LOVE' Performed by The Victor Silvester Orchestra. Courtesy of Castle Copyrights Ltd. Written by Victor Young and

Edward Heyman. Published by Chappell & Co. Inc.
'I ONLY HAVE EYES FOR YOU' Performed by The Victor Silvester Orchestra. Courtesy of Castle Copyrights Ltd. Written by Harry Warren and Al Dublin. Published by EMI United Partnership Ltd.
'BABY DID A BAD BAD THING' Performed by Chris Isaak. Courtesy of Reprise Records. By arrangement with Warner Special Products. Written by Chris Isaak. Published by C. Isaak Music Publishing Co.
'I GOT IT BAD (And That Ain't Good)' Performed by The Oscar Peterson Trio. Courtesy of Verve Records. Under licence from Universal Music Special Markets. Written by Duke Ellington and Paul Francis Webster. Published by EMI Music Publishing Ltd, The Estate of Duke Ellington and Webster Music Co.
'IF I HAD YOU' Performed by Roy Gerson. Courtesy of RozA1 Records. Written by Ted Shapiro, Jimmy Campbell and Reg Connolly. Published by Campbell Connelly & Co Ltd.
'NAVAL OFFICER' Performed by Jocelyn Pook and Electra Strings. Written by Jocelyn Pook. Published by WB Music Corp. and Chester Music Ltd
'BLAME IT ON MY YOUTH' Performed by Brad Mehldau. Courtesy of Warner Bros. Records Inc. By arrangement with Warner Special Products. Written by Oscar Levant and Edward Heyman. Published by Polygram International Publishing Inc.
'MASKED BALL' Performed by Jocelyn Pook and Electra Strings. Written by Jocelyn Pook. Published by Chester Music Ltd.
'MIGRATIONS' Performed by Jocelyn Pook and the Jocelyn Pook Ensemble with Manickam Yogeswaran. Courtesy of Virgin Records Ltd. Written by Jocelyn Pook and Harvey Brough. Published by Chester Music Ltd and Hubba Dots Ltd.

190 'STRANGERS IN THE NIGHT'
Performed by Peter Hughes
Orchestra. Written by Bert
Kaempfert, Charles Singleton and
Eddie Snyder. Published by MCA
Music Publishing/Screen Gems-EMI
Music. All rights controlled by
MCA Music Publishing.
MUSICA RICERCATA II: MESTO,
RIGIDO E CERIMONALE Dominic
Harlan, piano. Gyorgy Ligeti.
Published by Schott Musik
International GmbH & Co. KG.
'THE DREAM' Performed by Jocelyn
Pook and Electra Strings. Written by
Jocelyn Pook. Published by WB
Music Corp. and Chester Music Ltd.
Arthur Schnitzler *Traumnovelle*
published by S. Fischer Verlag,
Frankfurt, Germany.
Mobile phones by Orange. Lighting
Equipment by Hi-Lighting Ltd, Lee
Lighting Ltd.
Edited on Avid Film Composer.
Cameras by Arriflex. Colour by
Deluxe London.
Laboratory consultant Chester Eyre.
Negative cutter Trevor Collins.
Laboratory contact Ian Robinson.
Motion Picture Products by Kodak.
Titles by Chapman Beauvais. Sound
re-recorded at Deluxe Pinewood
Studios. Sound editing by Sound
Design Company. Dolby, Sony DTS.
Evening wear for Tom Cruise by
Cerruti. Digital Effects and
Animation by The Computer Film
Co., London.
With special thanks to: John Frieda
Inc, The City of Westminster, The
London Borough of Hackney, The
London Borough of Islington, The
London Borough of Camden, The
Royal Borough of Kensington &
Chelsea, The Metropolitan Police,
The Thames Valley Police, The
London Film Commission, The
Luton Hoo Foundation, The staff of
Hamleys of London, The Transport
Research Laboratory, The Chelsea
and Westminster Hospital, The
Hatton Garden Association, The
Gower Street Surgery, The
Nightingale Surgery, Jonathan
Boreham & Associates, Rover
Group, PRO.P.AG.AND.A Geneva,

LEEC Limited, Compaq Computers,
Hewlett Packard, Bang & Olufsen.
Sound re-recorded at Deluxe
Pinewood Studios. Made at Deluxe
Pinewood Studios and on UK
locations in Norfolk and The Home
Counties.
A Pole Star Production made by
Hobby Films Ltd.
THE END
Distributed by Warner Bros. A Time
Warner Entertainment Company.

– Running time: 159 minutes.
Distributed by Warner Bros.
Released: 16 July 1999.

UNCREDITED
[CREW]
The Peter Hughes Orchestra
includes: *Alto saxophone* Peter
Hughes (lead). *Trumpet* Kenny
Baker. *Piano and arranger* Gerry
Butler.

MAKING 'THE SHINING'
A film by Vivian Kubrick. *Assistant
Editor* Gordon Stainforth. *Edited
and Directed by* Vivian Kubrick.
With Stanley Kubrick, Jack
Nicholson, Shelley Duvall, Danny
Lloyd, Scatman Crothers, and
members of the crew.

– Running time: 33 minutes.
Distributed by Warner Bros.
Released 1980.

STANLEY KUBRICK: A LIFE IN PICTURES
A Time Warner Entertainment
Company.
Producer-Director Jan Harlan.
Associate Producer Anthony
Frewin. *Editor* Melanie Viner
Cuneo. *Camera-Sound* Manuel
Harlan. *Picture Research* Tom
Gambale, Camille DeBiase,
Marianne Bower. *Transcriptions*
Andrea Cunnington, Katie Barget.
Online Editor Alan Jones. *Colourist*
Nick Adams. *Avid Assistant* Claus
Wehlisch. *Computer Support* Nick
Frewin. *Sound Editing* Sound
Design Company. *Sound Supervisor*
Nigel Galt. *Re-Recording Mixers*
Graham V. Hartstone AMPS,
Brendan Nicholson AMPS. *Rostrum
Camera* Ken Morse. *Additional
Footage* Vivian Kubrick. *Archive
Film* Archive Films, British
Movietone News, British Pathe,
Historic Films.
Narrated by Tom Cruise.
Special Thanks: Christiane Kubrick.
Thanks Tony Lawson, Martin Short,
Leon Vitali.
Thanks to: Didier de Cottigniers,
Volker Landtag, Vincent LoBrutto,
Gene D. Phillips SJ, Nicolas Riddle,
Wolfgang Sedat, Adam Watkins,
Deutsche Grammophon – a
Universal Company.
*Interviewees in surname alphabeti-
cal order:* Ken Adam, Margaret
Adams, Brian Aldiss, Woody Allen,

Steven Berkoff, Louis C. Blau, John Calley, Milena Canonero, Wendy Carlos, Chris Chase, Sir Arthur C. Clarke, Alex Cox, Tom Cruise, Allen Daviau, Ed Di Giulio, Keith Dullea, Shelley Duvall, Anthony Frewin, Jan Harlan, James B. Harris, Michael Herr, Mike Herrtage, Phillip Hobbs, Nicole Kidman, Barbara Kroner, Christiane Kubrick, Anya Kubrick, Katharina Kubrick Hobbs, Paul Lashmar, György Ligeti, Steven Marcus, Paul Mazursky, Malcolm McDowell, Doug Milsome, Matthew Modine, Jack Nicholson, Tony Palmer, Alan Parker, Sydney Pollack, Richard Schickel, Martin Scorsese, Terry Semel, Alex Singer, Steven Spielberg, Sybil Taylor, Doug Trumbull, Sir Peter Ustinov, Leon Vitali, Marie Windsor, Alan Yentob.

– Running time: 48 minutes x 3. Distributed by Warner Bros. Released 2001.

232
The production team of *Stanley Kubrick: A Life in Pictures* in the walled garden at my house near St Albans, June 2001.
Left to right: Anthony (Tony) Frewin, associate producer; Melanie Viner Cuneo, editor; Jan Harlan, producer and director; Manuel Harlan, camera and sound.

233 (over page)
The director's chair . . .
A photograph by Matthew Modine taken on location at Bassingbourn Barracks during the shooting of *Full Metal Jacket*.

L'Envoi

'The most terrifying fact about the universe is not that it is hostile but that it is indifferent; but if we can come to terms with this indifference and accept the challenges of life within the boundaries of death – however mutable man may be able to make them – our existence as a species can have genuine meaning and fulfilment. However vast the darkness, we must supply our own light.'

STANLEY KUBRICK